MEDITERRANEAN LIVING
VIVRE AU BORD DE LA MÉDITERRANÉE
MEDITERRANES WOHNEN

MEDITERRANEAN LIVING
VIVRE AU BORD DE LA MÉDITERRANÉE
MEDITERRANES WOHNEN

EVERGREEN

EVERGREEN is an imprint of

TASCHEN GmbH

© 2007 TASCHEN GmbH

Hohenzollernring 53, D-50672 Köln

www.taschen.com

Editor Editrice Redakteur:
Simone Schleifer

English translation Traduction anglaise Englische Übersetzung:
Julia Hendler

French translation Traduction française Französische Übersetzung:
Marion Westerhoff

German translation Traduction allemande Deutsche Übersetzung:
Susanne Engler

Proofreading Relecture Korrektur lesen:
Gene Ferber, Marie-Pierre Santamarina, Martin Rolshoven

Art director Direction artistique Art Direktor:
Mireia Casanovas Soley

Graphic design and layout Mise en page et maquette Graphische Gestaltung und Layout:
Laura Millán

Printed by Imprimé par Gedruckt durch:
Nexográfico, Spain

ISBN: 978-3-8228-4051-1

The Mediterranean coast is attracting a growing number of people from all over the world, both holiday-makers and other visitors, some of whom eventually decide to settle in one of the countries that enjoy its unique environment. Big cities, small towns and villages along the coast or further inland all seem to offer a lifestyle shaped by a gentle climate, regional characteristics and thousand-year-old traditions. The so-called 'traditional Mediterranean style' is typical of the architectural landscape and, combined with ultramodern, minimalist or even audaciously extravagant concepts, and thus offers an astonishing diversity of styles.

Today nineteen European countries share the Mediterranean coast and include a great many islands and archipelagos. Their origins go back long before Antiquity, as human settlements started some 75,000 years ago. Great civilizations such as the Greeks, Egyptians, Phoenicians and Romans settled on the shores of this enormous lake, turning it into one of the most vital regions in the world. For thousands of years the Mediterranean basin has enjoyed a unique situation, linking Europe, Africa and Asia, and it is still regarded as the cradle of the West. It is a bridge between East and West, a frontier between the Christian and Islamic worlds that boasts an incredibly rich variety of architectural styles alongside Gothic and Moorish, and evolving in striking ways, such as Portuguese manuelismo, still present in many buildings.

The benign climate, with its dry summers and mild winters, as well as the stunning tapestry of bays, rocky coves, sandy beaches, lush mountain ranges and strong red earth have all conspired to create a unique Mediterranean architectural style. Exceptionally beautiful houses, apartments and estates, many of which have been meticulously restored, all reflect their surroundings. The bright colors, the terracotta tiles of the roofs, the white-washed walls and interior details are still the most typical design elements, but reinterpreted in a thousand different ways.

The residences featured in this book are fine examples of the splendor and enchantment of Mediterranean architecture. They have been selected to pay homage to the various cultures that contribute to this resplandence and to illustrate the perfect fusion between tradition and modernism.

La vie et l'art de vivre en Méditerranée fascinent de plus en plus de personnes dans le monde entier, les incitant à passer leurs vacances dans cet environnement, et même, pour certains, à s'y installer définitivement. Que ce soit dans les grandes villes, la campagne ou directement sur la côte, un style particulier s'y est développé, reflet de chacune de ces régions, fruit de la douceur du climat et d'une tradition millénaire. Il en découle un paysage architectural qui s'illustre surtout par un « style classique méditerranéen » revisité de concepts ultramodernes, minimalistes, allant jusqu'à une extravagance audacieuse, déclinant ainsi une large palette pour satisfaire les goûts les plus divers.

En Europe, l'espace méditerranéen compte aujourd'hui 19 pays indépendants ainsi qu'une multitude d'îles et d'archipels. Son origine remonte bien avant l'Antiquité, puisqu'il y a plus de 75.000 ans, des peuples s'installaient surtout dans la partie européenne. En effet, les grandes civilisations, à l'instar des anciens Egyptiens, Phéniciens, Grecs et Romains, s'établirent sur les rives de cette mer intérieure pour faire du monde méditerranéen, aussi loin que le temps remonte, une région centrale du globe. Ainsi, au fil des siècles, le bassin méditerranéen, situé à la croisée des continents d'Europe, d'Asie et d'Afrique, a façonné un paysage culturel des plus variés, considéré encore de nos jours comme le « berceau de l'occident ». Créant un pont entre l'orient et l'occident, mais également une frontière entre le christianisme occidentale et le monde de l'Islam, cette région a vu naître des courants stylistiques, à côté du style mauresque et gothique, à l'instar du style manuélin au Portugal, encore présent dans maints édifices.

L'architecture méditerranéenne porte l'empreinte visible de l'extrême douceur du climat aux étés secs, la clémence des hivers riches en précipitations et des paysages à couper le souffle, jalonnés de baies, montagnes et alentours aux couleurs de terre cuite. Maisons exceptionnelles, appartements, propriétés souvent restaurées de fond en comble, tous affichent des éléments récurrents, reflets du paysage méditerranéen : couleurs vives, tuiles de terre cuites et carreaux de céramiques, façades blanchies à la chaux et détails de murs intérieurs, régulièrement intégrés au design et interprétés de mille et une façons.

Les demeures présentées dans cet ouvrage reflètent la splendeur et le charme de l'architecture méditerranéenne, illustrant, par le biais de projets de différents pays, la fusion parfaite entre tradition et modernité.

Leben und Lebensart am Mittelmeer sind faszinierend und bewegen immer mehr Menschen aus aller Welt dazu, dieses Landschaftsgebiet als Ferienziel und häufig genug auch als Wohnsitz auszuwählen. Ob in größeren Städten, ländlichen Gebieten oder den Zonen, die direkt an der Küste liegen – angepasst an die jeweilige Region hat sich ein ganz eigener Stil entwickelt, der durch ein mildes Klima und eine jahrtausendlange Tradition geprägt ist. Dem entspricht auch das architektonische Bild, das sich vor allem durch die Neuinterpretation des „klassisch-mediterranen Stils" in Form von ultramodernen, minimalistischen bis hin zu extravaganten und gewagten Konzepten auszeichnet und somit einer weit reichenden Palette unterschiedlicher Geschmacksrichtungen gerecht wird.

Zum europäischen Mittelmeerraum zählen heute 19 unabhängige Länder sowie zahlreiche Inseln und Inselgruppen. Seine Entstehungsgeschichte reicht bis weit vor die Antike zurück, wo vor ca. 75.000 Jahren die ersten Völker überwiegend den europäischen Teil des Gebietes besiedelten. Hochkulturen wie die der alten Ägypter, Phönizier, Hethiter, Griechen und Römer entstanden an den Ufern dieses Binnenmeeres und machten die mediterrane Welt seit frühester Zeit zu einer zentralen Weltregion. So hat der Mittelmeerraum im Laufe der Jahrtausende als Knotenpunkt zwischen den Kontinenten Europa, Asien und Afrika jene vielfältige Kulturlandschaft entstehen lassen, die auch heute noch als die »Wiege des Abendlandes« bezeichnet wird. Als Brücke zwischen Orient und Okzident, aber auch als Grenze zwischen dem christlichen Abendland und der Welt des Islams, wurden hier, neben dem maurischen und gothischen Baustil, ganz eigene, regionale Stilrichtungen geboren, wie beispielsweise der manuelinische Stil in Portugal, der noch heute in einer Vielzahl von Bauwerken vorzufinden ist.

Auch das äußerst milde und im Sommer trockene Klima, mit seinen weichen, niederschlagsreichen Wintern, sowie die atemberaubende Umgebung mit ihren Buchten, Bergen und terrakottafarbenden Landstrichen, prägen die mediterrane Architektur unverkennbar. Die einzigartigen Häuser, Wohnungen und oft von Grund auf restaurierten Fincas zeigen immer wiederkehrende Komponenten, die die Mittelmeerlandschaft widerspiegeln. So sind beispielsweise leuchtende Farben, Terrakottaziegel und Keramikfliesen sowie getünchte Fassaden und Innenwände Elemente, die immer wieder in das Design integriert und auf ganz unterschiedliche Art und Weise neu interpretiert werden.

Die in diesem Buch vorgestellten Domizile spiegeln den Glanz und Charme der mediterranen Architektur wider und zeigen anhand von Projekten aus unterschiedlichen Ländern die gelungene Fusion von Tradition und Moderne.

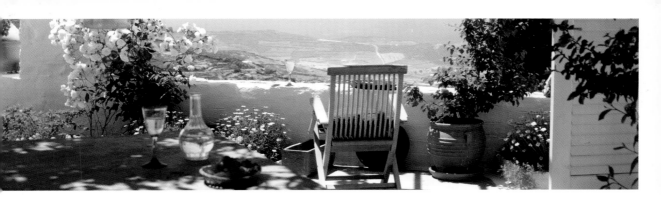

MEDITERRANEAN LIVING
VIVRE AU BORD DE LA MÉDITERRANÉE
MEDITERRANES WOHNEN

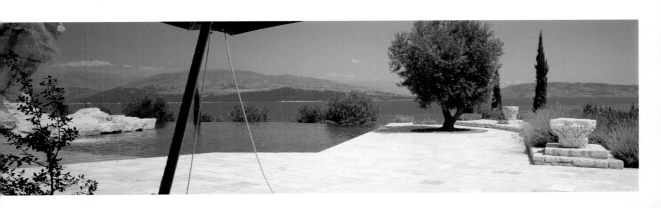

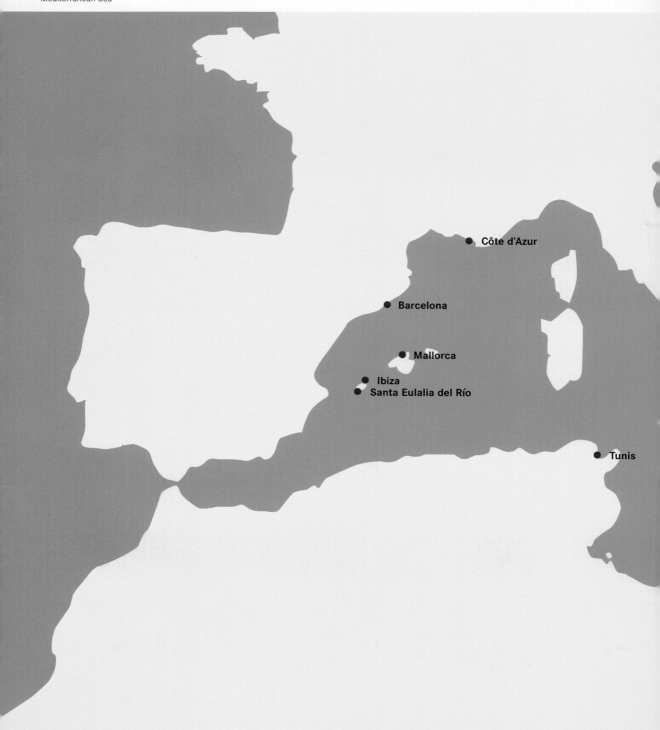

Mediterranean Sea

Côte d'Azur

Barcelona

Mallorca

Ibiza
Santa Eulalia del Río

Tunis

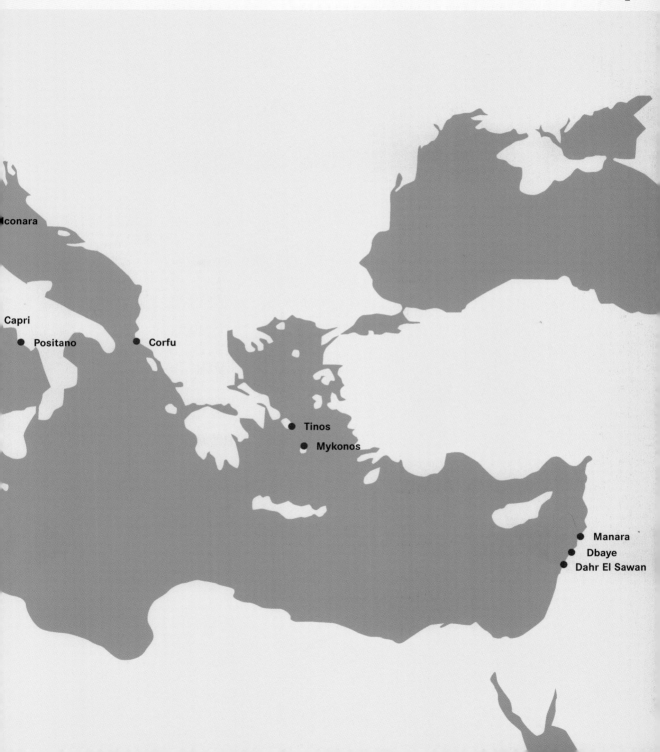

☐ Apartment in Tunis

Appartement à Tunis

Apartment in Tunesien

Adrienne Bouyssonie, Philippe Cointeault,
Frédéric Vasseur

The owners of this apartment were looking for an atmosphere of quiet, comfort and harmony. The house is built in a U-shape and organized around a small pool, a key piece in its design. The most striking thing in the decoration of the apartment is the use of the grey Foussana marble that is used on the floor, in the bathrooms and the outside. This material is used in contrast with the Mediterranean white of the basic structures of the apartment. The creation of small openings makes the pure white light blend into different shades. There are only five doors in the building, reserved for intimate spaces requiring privacy. These spaces are the bedroom and the basement, used for the most technical aspects of the place. The range of colors used in the home inspire calm, relaxation and tranquility, but above all softens the strong, direct light, likewise filtered out by large cotton textile panels from Mali.

Les propriétaires de cet appartement cherchaient une atmosphère dégageant sérénité, confort et harmonie. La maison en forme de U s'organise autour d'une petite piscine, clé de voûte du design. La décoration de l'appartement exalte l'emploi du marbre gris de Foussana, employé pour les sols, les salles de bain et l'extérieur. Ce matériau est utilisé sciemment pour contraster avec le blanc méditerranéen des structures de base de l'appartement. Les petites ouvertures permettent de décliner la lumière naturelle directe et blanche en un kaléidoscope de diverses nuances. L'ensemble de l'habitation n'offre que cinq portes, réservées aux espaces privés, leur conférant ainsi l'intimité nécessaire, à savoir les chambres et le sous-sol réservés aux aspects plus techniques de la maison. La gamme de couleurs déclinée dans les espaces de vie dégage calme, détente et sérénité tout en atténuant la violence de la lumière directe, tamisée par de grands panneaux textiles de coton réalisés au Mali.

Die Eigentümer dieser Wohnung wünschten sich Ruhe, Komfort und Harmonie. Das Haus wurde in Form eines U's um einen kleinen Swimmingpool angelegt, der das Schlüsselelement für die Gestaltung ist. Das auffallendste Dekorationselement der Wohnung ist der graue Marmor aus Foussana, der am Boden, in den Bädern und für die Außenanlagen benutzt wurde. Dieses Material bildet einen Kontrast zu den typisch mediterranen, weißen Strukturelementen der Wohnung. Durch kleine Öffnungen fällt reines, weißes Licht ein, das verschiedene Nuancen schafft. Das Gebäude hat insgesamt nur fünf Türen, die die Räume schließen, in denen man sich mehr Privatsphäre wünscht. Das sind die Schlafzimmer und der Keller des Hauses, in dem die Technik untergebracht ist. Die in der Wohnung verwendete Farbpalette wirkt ruhig und entspannend und besänftigt das reine Licht, das durch große Baumwollpaneele aus Mali gedämpft wird.

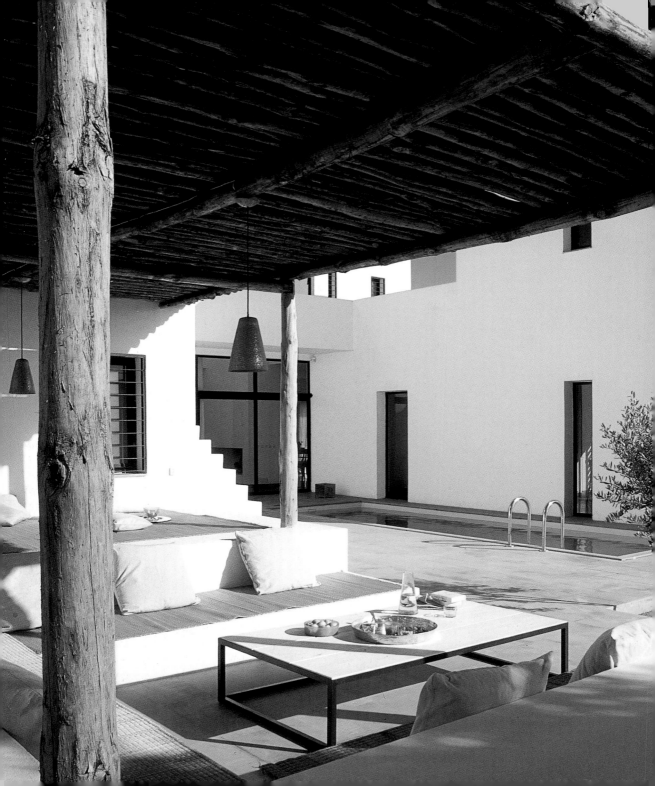

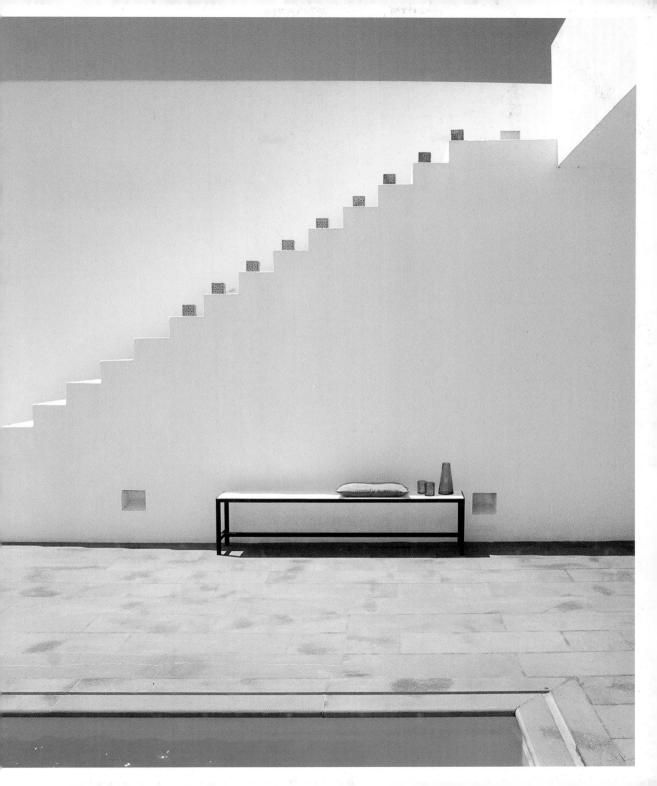

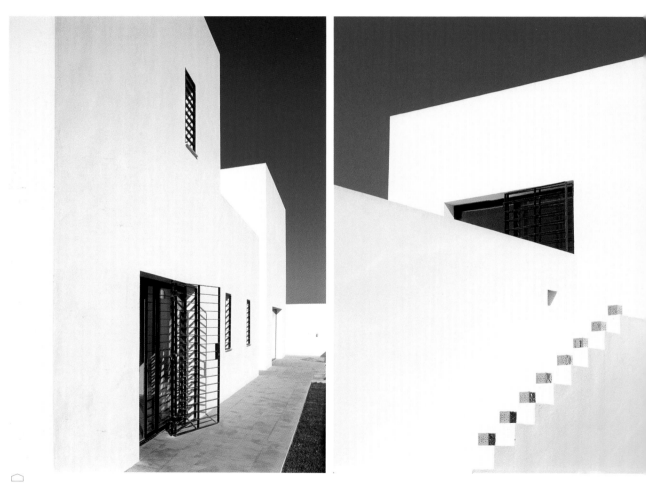

Doors and windows open onto a footpath that runs along the back of the house, allowing the light to come in at different levels and create a soothing atmosphere interio

Portes et fenêtres s'ouvrent sur un couloir extérieur qui parcourt la façade arrière de la maison de sorte que la lumière y pénètre à différents niveaux, créant une atmosphère intérieure tout en douceur.

Die Türen und Fenster öffnen sich zu einem äußeren Gang, der an der hinteren Fassade des Hauses entlang führt. Dadurch fällt das Licht aus verschiedenen Höhen ein und lässt eine sanfte Atmosphäre im Inneren entstehen.

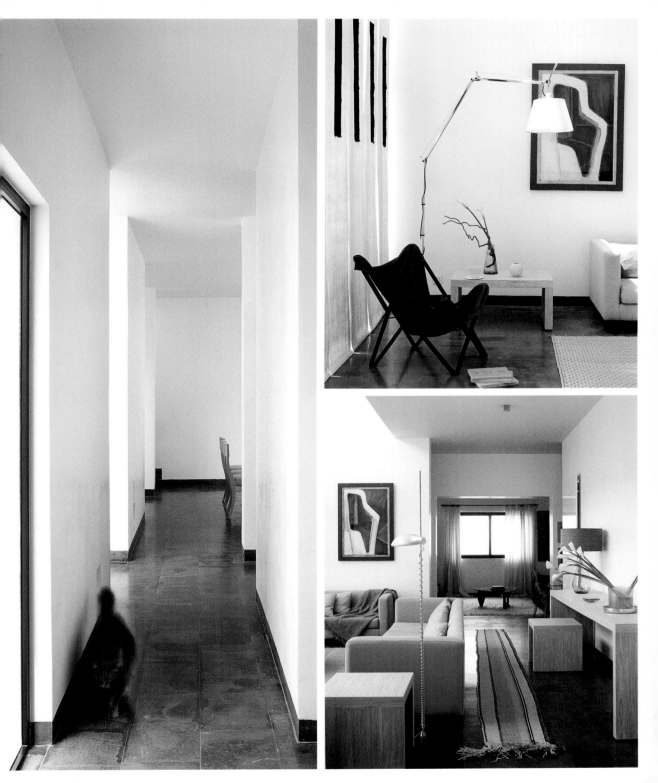

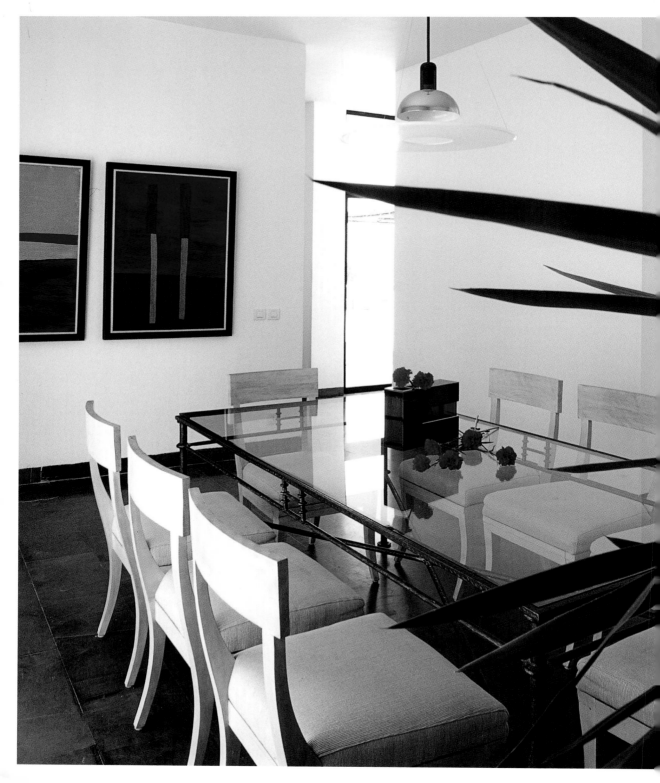

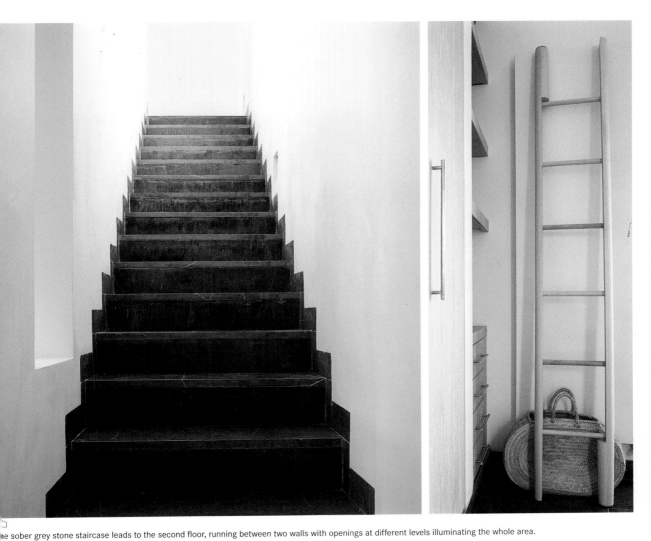

he sober grey stone staircase leads to the second floor, running between two walls with openings at different levels illuminating the whole area.

escalier en pierre grise, aux lignes épurées, s'élève vers le deuxième étage entre deux murs dotés d'ouvertures à différents niveaux qui illuminent toute cette zone.

e Treppe aus grauem Naturstein mit ihren reinen Linien führt zwischen zwei Wänden, die auf verschiedenen Höhen Fenster haben, so dass viel Licht in diesen Bereich nfällt, zum zweiten Stockwerk.

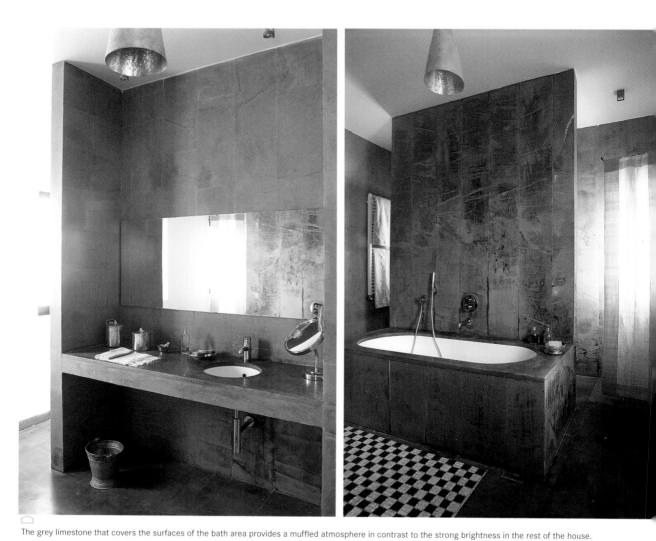

The grey limestone that covers the surfaces of the bath area provides a muffled atmosphere in contrast to the strong brightness in the rest of the house.

La pierre calcaire grise qui habille les surfaces de la zone de la salle de bains, crée une ambiance feutrée, contrastant avec le reste de la maison, inondé de lumière.

Der graue Kalkstein, mit dem die Flächen im Badezimmer verkleidet sind, lässt eine warme Atmosphäre und somit einen Kontrast zu der kraftvollen Beleuchtung im Rest des Hauses entstehen.

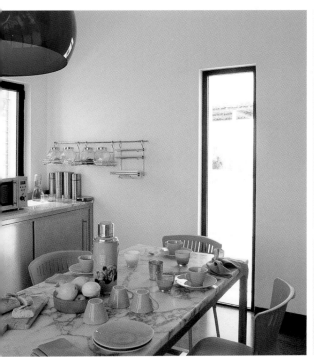

☐ House in Ibiza
Maison à Ibiza
Haus auf Ibiza

Juan de los Ríos

Standing on a hillside with views over the Mediterranean, this residence is made up of two houses, the main house and the guesthouse. Its design is elegant without being ostentatious and its pure lines make for outstanding architecture. The pool area connects the two houses and includes a spacious terrace with spectacular views over the sea. Surrounded by other outdoor areas, such as porches, the house is protected by a wooded area. The rectangular shapes with their straight lines and light tones define this open-structure type of architecture. The stone walls protecting the house form a new arrangement of terraces and delimit the different levels, allowing the native vegetation to grow in the spaces between them. Inside the residence, low walls built with the same materials mark the limits of the various spaces.

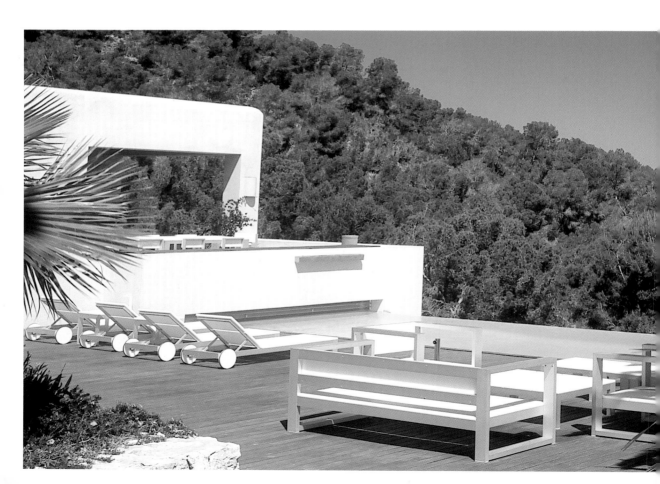

Située à flanc de montagne face à la Méditerranée, cette résidence est composée de deux maisons, l'habitation principale et celle des invités. Sans ostentation, le design est élégant et ses lignes épurées exaltent son architecture. La zone qui accueille la piscine relie les deux maisons et intègre une large terrasse dotée de vues spectaculaires sur la mer. Entourée d'autres zones extérieures, comme les porches, la maison est protégée par une zone boisée. Les volumes rectangulaires, aux lignes droites conjuguées aux tons clairs façonnent une architecture aux structures ouvertes. Les murs de pierre qui protègent la maison, dessinent un nouvel agencement de terrasses et délimitent les différents niveaux, façonnant des espaces accueillant la végétation autochtone. A l'intérieur de la demeure, des petits murs construits du même matériau, délimitent les volumes.

Diese Gebäudegruppe steht auf einem Berghang mit Blick auf das Mittelmeer und setzt sich aus zwei Häusern zusammen. Eines dient als Wohnsitz der Eigentümer, das andere ist den Besuchern zugedacht. Der elegante Stil und die einfachen, nicht übertriebenen Linien unterstreichen die Architektur. Die beiden Häuser sind durch einen Bereich verbunden, in dem sich der Swimmingpool und eine große Terrasse mit wundervollem Blick auf das Meer befinden. Das Haus ist von weiteren Außenbereichen wie Verandas und einem kleinen Baumbestand umgeben. Die rechteckigen Formen, geraden Linien und hellen Farben lassen die architektonische Struktur sehr offen wirken. Die Steinmauern schützen die Villa, formen Beete und trennen verschiedene Ebenen voneinander ab, einige davon mit autochthoner Vegetation bewachsen. Auf dem Grundstück markieren kleine Mauern aus den gleichen Steinen die verschiedenen Körper des Gebäudes.

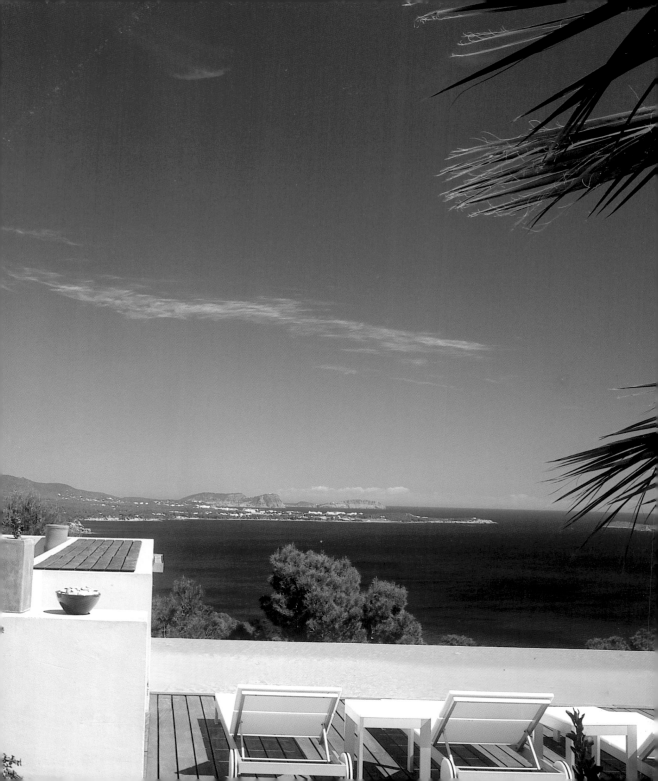

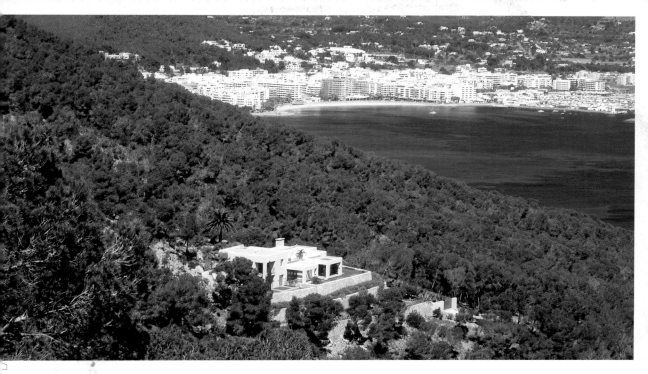

The spectacular landscape imposes a concept of pure lines and simple spaces that stand out in their surroundings, linking past and present on the island.

L'aspect spectaculaire du paysage impose une conception aux lignes pures et volumes simples qui exaltent l'environnement dans une fusion étroite entre le présent et le passé de l'île.

Die beeindruckende Landschaft der Umgebung veranlasste die Planer, reine Linien und einfache Formen zu benutzen, die die Umgebung unterstreichen und die Vergangenheit der Insel mit der Gegenwart verbinden.

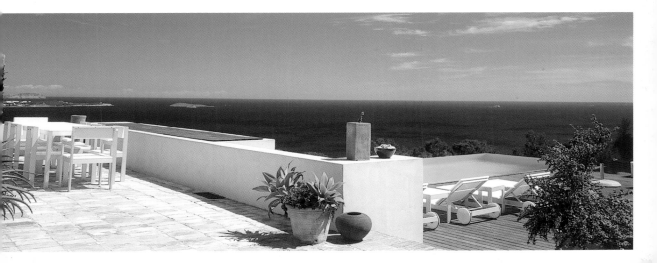

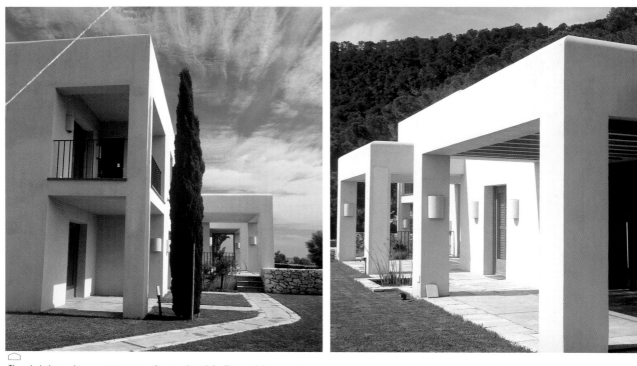

The whole house has a contemporary air, even though its lines and the materials used represent the traditional architecture of the island.

Toute la maison dégage une allure très contemporaine, même si ses lignes et les matériaux utilisés sont tirés de l'architecture traditionnelle de l'île.

Das ganze Haus wirkt sehr modern, obwohl seine Linien und Materialien auf die traditionelle Architektur der Insel verweisen.

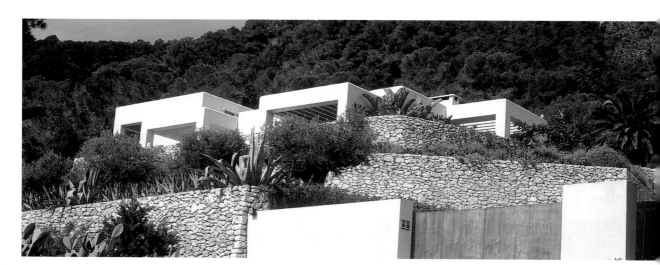

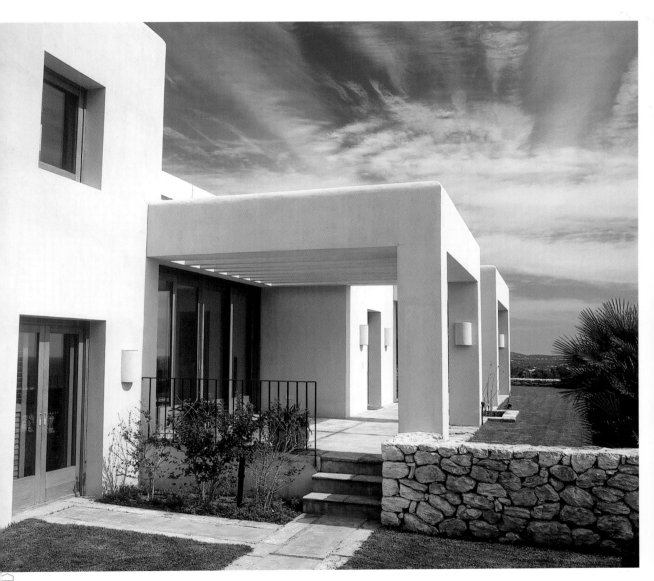

The robust pergolas at the back of the house break the powerful summer sun, helping to provide a cooler environment inside.

Les façades arrière sont agrémentées de robustes pergolas qui tamisent la forte lumière d'été, contribuant ainsi à rafraîchir le climat intérieur.

Die hinteren Fassaden sind mit robusten, gemauerten Pergolen versehen, die das starke Sonnenlicht im Sommer dämpfen und das Raumklima kühlen.

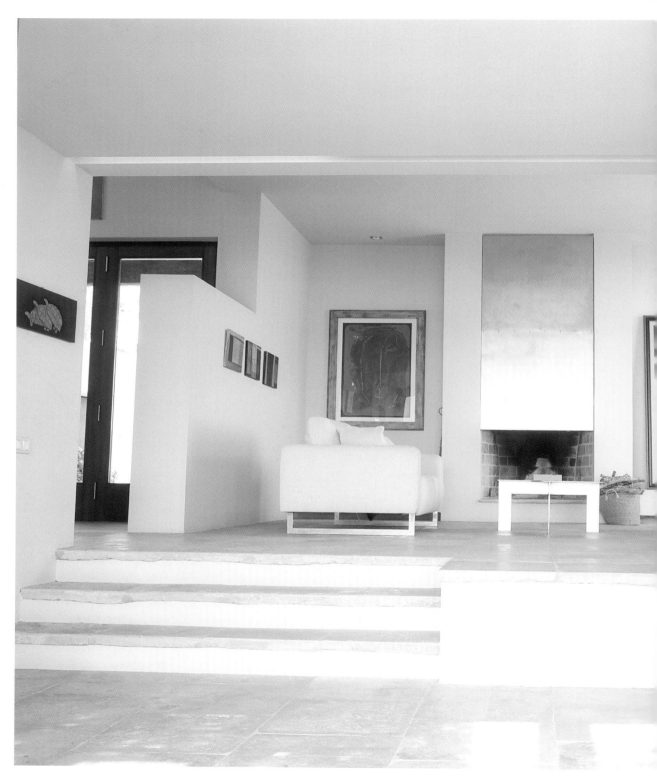

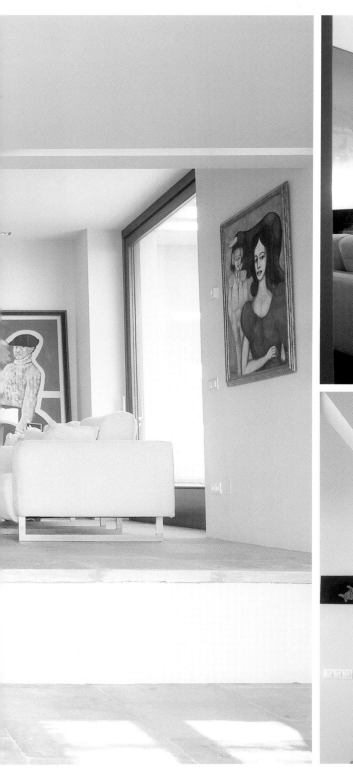
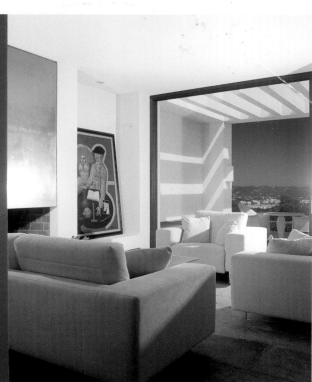

☐ Rothschild Pavilion
Pavillon Rothschild
Rothschild Pavillon

Estudio BC

Surrounded by the olive and cypress groves that shelter the Albanian coast, this pavilion, attached to the main house, was conceived as a leisure area, with a swimming pool, a living room, a kitchen, dressing rooms and bathrooms. Strong, solemn and eternal, like an enormous Corinthian column, it is laid out in the manner of Roman villas of the type that used to be built in the region in the past. The simplicity of the buildings designed by the Estudio BC team is inspired by the scenery and topography of their surroundings, by the trees and rocks. They are timeless architectural works that respect the forms imposed by tradition and necessity, drawing inspiration from vernacular sources, and refuse to be dictated to by fashion.

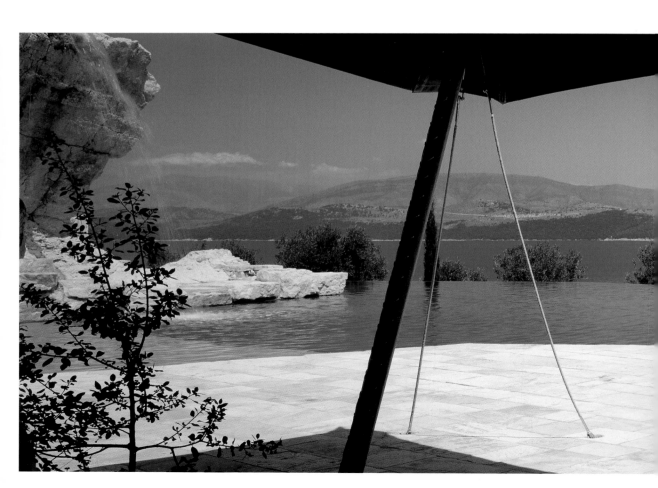

Entourée d'oliviers et de cyprès, écrin protecteur de la côte d'Albanie, cette construction annexée à l'habitation principale est conçue pour être une aire de détente, comprenant piscine, salle à manger, cuisine, vestiaire et toilettes. Elle se dresse à l'instar d'une immense colonne corinthienne, solennelle, éternelle et inébranlable. Sa disposition rappelle celle d'une villa romaine, à l'image de celles construites autrefois dans cette région. Fortes d'une grande sobriété, les œuvres conçues par l'équipe du Estudio BC tirent leur force des vues et de la topographie des lieux, des arbres et des rochers. Œuvres intemporelles, ignorant la mode, elles répondent à une forme déterminée par la tradition et la nécessité, puisant l'inspiration aux sources vernaculaires.

Dieses Gebäude ist von den Olivenbäumen und Zypressen umgeben, die die Küste Albaniens beschützen. Es handelt sich um einen Anbau an ein Hauptgebäude, der einen Erholungsbereich mit Swimmingpool, Speisezimmer, Küche, Umkleidekabinen und Toiletten umfasst. Der Bau richtet sich mit der Erhabenheit, Beständigkeit und Festigkeit einer massiven, korinthischen Säule auf und ist wie die römischen Villen angelegt, die man einst in dieser Region zu bauen pflegte. Die Bauten, die von dem Architektenteam Estudio BC entworfen wurden, zeichnen sich durch eine Einfachheit aus, die ihre Kraft aus dem Ausblick und der Geländeform, den Bäumen und den Felsen zieht. Es handelt sich um ein zeitloses Bauwerk, das nicht von der Mode beeinflusst ist, sondern aus der Tradition und den Anforderungen entstand und von einheimischen Quellen inspiriert wurde.

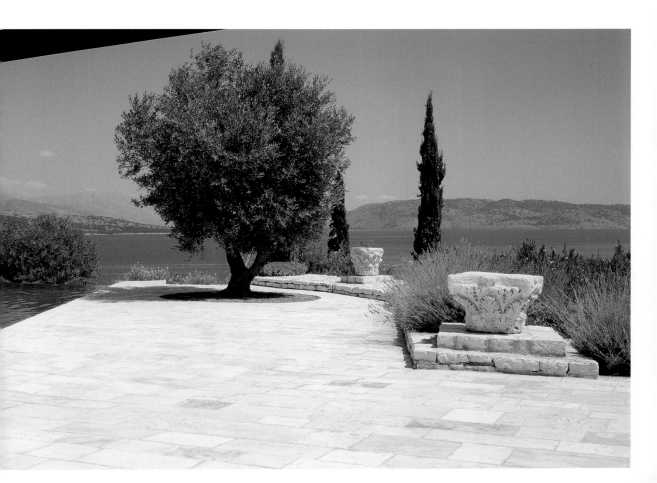

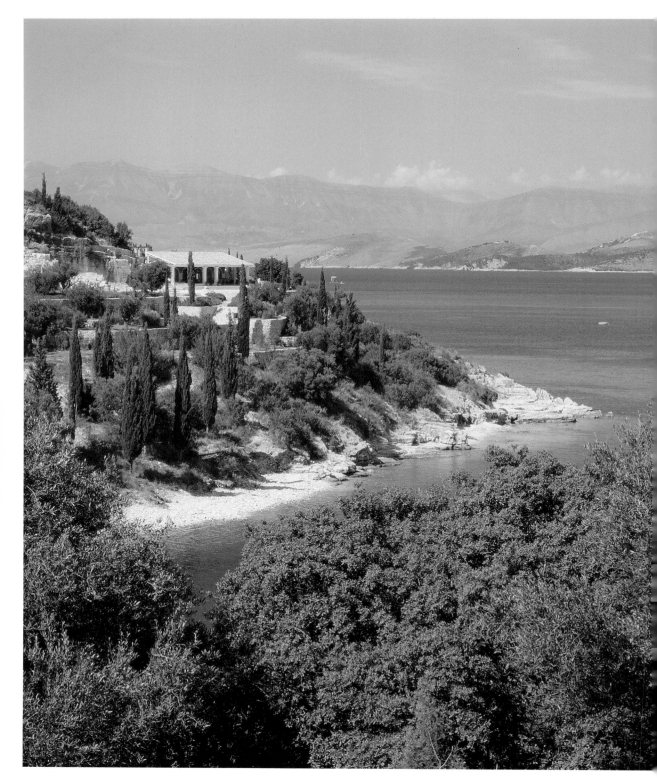

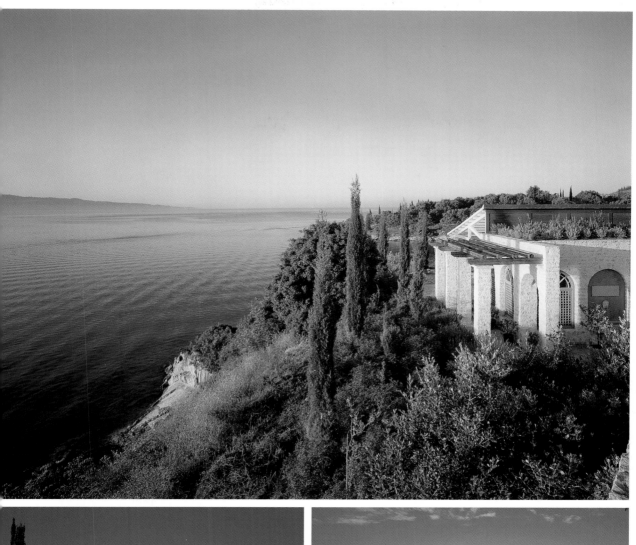
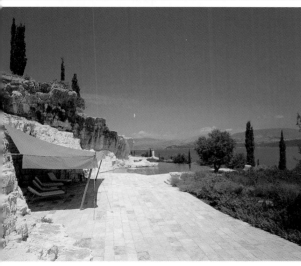
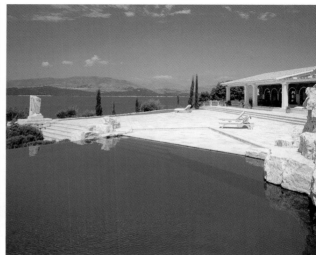

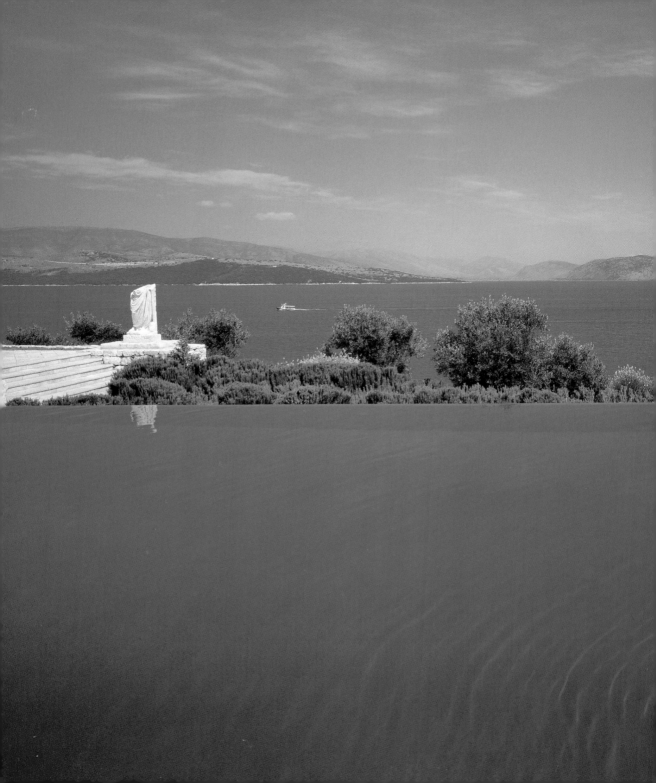

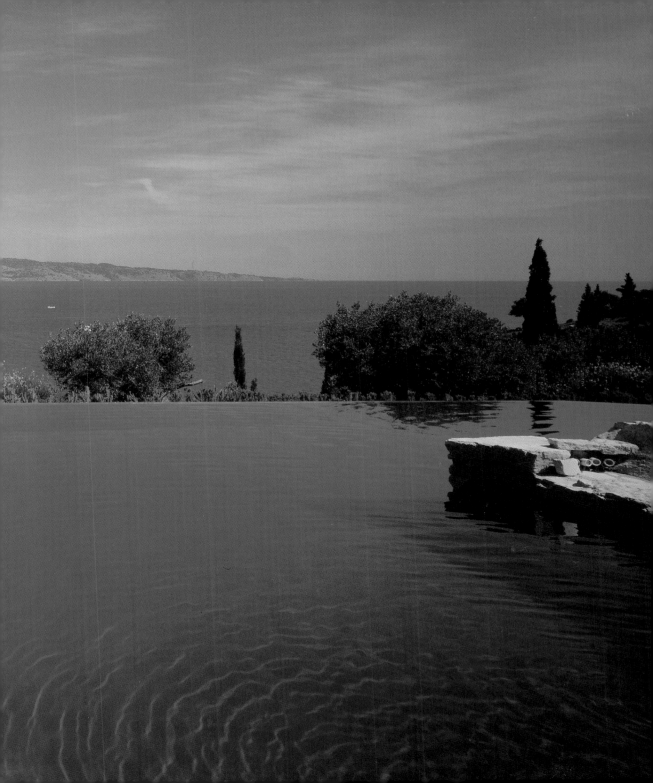

☐ Can Labacaho

Bruno Erpicum

This house is located on the top of a gently rolling hill, above traditional farming terraces, and enjoys fine views over the Mediterranean Sea. It is made up of three parts: the main one, of concrete, stands out with its strong presence; the second, of glass, opens towards the south and creates an exterior space defined by furniture designed by the architect; and the third, set between the other two, is built of wood. The contemporary artwork decorating the house gives it distinction and style. An outdoor pool, laid out in the west wing, completes the ensemble in complete harmony with the extremely fine lines of the architecture. An interior patio, with high walls painted in a particularly daring hue of violet, separates the main bedroom from the rest of the house.

Cette maison située sur les hauteurs d'une colline aux lignes douces, au-dessus des traditionnelles terrasses cultivées, permet de savourer les vues sur la mer Méditerranée. Elle se compose de trois volumes : le volume principal, en béton, se démarque par son omniprésence, le deuxième, tout en verre, s'ouvre vers le sud en créant un espace extérieur, défini par des meubles dessinés par l'architecte. Enfin, le troisième, inséré entre les deux autres, est tout en bois. Les œuvres d'art contemporain qui décorent l'habitation lui confèrent élégance et style. Une piscine extérieure, située dans l'aile septentrionale, parachève l'ensemble et se marie à merveille à cette architecture aux lignes d'une pureté extrême. Un patio intérieur, aux murs très élevés peints dans un violet particulièrement audacieux, sépare la chambre des maîtres du reste de la maison.

Dieses Haus steht oben auf einem sanften Hügel auf den traditionellen Terrassenfeldern, die von den Bauern angelegt wurden. Von diesem Standort aus hat man einen wundervollen Blick auf das Mittelmeer. Das Gebäude besteht aus drei Körpern, von denen der Hauptkörper aus Beton besonders ins Auge fällt. Der zweite, verglaste Körper öffnet sich nach Süden und lässt so einen Raum im Freien entstehen, der durch Möbel, die der Architekt selbst entworfen hat, abgetrennt ist. Der dritte Körper, der zwischen den beiden anderen steht, ist aus Holz. Die zeitgenössischen Kunstwerke, mit denen das Haus dekoriert ist, lassen es edel und stilvoll wirken. Im Westflügel vervollständigt ein Swimmingpool im Freien, der sich harmonisch an die klaren, architektonischen Linien anpasst, das Gesamtbild. Ein Innenhof mit hohen, in einem gewagten Violett gestrichenen Wänden, trennt das Hauptschlafzimmer von den anderen Bereichen des Hauses ab.

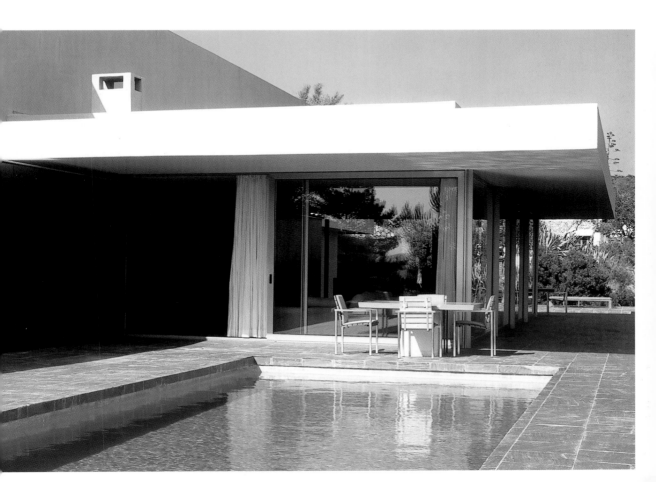

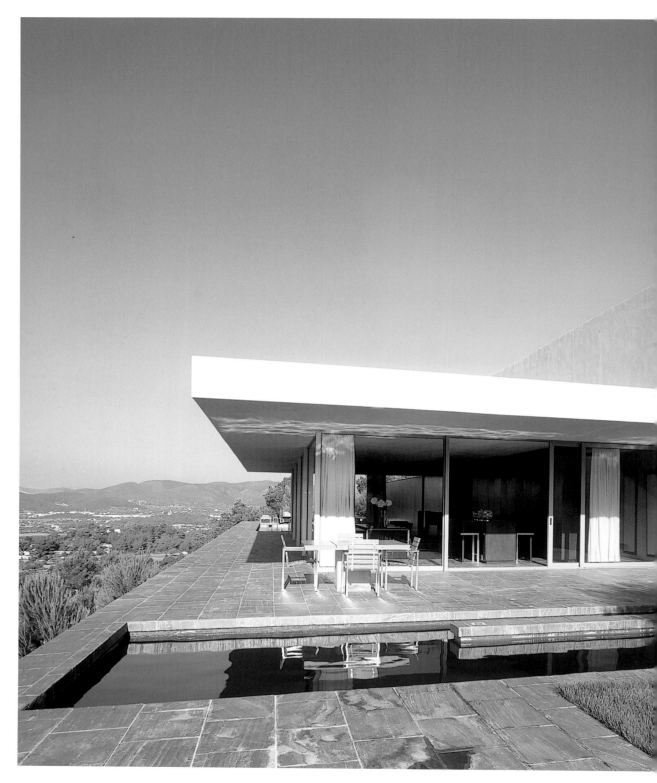

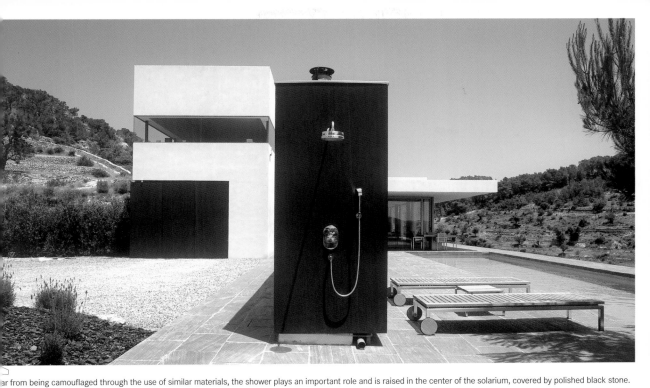

ar from being camouflaged through the use of similar materials, the shower plays an important role and is raised in the center of the solarium, covered by polished black stone.

oin de se cacher sous des matériaux similaires, la douche qui s'élance au centre du solarium, avec son habillage de pierre noire polie, joue un rôle majeur.

ie Dusche ist sehr auffällig und man vermied, sie durch den Gebrauch ähnlicher Materialien zu verbergen. Sie steht mitten im Solarium und ist mit schwarzem, poliertem tein verkleidet.

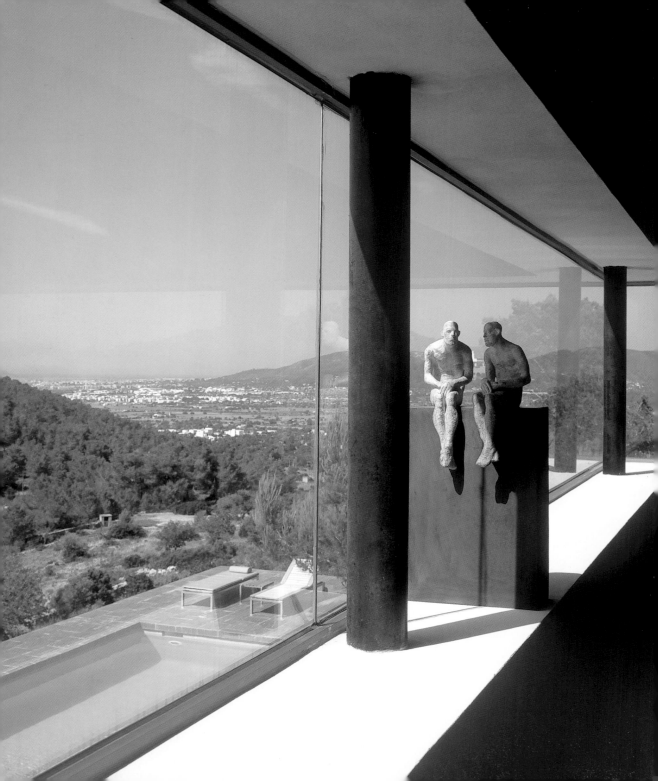

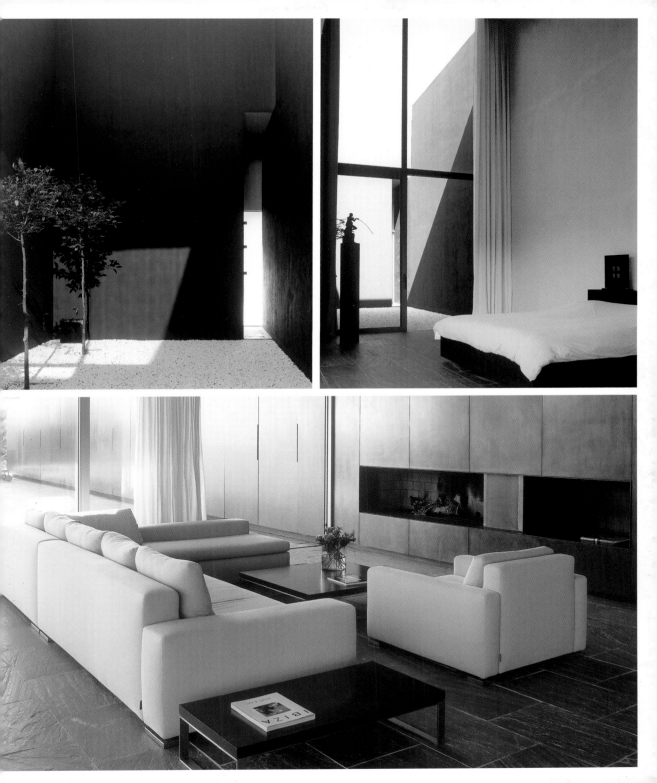

Villa A

Raed Abillama Architects

This project involved the renovation and extension of a traditional Lebanese house badly damaged during the civil war. The ruin served as a base on which a new five-bedroom house was built to accommodate a family with three children. The original structure was a single-story house made of limestone. A second story was added later and included a front porch with five arches forming a gallery and an extension of the eastern façade by about one and a half meters. During the first stage of the reconstruction, a coat of reinforced concrete was applied to the interior surfaces and to the southwestern corner. A vertical circulation core as well as a new block, similar in size to the old one and treated as a new building with its own dynamics, were added to complete the structure. This new element, however, was subtle enough not to overpower the iconic image of the old section nor disrupt the harmony of the project as a whole.

Ce projet concerne la rénovation et l'agrandissement d'une maison libanaise traditionnelle, fortement endommagée lors de la guerre civile. La ruine est le point de départ de la construction d'une nouvelle maison dotée de cinq chambres à coucher pour accueillir une famille de trois enfants. La structure originale est constituée d'une maison à un étage avec un hall central, construite en roche calcaire. Un deuxième étage ajouté ultérieurement, composé d'une galerie de cinq arcades en façade, affiche également un prolongement de la façade est, d'environ un mètre et demi vers l'extérieur. Dans la première phase de reconstruction, les faces intérieures et l'angle sud-ouest ont été habillés de béton armé. Un noyau de circulation vertical vient compléter l'ensemble, auquel s'ajoute un nouveau bloc de taille similaire à l'ancien, traité comme un nouveau bâtiment doté de ses propres dynamiques. Toutefois, ce nouvel élément est assez subtil pour ne pas écraser l'image iconique de l'ancienne partie, ni briser l'harmonie de l'ensemble du projet.

Bei diesem Bauvorhaben wurde ein traditionelles Haus im Libanon, das im Bürgerkrieg sehr stark beschädigt wurde, renoviert und erweitert. Das zerstörte Gebäude war die Grundlage für die Errichtung eines neuen Hauses mit fünf Schlafzimmern für eine Familie mit drei Kindern. Die Originalstruktur war ein einstöckiges, zentral gelegenes Gebäude aus Kalkstein. Bei der späteren Konstruktion eines zweiten Stockwerks wurde an der vorderen Fassade eine Veranda mit fünf Bögen geschaffen und die Ostfassade wurde ungefähr anderthalb Meter versetzt. In der ersten Bauphase schuf man eine Betonverkleidung zur Verstärkung der Innenflächen und an der Südwestseite einen vertikalen Anbau für Treppen und Gänge. Außerdem wurde ein neuer Baukörper in der gleichen Größe angefügt und als ein neues Gebäude mit eigener Dynamik behandelt. Dennoch ist dieser neue Block so zurückhaltend gestaltet, dass er das traditionelle Aussehen des alten Segments nicht negativ beeinflusst und sich harmonisch in das Gesamtbild einfügt.

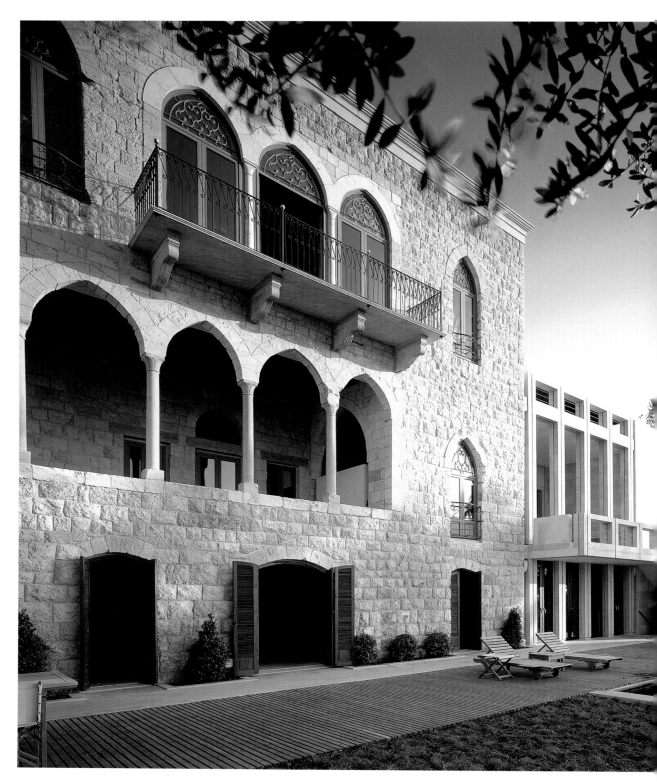

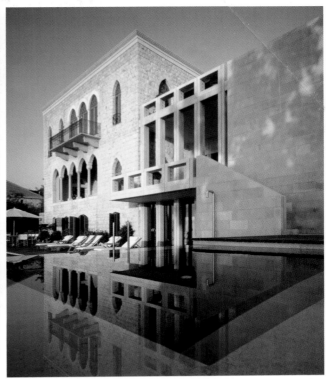
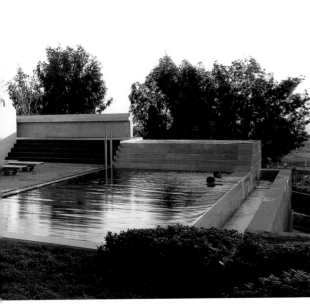
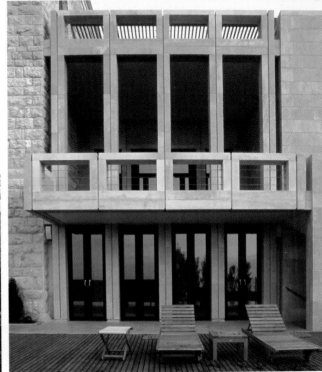

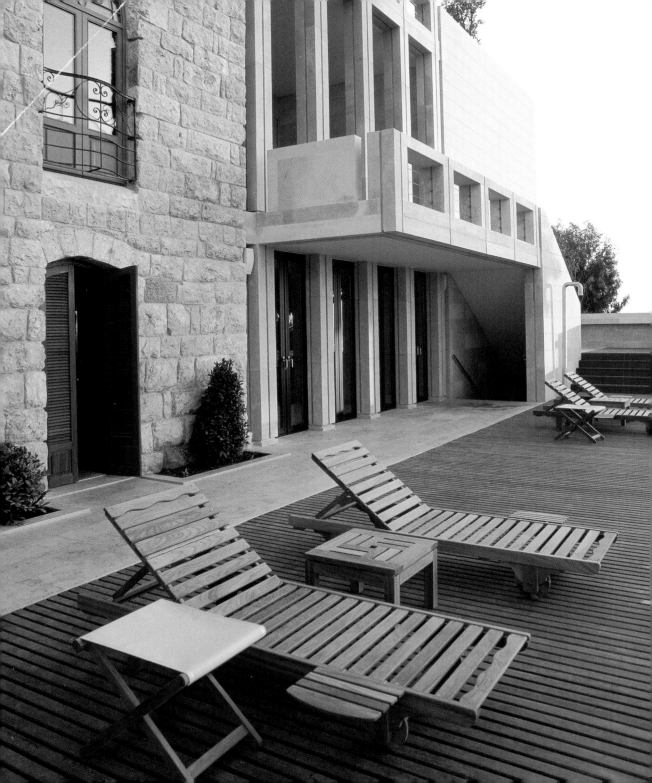

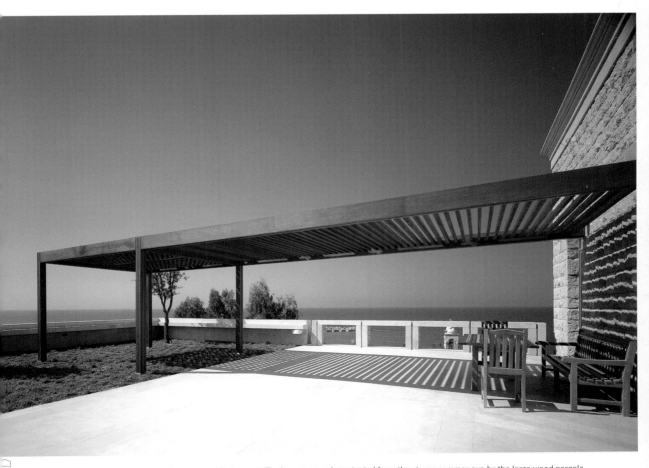

The renovation has given the façade a suggestive asymmetrical aspect. The large terrace is protected from the strong summer sun by the large wood pergola.

Après restauration, la façade révèle une subtile asymétrie. La grande pergola de bois protège la terrasse du soleil torride de l'été.

Bei der Renovierung gestaltete man die Fassade ein wenig asymmetrisch. Eine große Pergola aus Holz schützt die weiträumige Terrasse vor der starken Sommersonne.

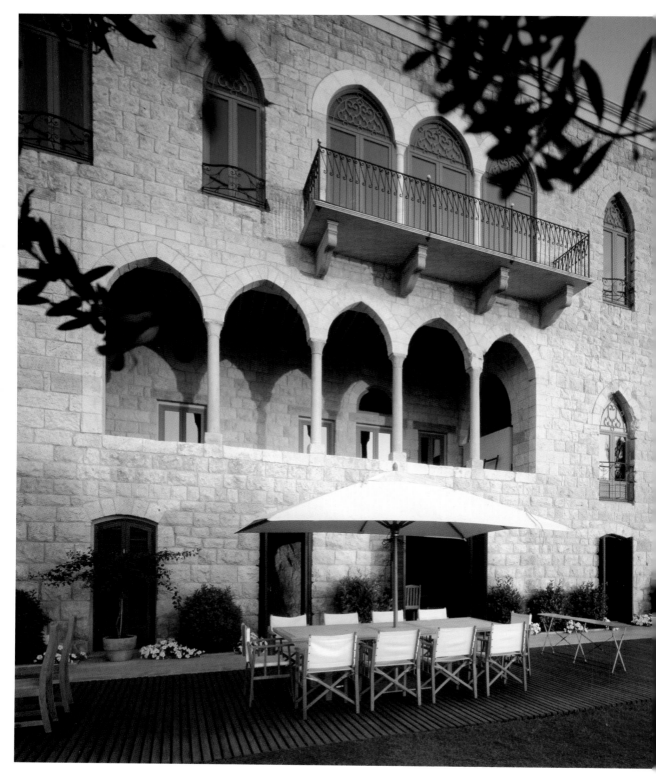

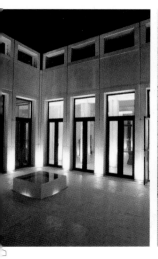
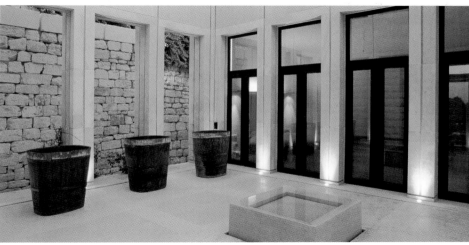

This magnificent villa, located on the coast of Lebanon, has been enlarged resulting in an eclectic fusion of architectural elements from different periods.

L'agrandissement de cette splendide villa, située sur la côte du Liban, affiche un mélange éclectique d'éléments architecturaux de différentes époques.

Diese wundervolle Villa an der Küste im Libanon wurde so erweitert, dass der Eklektizismus der architektonischen Elemente verschiedener Epochen miteinander vermischt wurde.

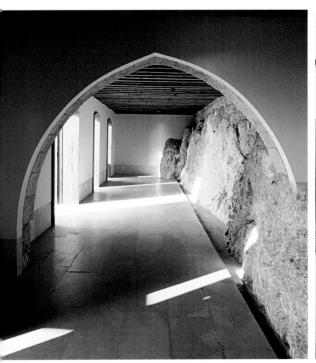

□ Can Km 15

Bruno Erpicum

Ibiza is a place known for its beautiful landscape and as one of the most valued tourist destinations. The home shown here fits the image of modernity and the style of this idyllic island perfectly. The lines of the architecture are extremely clean and bring lightness and elegance to the construction. The quality of the materials, the artwork and the perfect choice of colors present elegant and classy rooms. Lush interior patios, whose main elements are water and stone, create a space full of enchantment. The interiors, original and sober, bring class and beauty to a home that captivates with its forms and magnificent views over the surrounding countryside. White dominates the exteriors and creates an atmosphere full of tranquility.

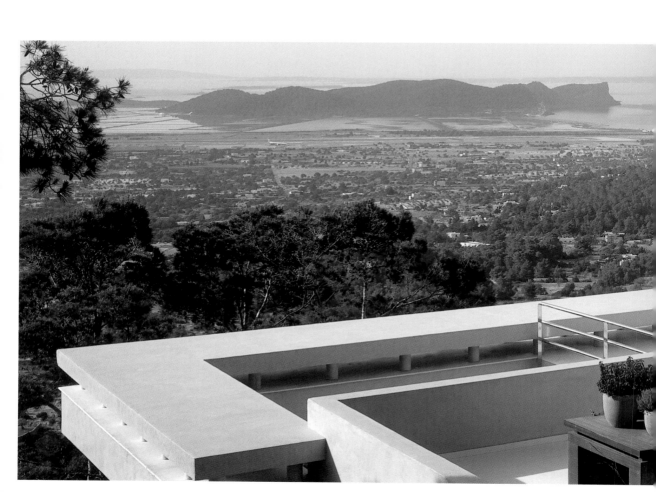

Ibiza, connue pour la beauté de ses paysages, est aussi une des destinations touristiques de prédilection. La résidence qui suit s'adapte à merveille à l'image de modernité et au style qui se dégage de cette île idyllique. Les lignes architecturales, d'une extrême pureté, confèrent légèreté et élégance à la construction. La qualité des matériaux, les œuvres d'art et le choix judicieux des couleurs forgent ensemble des pièces élégantes d'une grande classe. Des patios intérieurs inondés de végétation, avec la pierre et l'eau comme éléments clés, créent un espace très charmant. Les intérieurs, originaux et sobres, confèrent classe et beauté à une habitation captivante par ses formes et ses merveilleuses vues sur l'extérieur. Le blanc, couleur dominante des extérieurs, confère à l'ensemble une ambiance de calme suprême.

Ibiza gehört mit ihrer wundervollen Landschaft zu den beliebtesten Touristenzielen. Das Haus, das im Folgenden gezeigt wird, passt perfekt zu dem eleganten Stil und der Modernität, die diese idyllische Insel auszeichnen. Die architektonischen Linien des Gebäudes sind äußerst klar und lassen es leicht und elegant wirken. Durch die qualitativ hochwertigen Materialien, die Kunstwerke und die gelungene Auswahl der Farben entstand eine Reihe von stilvollen und edlen Räumen. Die bepflanzten Innenhöfe, in denen Wasser und Stein die prägenden Elemente sind, verleihen der Villa einen ganz besonderen Zauber. Die schlichten, im Originalzustand belassenen Räume geben diesem Haus mit seinen faszinierenden Formen und dem wundervollen Ausblick Eleganz und Klasse. In den Außenbereichen herrscht die Farbe Weiß vor, so dass eine ruhige und gelassene Atmosphäre entsteht.

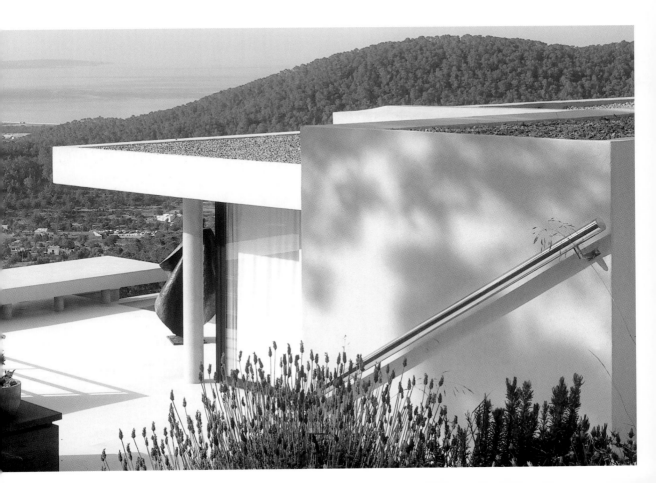

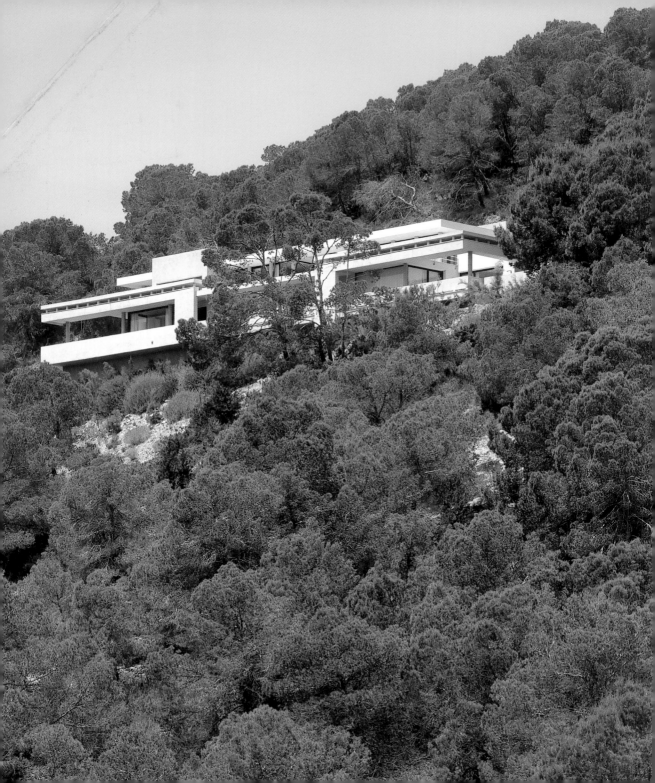

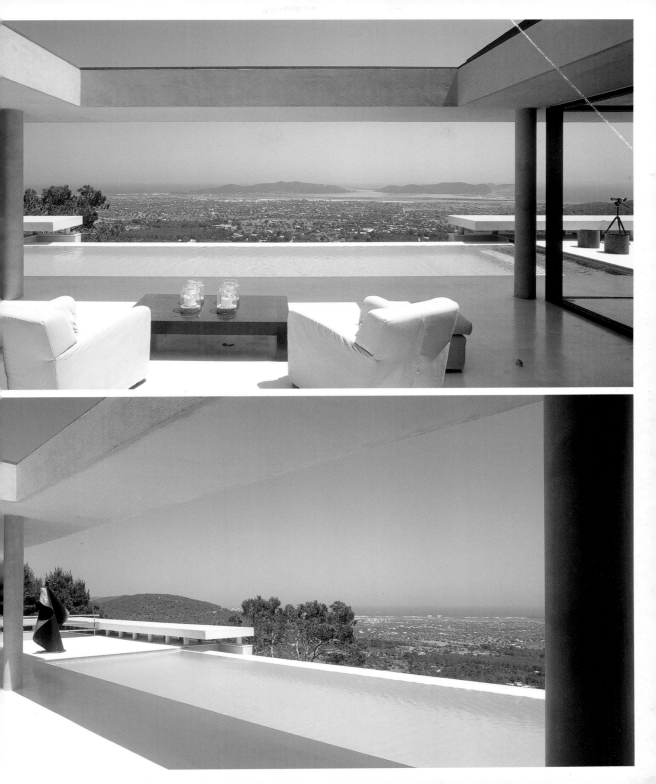

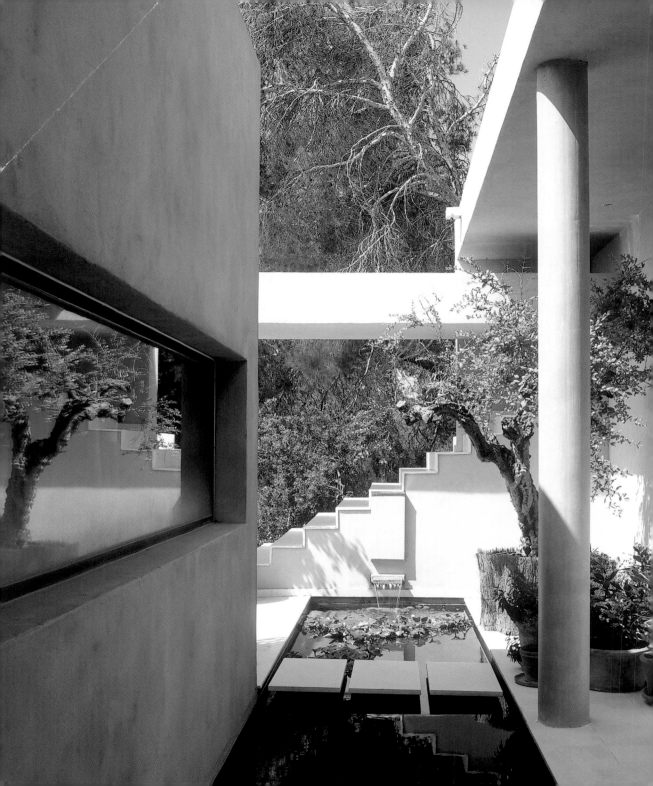

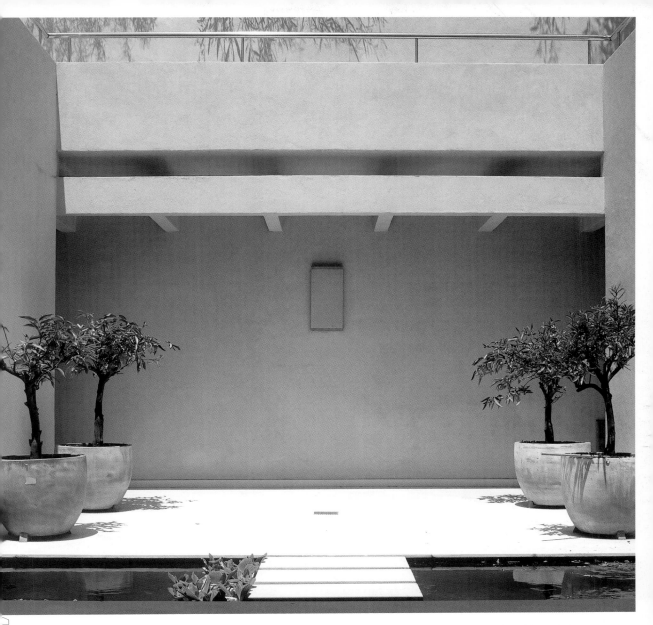

The large round planters offer the perfect contrast to the rectilinear volumes that dominate the construction, integrating perfectly into the architectural plan.

Les grandes jarres arrondies offrent un parfait contraste aux volumes rectilignes qui prédominent la construction, s'intégrant à merveille au programme architectural.

Die großen, runden Blumentöpfe bilden den perfekten Gegensatz zu den geradlinigen Formen der Konstruktion, die alle dem Gebäude zugedachten Funktionen erfüllen.

The living room area is separated from the dining room by a spectacular brick fireplace built as an enormous rectangular volume attached to the ceiling.

La zone de séjour est séparée de la salle à manger par le biais d'une cheminée spectaculaire constituée d'un énorme volume rectangulaire qui descend du plafond.

Das Wohnzimmer ist vom Speisezimmer durch einen auffälligen, gemauerten Kamin getrennt, der eine riesige, rechteckige Form bildet, die von der Decke herabsteigt.

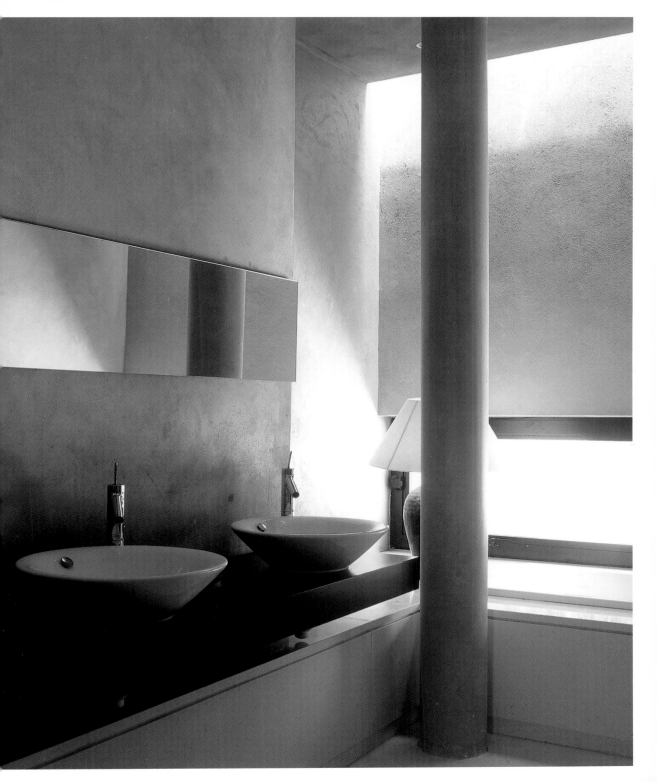

Tagomago House
Maison Tagomago
Tagomago Haus

Carlos Ferrater, Joan Guibernau

The house is set in a Mediterranean background of pine trees and junipers facing the sea and the island of Togomago, on a site leaning slightly towards the cliff. Given its use as a holiday residence, a distribution was suggested that evolves around a core represented by the main building, around which various semi-autonomous pavilions are located forming, in turn, porches, open-air terraces and patios. This allows for a gradual and progressive use of the space dependent on the number of occupants. The structure of the house, around a longitudinal axis, offers isolated, perfectly oriented, rooms that can be independently used. The programme is flexible as regards the use of traditional building elements, such as concrete, stone and wood.

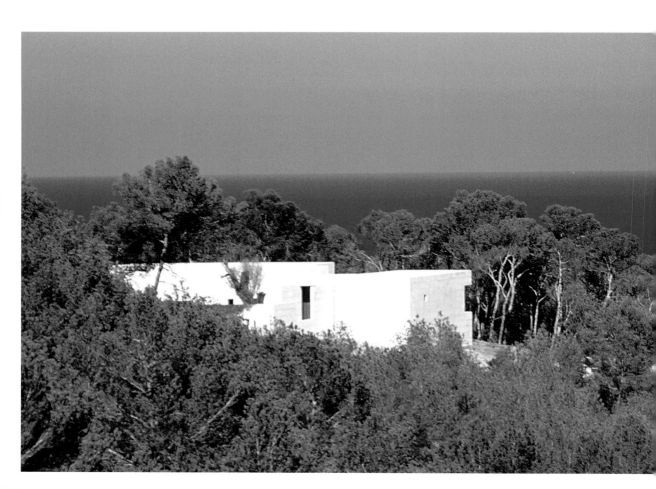

La maison est implantée au cœur d'un paysage méditerranéen ponctué de pins et de sabines, face à la mer et à l'île de Tagomago, sur un terrain accusant une légère pente vers la falaise. Pour répondre à son rôle de maison de vacances, cet espace de vie est constitué d'un noyau formant l'habitation principale, autour duquel s'érigent divers pavillons jouissant d'une certaine autonomie. Ils enserrent divers espaces à ciel ouvert sous forme de porches, terrasses et patios. Une formule qui permet une utilisation progressive et flexible de l'espace en fonction du nombre d'habitants. La distribution spatiale le long d'un axe longitudinal crée des pièces isolées et parfaitement orientées, indépendantes les unes des autres. Le programme affiche une grande souplesse dans l'utilisation d'éléments constructifs traditionnels, comme le béton, la pierre et le bois.

Das Haus fügt sich in eine mediterrane Landschaft voller Pinien und Sadebäumen ein. Es liegt dem Meer und der Insel Tagomago gegenüber, auf einem Gelände, das sich leicht zur Steilküste neigt. Da es sich um ein Ferienhaus handelt, wurde zunächst ein Haupthaus angelegt, um das herum mehrere unabhängige Pavillons stehen, die Anlagen im Freien wie Verandas, Terrassen und Höfe umschließen. So ist eine progressive und flexible Nutzung möglich, je nachdem, wieviele Familienmitglieder und Gäste gerade da sind. Das Haus liegt an einer Längsachse, so dass die verschiedenen Körper perfekt angeordnet sind und unabhängig voneinander genutzt werden können. Es wurden traditionelle Baumaterialien wie Beton, Naturstein und Holz benutzt.

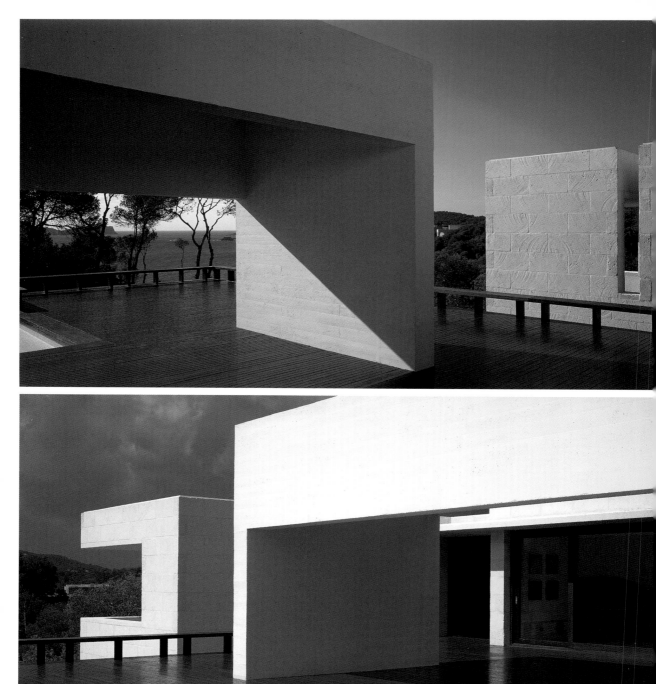

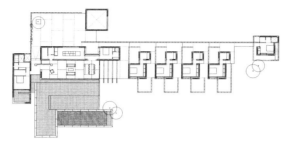

Plan Plan Grundriss

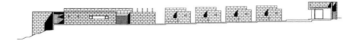

Sections Sections Schnitte

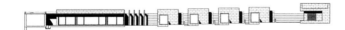

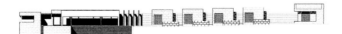

Elevation Élévation Aufriss

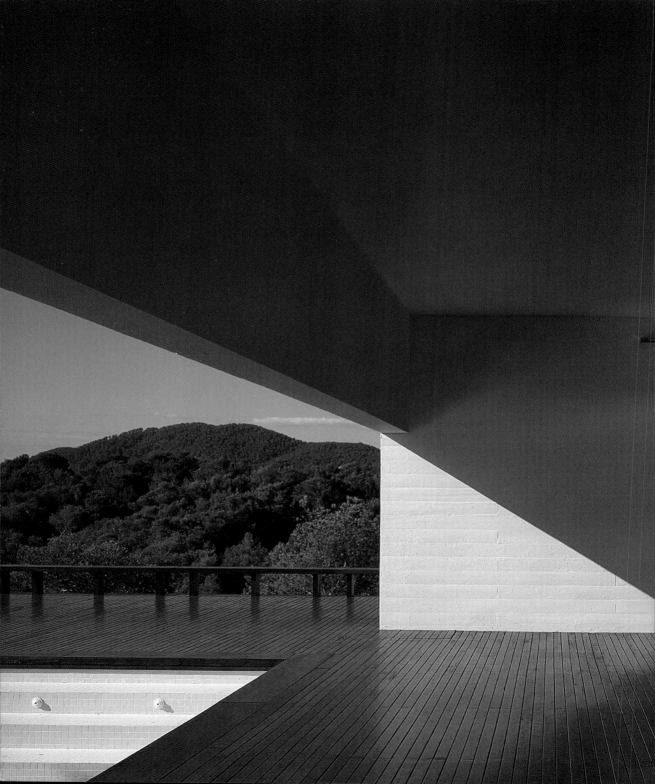

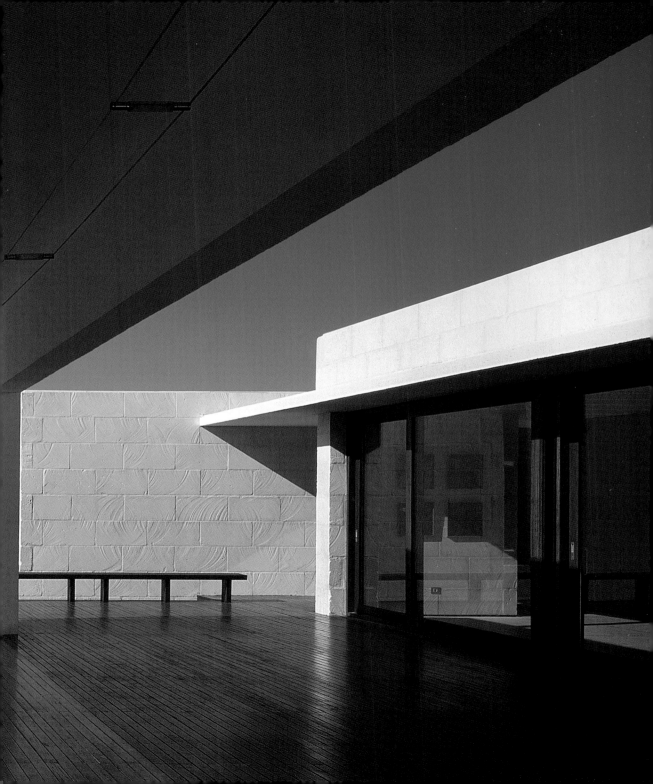

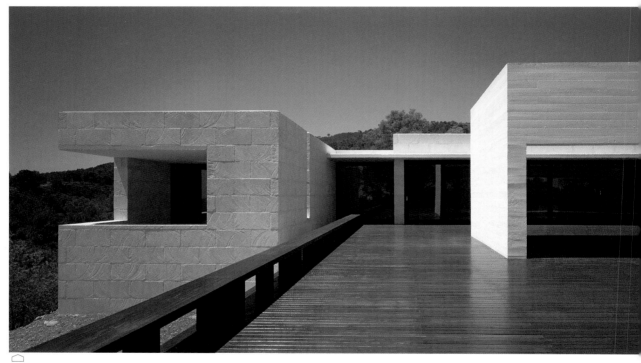

The different modules or pavilions, self-contained and separated by open spaces, allow great flexibility of use.

Les divers modules ou pavillons, indépendants les uns des autres et séparés par des espaces ouverts, permettent une grande souplesse d'emploi.

Die verschiedenen Module oder Pavillons, die voneinander unabhängig und durch offene Räume getrennt angeordnet sind, ermöglichen eine sehr vielseitige Benutzung.

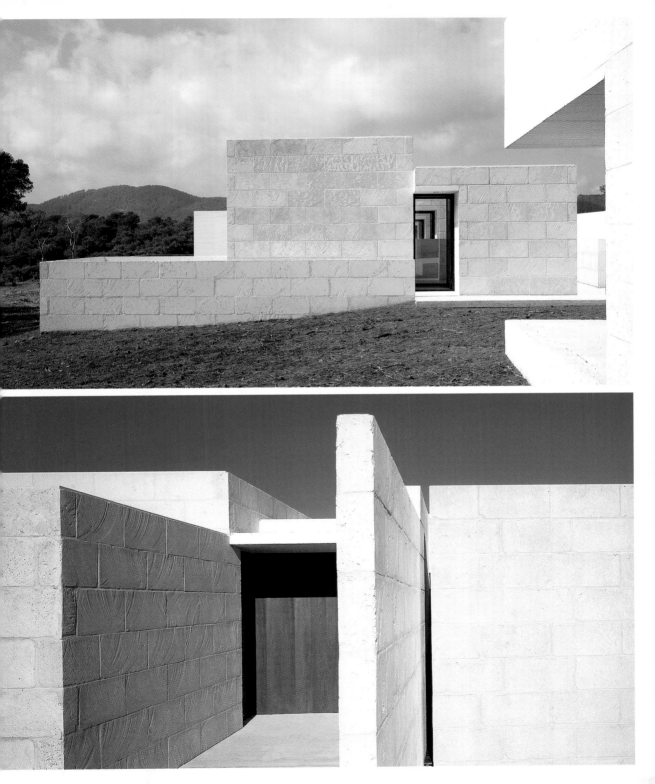

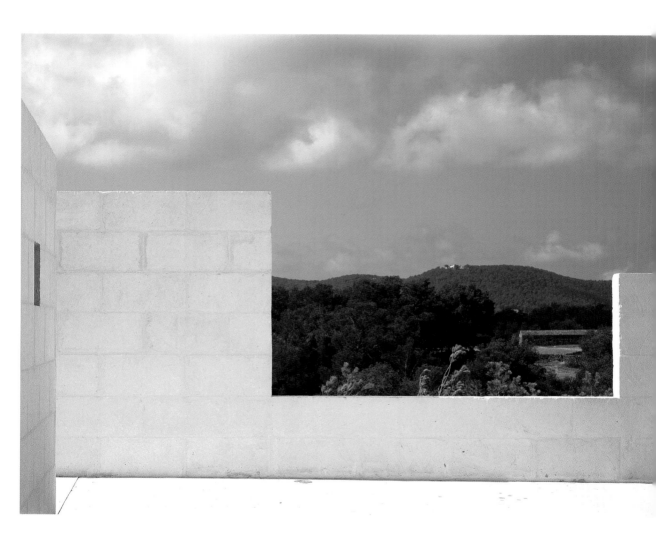

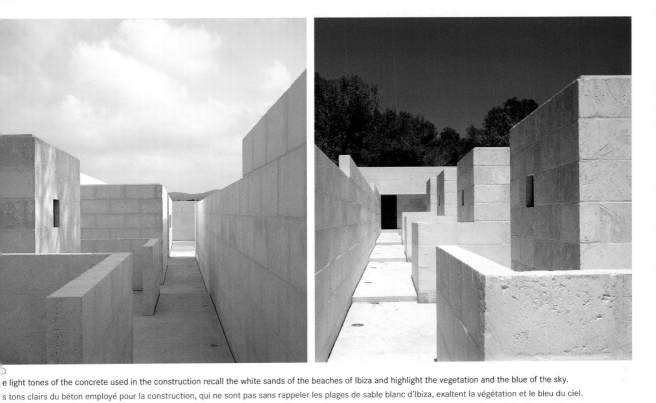

The light tones of the concrete used in the construction recall the white sands of the beaches of Ibiza and highlight the vegetation and the blue of the sky.

Les tons clairs du béton employé pour la construction, qui ne sont pas sans rappeler les plages de sable blanc d'Ibiza, exaltent la végétation et le bleu du ciel.

Die hellen Töne, des am Bau verwendeten Betons, erinnern an den weißen Sand der Strände Ibizas und unterstreichen die Vegetation und den blauen Himmel.

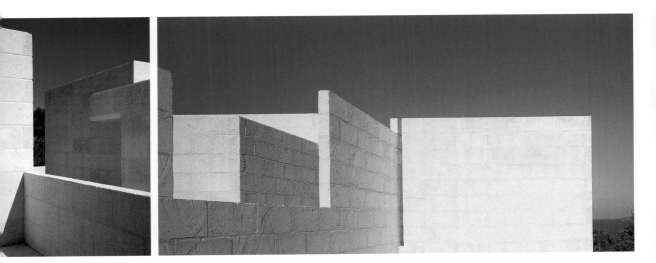

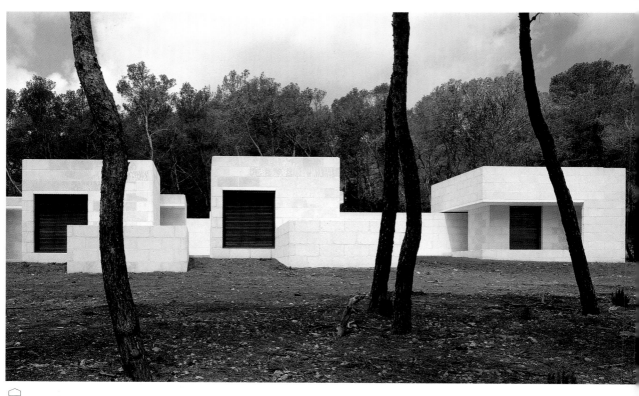

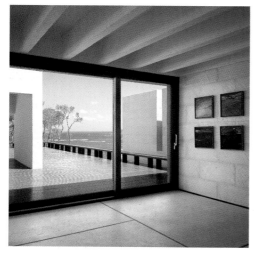 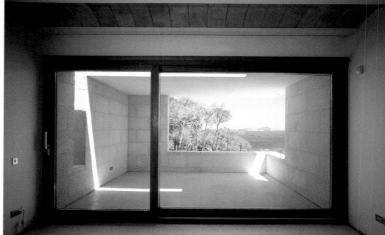

The modules, built according to a common program but each one different from the other, adapt to the needs of the main house, depending on the use and the number of guests.

Les modules, construits selon un programme commun tout en étant différents les uns des autres, instaurent un dialogue avec l'habitation principale, selon l'utilisation e le nombre d'habitants.

Die Module sind nach einem Gesamtkonzept geschaffen, unterscheiden sich aber dennoch voneinander, so dass ein wechselnder Dialog mit der Hauptwohnung entsteh je nach der jeweiligen Nutzung und Anzahl der Bewohner.

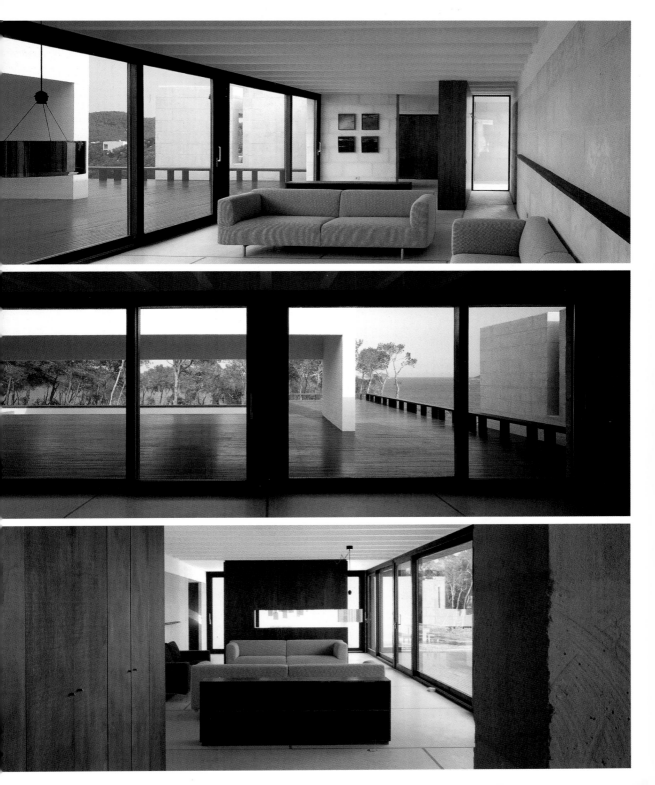

Tsirigakis House
Maison Tsirigakis
Tsirigakis Haus

Kengo Kuma & Associates

The volcanic ground on which this house stands and the lashing of the gales from the Aegean Sea, made it necessary to build a reinforced concrete structure capable of supporting the weight of the house, and to erect stone walls in order to protect the pool and the patio. Most surfaces are clad with the same stone that shores up the terrain, thus blending the architectural volume with the surrounding landscape and reflecting the concept of integrated architecture. In fostering energy efficiency and blurring any artificial boundaries between the building and the surrounding landscape, this bioclimatic architecture has managed to draw natural light into the building while avoiding the harshness of the sun, and to take advantage of the favorable climate through the integration of the construction into the slopes, the recycling of water and the building's roof gardens.

Pour consolider cette maison érigée sur un sol volcanique et fouettée par les vents violents de la Mer Egée, il a fallu construire un corps en béton armé et élever des murs de pierre protégeant la piscine et le patio. Les surfaces, en grande partie revêtues de la pierre issue du terrain, accentuent l'intégration du volume architectural au paysage environnant, reflétant ainsi le concept d'une architecture intégrée. Réduire la consommation d'énergie et estomper les démarcations entre bâtiment et paysage sont le fruit de cette architecture bioclimatique. En effet, elle permet de capter la lumière du jour tout en atténuant la rigueur du soleil et d'exploiter également les conditions climatologiques les plus favorables par le biais de diverses méthodes : l'insertion de la construction à la pente du terrain, le recyclage des eaux et l'implantation de jardins sur les toits.

Das Vulkangestein, das dieses Haus hält, und die starken Winde der Ägäis, denen es ausgesetzt ist, waren der Grund, warum die Architekten einen Körper aus Stahlbeton schufen, der das Haus verstärkt, und Mauern aus Naturstein zum Schutz des Swimmingpools und des Hofes hochzogen. Die meisten Flächen sind mit dem gleichen Gestein verkleidet, das das Gelände stützt. Deshalb fügt sich die Architektur harmonisch in die umgebende Landschaft ein und beweist, dass das leitende Planungskonzept eine integrierte Architektur war. Um den Energieverbrauch zu senken und die Grenzen zwischen dem Gebäude und der Landschaft zu verwischen, wird bei dieser bioklimatischen Bauweise das Tageslicht eingefangen, jedoch trotzdem ein Schutz vor zu intensiver Sonneneinstrahlung geschaffen. Die günstigen klimatischen Faktoren wurden ausgenutzt, indem die Geländeneigungen in das Gebäude integriert wurden, das Wasser wieder verwertet wird und die Dächer begrünt sind.

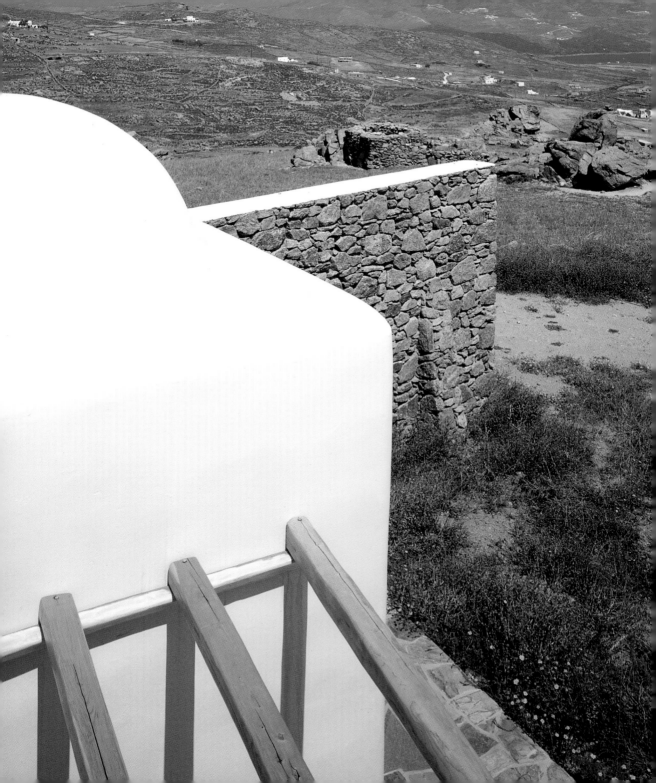

Plan Plan Grundriss

The project has reinforced the external structure in order to make it more resistant to atmospheric conditions. The ensemble integrates perfectly into the landscape.

Le projet vise à renforcer la structure externe afin de la rendre plus résistante aux conditions atmosphériques. L'ensemble s'intègre parfaitement au paysage.

Die äußere Struktur des Hauses wurde verstärkt, damit sie besser den klimatischen Bedingungen widersteht. Das Gesamtbild des Gebäudes integriert sich perfekt in die umgebende Landschaft.

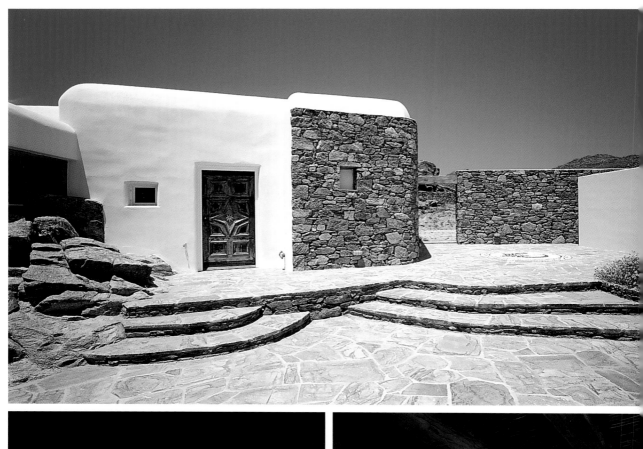

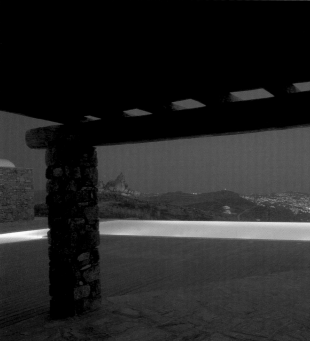

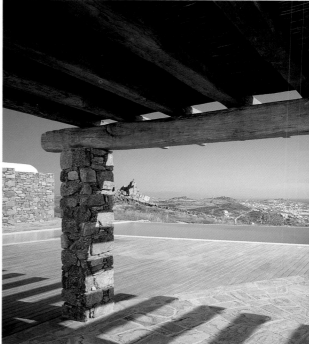

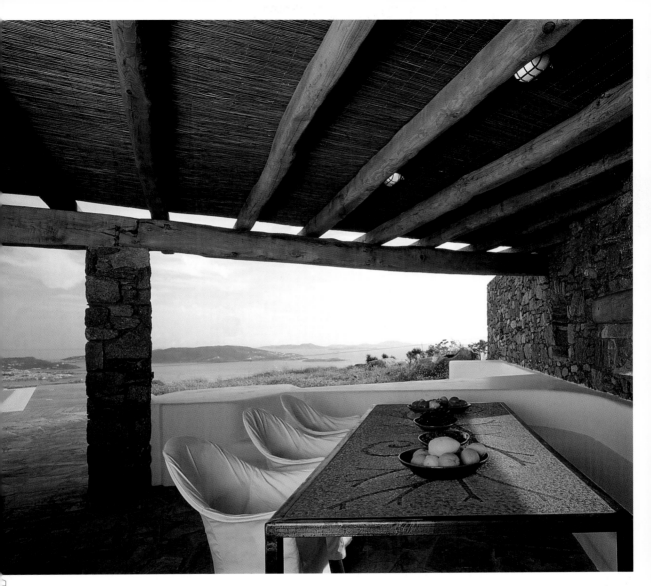

e smooth curved lines can be appreciated in different parts of the house: on the façade, the walls or on the white-washed terrace, reclaiming the organic forms of ditional architecture.

douceur des lignes courbes se retrouve en différents points de la maison : sur la façade, les murs ou dans le blanc chaulé de la terrasse, en réutilisant les formes ganiques de l'architecture traditionnelle.

an kann an verschiedenen Stellen des Hauses sanfte, gebogene Linien entdecken, zum Beispiel an der Fassade, an den Wänden und an der gemauerten Bank auf der rrasse. Diese Formen spielen auf die organischen Formen der traditionellen Architektur an.

☐ House Eivissa
Maison Eivissa
Haus Eivissa

Martínez Lapeña-Torres Arquitectes

This project shows that a traditional Ibiza style house can be updated harmoniously with a contemporary design without compromising the traditional composition of its design. To achieve this, the rooms, with an open layout, were filled with modern furniture, combined with traditional materials and colors. For example, as is frequently the case in Mediterranean architecture, the color white is dominant and the walls are white-washed. The individual decorative elements, such as paintings, rugs and the Florentine furniture by Zanotta, define areas of colors, as diverse as orange, red and blue. The dining room is the central and functional axis of this bare, open space. The other rooms, like the kitchen, bathroom, bedroom and the office, branch off from the living room in the form of a star. The importance of the living room as a central element is also seen in the design of the terrace where warm summer nights can be enjoyed, as in a summer room.

Ce projet montre qu'une maison traditionnelle du style d'Ibiza est compatible avec un design contemporain sans pour autant compromettre la composition de la conception traditionnelle. Pour y parvenir, les pièces à l'espace ouvert, disposent d'un mobilier moderne associé à des matériaux et couleurs traditionnels, à l'instar du blanc dominant et des murs peints à la chaux, typiques de l'architecture méditerranéenne. Les éléments décoratifs individuels, tels les peintures, les tapis et le mobilier florentin de Zanotta, définissent des zones de diverses couleurs : orange, rouge et bleu. Le salon est l'axe central qui définit les fonctions de cet univers dépouillé. L'espace restant, à l'instar de la cuisine, salle de bains, chambre à coucher et de l'office, s'articule, en étoile, autour du salon. Ce dernier est mis en valeur, dans sa fonction d'élément central, par le design de la terrasse, où l'on peut profiter des chaudes soirées estivales comme dans un salon d'été.

Bei diesem Umbau wurde bewiesen, dass man ein traditionelles, ibizenkisch gestaltetes Haus harmonisch auf moderne Weise gestalten kann, ohne dabei die althergebrachte Komposition zu zerstören. Dazu wurden die offenen Räume mit zeitgemäßen Möbeln ausgestattet, die jedoch gleichzeitig mit traditionellen Materialien und Farben kombiniert sind. So herrscht wie so häufig in der mediterranen Architektur die Farbe Weiß vor, und die Wände sind mit Kalk gestrichen. Individuelle Dekorationselemente wie Gemälde, Teppiche und die florentinischen Möbel von Zanotta definieren mit verschiedenen Farben wie Orange, Rot und Blau unterschiedliche Bereiche. Das Wohnzimmer ist die zentrale und funktionelle Achse dieser großen und freien Wohnumgebung. Die übrigen Räume wie die Küche, das Bad, das Schlafzimmer und das Büro gehen sternförmig vom Wohnzimmer ab. Die Bedeutung des Wohnzimmers als zentrale Achse wird auch durch die Gestaltung der Terrasse unterstrichen, auf der man warme Sommernächte wie in einem sommerlichen Wohnzimmer genießen kann.

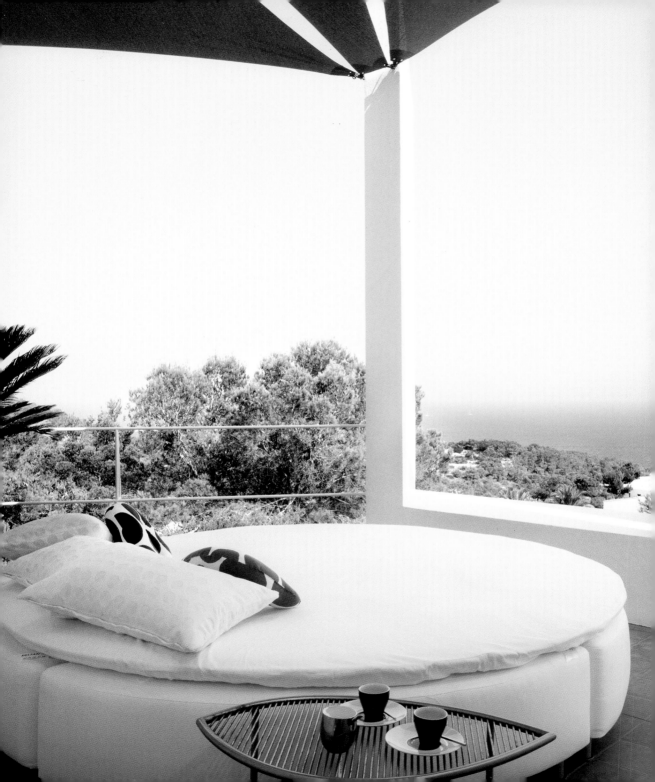

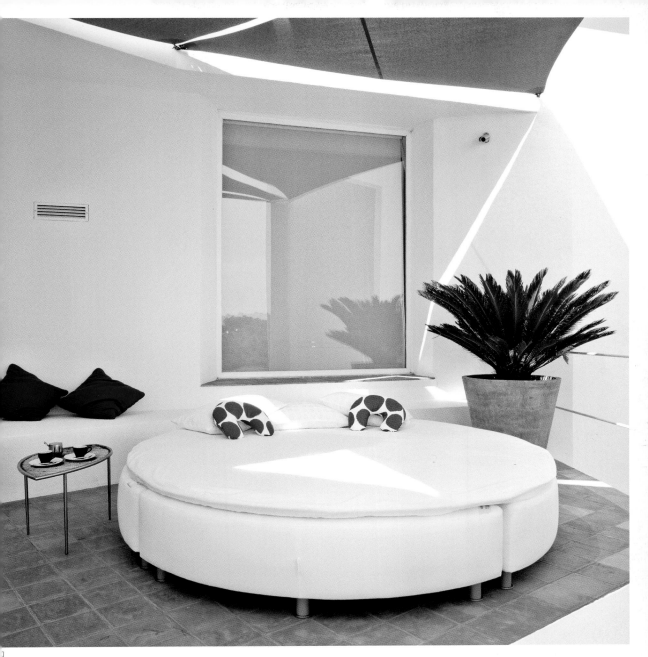

e terrace, from which one can enjoy a privileged view of the coast, has been conceived as a space to relax with furniture inviting rest and informal get-togethers.

terrasse, dotée d'une vue privilégiée sur la côte, est conçue comme une zone de détente agrémentée d'un mobilier propice au repos et aux rencontres informelles.

n der Terrasse aus hat man einen besonders schönen Blick auf die Küste. Ein Ruhebereich mit Möbeln, auf denen man sich entspannen oder mit Freunden und der
milie unterhalten kann.

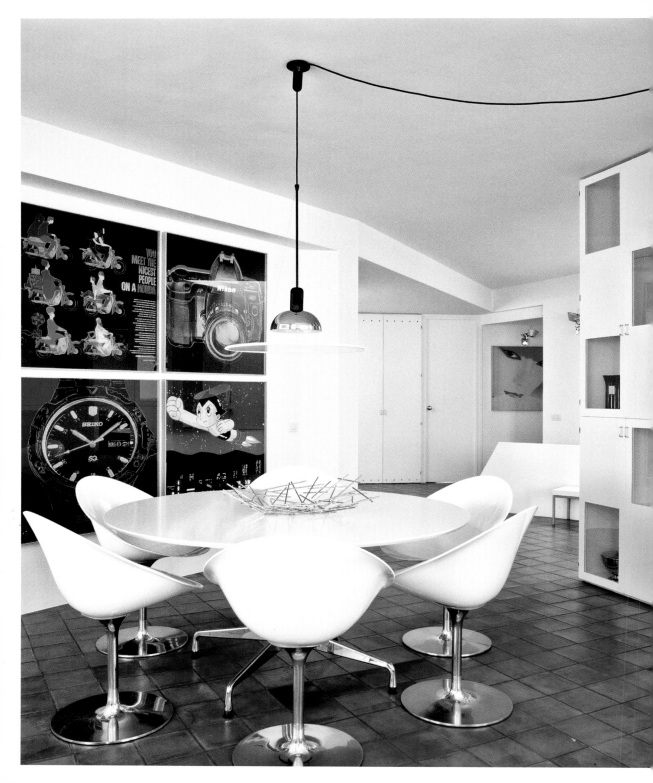

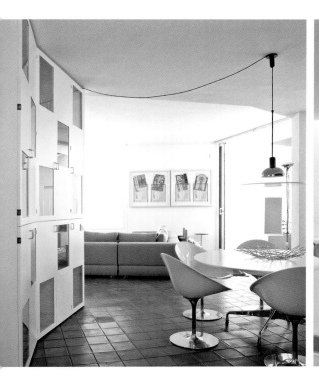
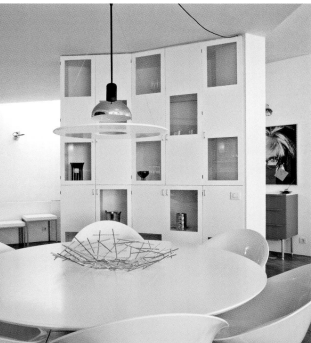

Although it is part of a tourist enclave, this house is designed for every day living, as can be seen in the practical spaces made for storage and the art collection.

Tout en se situant dans une enclave touristique, cette maison est conçue pour y vivre au quotidien, comme le prouvent les espaces de rangement pratiques et la collection d'œuvres d'art.

Obwohl sich dieses Haus in einer touristischen Region befindet, wird es auf alltägliche Weise bewohnt. Das zeigen die praktischen Lagerbereiche und die schöne Kunstsammlung.

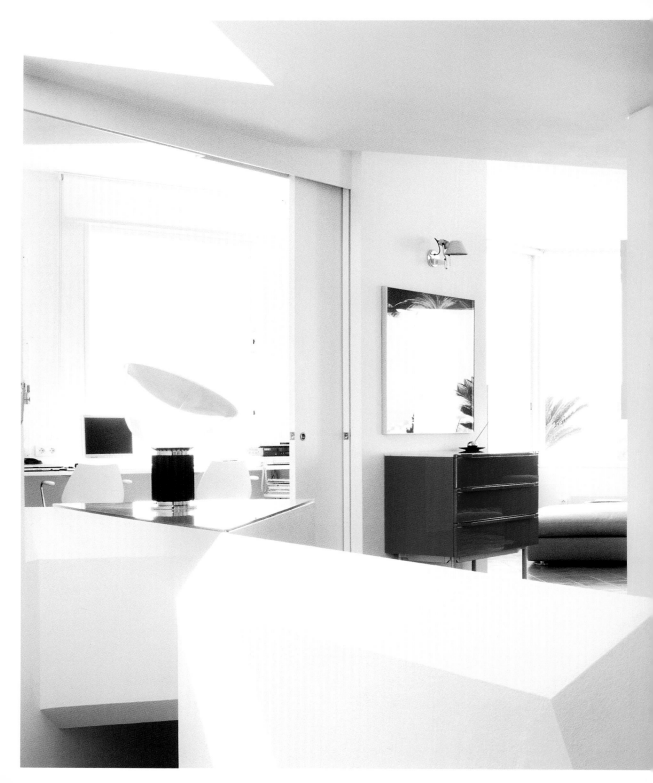

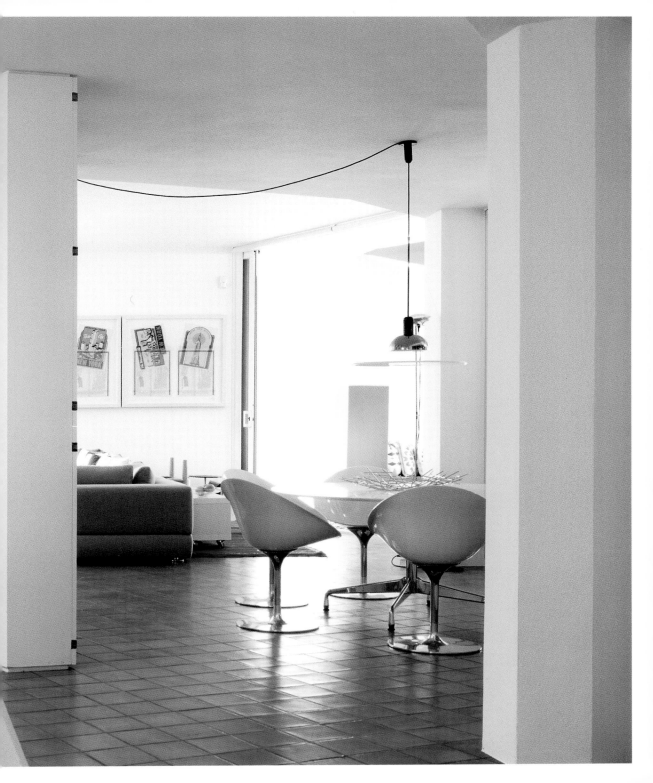

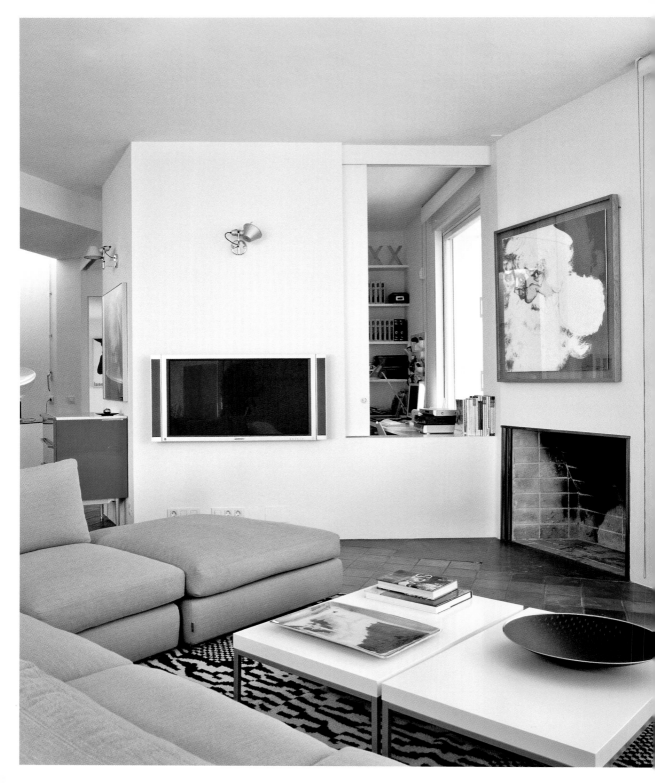

Villa in the south of France
Villa dans le sud de la France
Villa in Südfrankreich

This project was designed following the widespread tradition of holiday-making in southern France. The site chosen is an open slope running down towards the sea and exposed to sunlight all day. The house is composed of several blocks situated on the different levels of the slope. The interior and exterior spaces are distributed in U-shaped volumes supporting another, longer, building. This complex spatial distribution helps maintain a close relationship with the landscape and the vistas. The lounge, the game and billiard rooms, and the cinema sit together on one of the concrete blocks, anchored to the ground by a stone-made base, located in the gravity center of the garden. The trace of the concrete shuttering produces a minimalist and sober space, and the swimming-pool, which originates from this very point, reaches up to the level of the lounge and stretches out towards the sea.

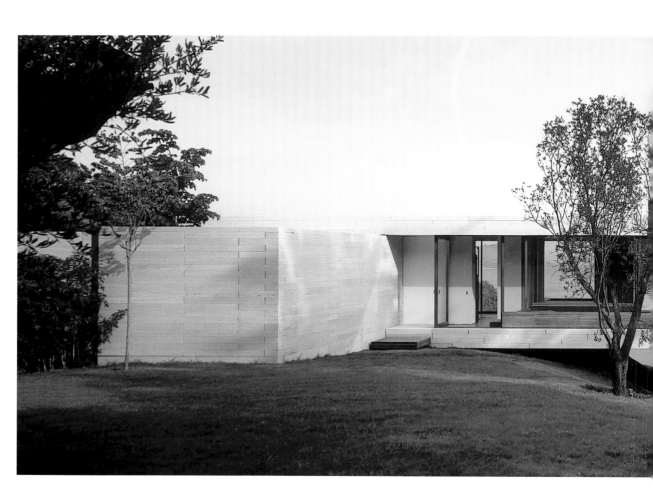

Ce projet est conçu pour réaliser les traditionnelles vacances dans le sud de la France. La parcelle, située sur une pente, face à la mer, épouse la forme du terrain. L'habitation est constituée de divers blocs de béton situés sur les différents niveaux. Les espaces intérieurs et extérieurs s'articulent autour de volumes en forme de U sur lesquels repose un autre bloc tout en longueur. Cette organisation complexe permet de maintenir une relation étroite entre le paysage et les vues. Le salon et les salles de jeux, de billard et de cinéma sont réunis dans un des blocs de béton, ancré dans le sol grâce à un socle de pierre, situé sur le centre de gravité du jardin. Le coffrage de béton s'imprime en espace minimaliste et sobre. La piscine qui naît à cet endroit, arrive jusqu'au niveau des salles pour s'étendre vers la mer.

Diese Villa ist eines der typischen Ferienhäuser im Süden Frankreichs. Das Gelände liegt auf einem Abhang in Richtung des Meeres und des Verlaufs der Sonne. Das Gebäude besteht aus mehreren Blöcken auf verschiedenen Ebenen. Die Innen- und Außenräume verteilen sich in einer U-Form, auf der ein weiterer, sehr langer Körper aufliegt. Durch diese komplexe Aufteilung ist die Beziehung zu der Landschaft und dem Ausblick sehr eng. Das Wohnzimmer und das Spielzimmer mit Billard und Kino befinden sich in einem der Betonblöcke, die durch ein Fundament aus Naturstein im Boden verankert sind und im Zentrum des Gartens liegen. Durch die Betonverkleidungen entsteht ein minimalistischer und schlichter Raum, in dem der Swimmingpool beginnt, der bis zum Bereich des Wohnzimmers reicht und sich zum Meer hin öffnet.

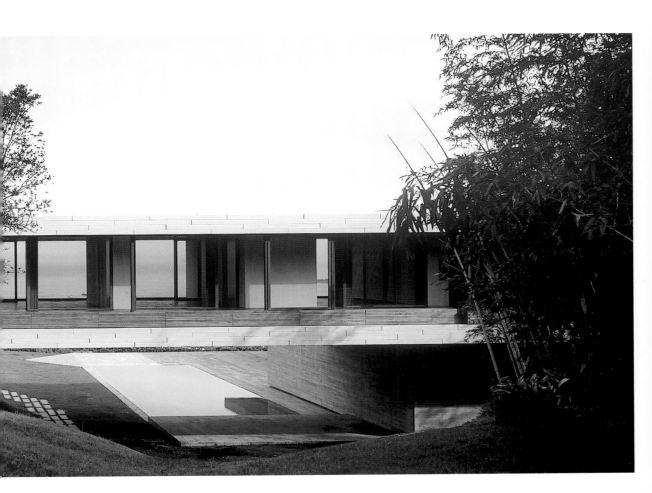

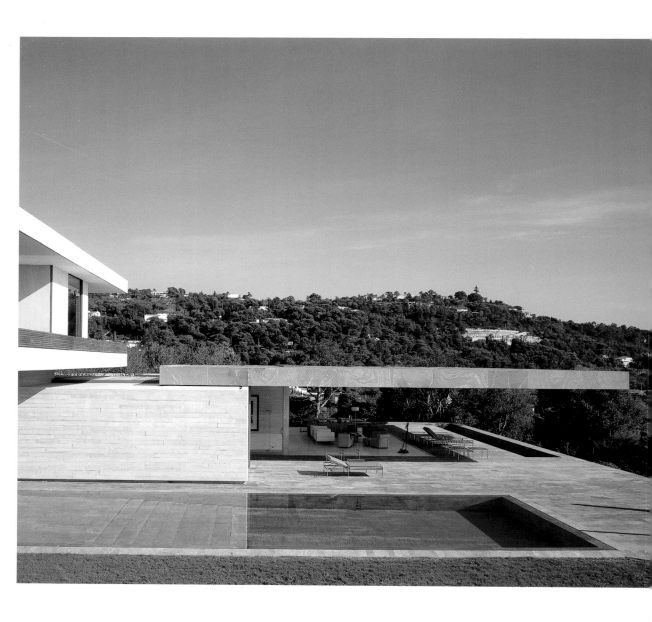

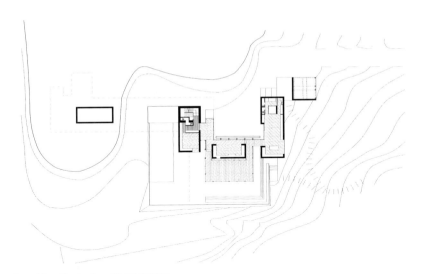

Ground floor Rez-de-chaussée Erdgeschoss

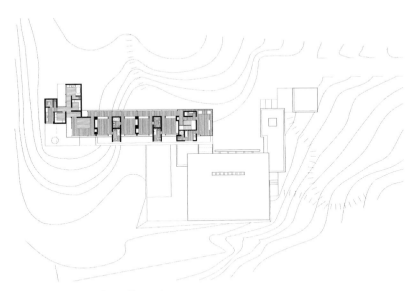

First floor Premier étage Erstes Obergeschoss

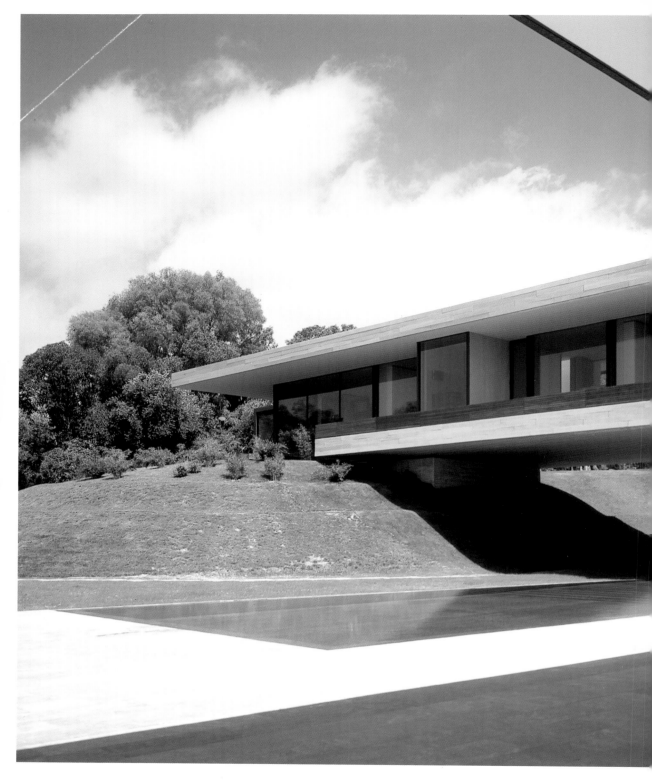

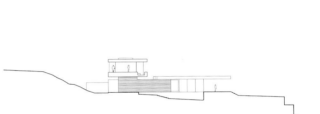

Elevations Élévations Aufrisse

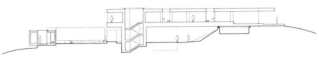

Section Section Schnitt

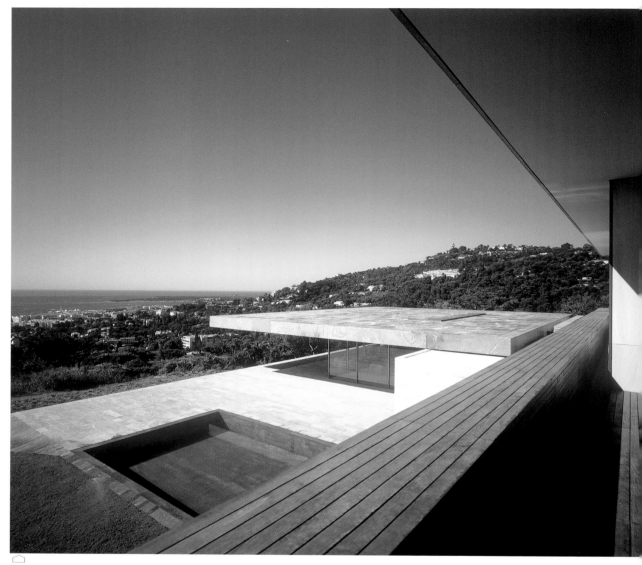

The house receives a great amount of light all day thanks to its orientation. The cantilever of the terrace creates a wide shady area that makes a great living space to be enjoyed throughout the summer.

Grâce à son orientation, la maison est inondée de lumière jusqu'à la fin de la journée. L'encorbellement de la terrasse engendre une large zone d'ombre, qui en fait un espace de vie utilisé tout au long de l'été.

Das Haus ist so ausgerichtet, dass den ganzen Tag über viel Tageslicht einfällt. Der Vorsprung der Terrasse lässt eine große, schattige Zone entstehen, in der man sich im Sommer gerne aufhält.

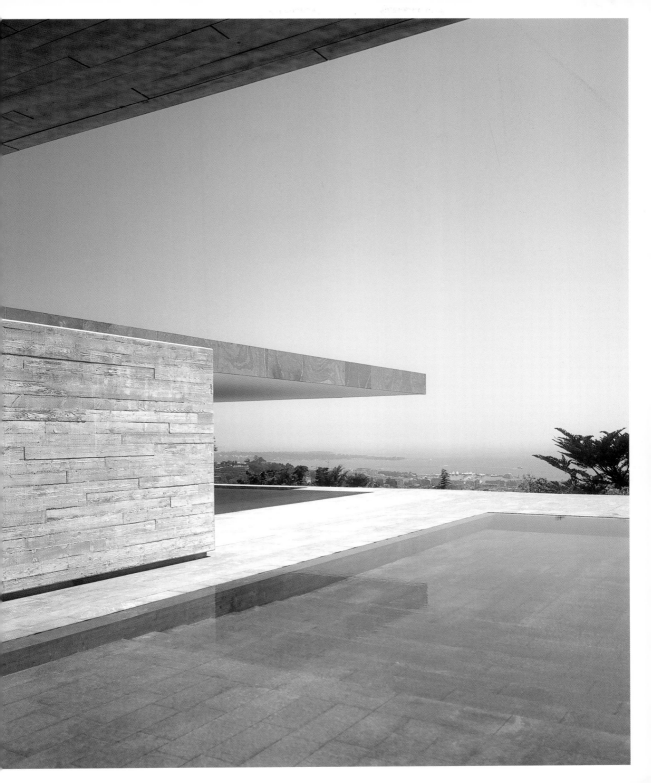

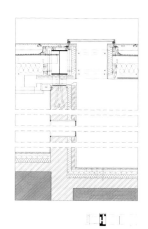

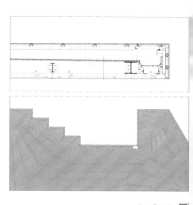

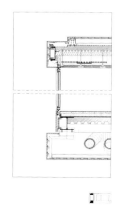

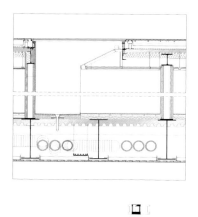

Construction details Détails de construction Konstruktionsdetails

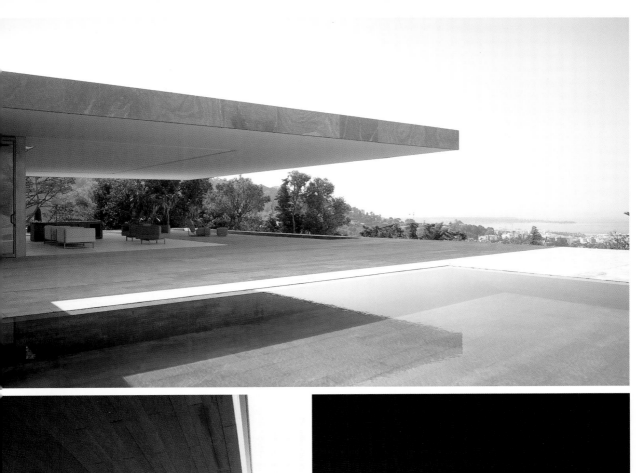
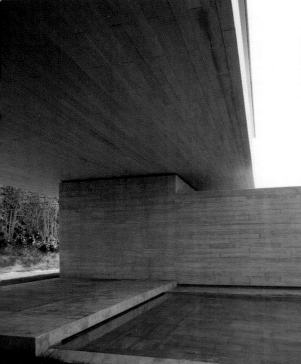
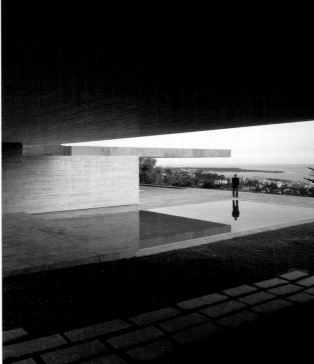

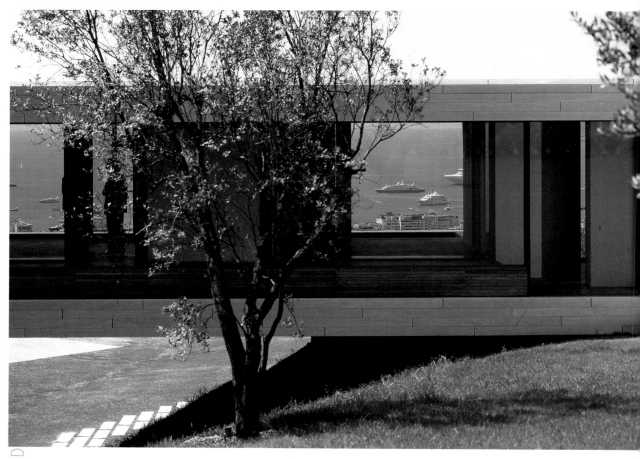

The house projects outwards over the smooth slope towards the drop, and creates a generous interior space surrounded by wide bay windows.

La maison se projette au-dessus du vide et de la pente douce, créant un espace intérieur généreux entouré de larges baies vitrées.

Das Haus wird über dem sanften Abhang ins Leere verlängert, so dass ein großer Innenraum mit riesigen Fenstern entsteht.

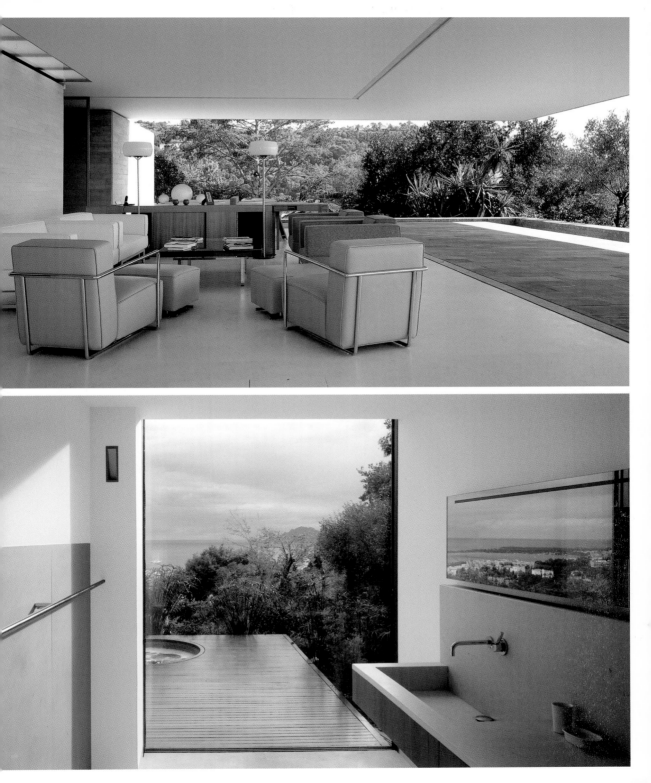

Modern House by the Sea
Maison moderne au bord de la mer
Modernes Haus am Meer

CLS Architetti

The Côte d'Azur is a holiday destination associated with luxury and the most select surroundings. This exclusive residence has been renovated to restore the rooms, give more continuity to the spaces and open them up to the sea. The ground-floor has three distinct spaces: a studio, a living room and a dining room of contemporary design. On the lower ground floor, also the object of an important remodeling process, a spectacular fitness and spa area has been created. The apparent simplicity of the decoration actually shows an audacious, elegant and personal style. The terrace, covered in parts with light awnings, enables one to enjoy the outdoor spaces and the breathtaking sea views at any time of the day in this corner of the house where the sunsets seem endless.

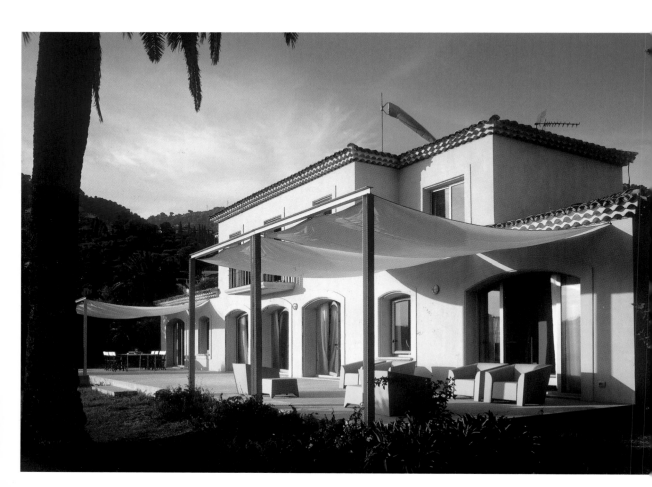

La Côte d'Azur est une destination de vacances, synonyme de luxe et d'ambiances ultra chics. La réhabilitation de cette résidence exclusive vise à restaurer les pièces, fluidifier les espaces et les ouvrir sur la mer. Le rez-de-chaussée présente trois espaces différenciés : un studio, un salon et une salle à manger au design contemporain. Le sous-sol, entièrement remodelé, s'est transformé en une salle de remise en forme et de spa spectaculaire. La simplicité apparente de la décoration affiche en réalité un style audacieux, élégant et personnel. La terrasse, ombragée, par endroits, grâce à de légers velums, permet de profiter des espaces extérieurs et des époustouflantes vues sur la mer, à toute heure de la journée, dans ce recoin paisible de la villa oú les crépuscules semblent s'éterniser.

Die Côte d'Azur ist ein Ferienziel, mit dem man Luxus und exklusive Umgebungen verbindet. Dieses einmalige Wohnhaus wurde umgebaut, um die Räume neu zu gestalten, durchgehender zu machen und sie gleichzeitig zum Meer hin zu öffnen. Im Erdgeschoss befinden sich drei unterschiedliche Bereiche: ein Atelier, ein Wohnzimmer und ein modern gestaltetes Speisezimmer. Im Untergeschoss, das ebenfalls umgestaltet wurde, richtete man einen luxuriösen Fitnessraum mit Whirlpool ein. Die anscheinende Einfachheit der Dekoration zeigt sich in Wirklichkeit als gewagt, elegant und sehr persönlich. Auf der Terrasse, die an einigen Stellen mit leichten Sonnendächern überdacht ist, kann man zu jeder Tageszeit die frische Luft und den wundervollen Blick auf das Meer genießen. Hier scheint die Abenddämmerung ewig zu dauern.

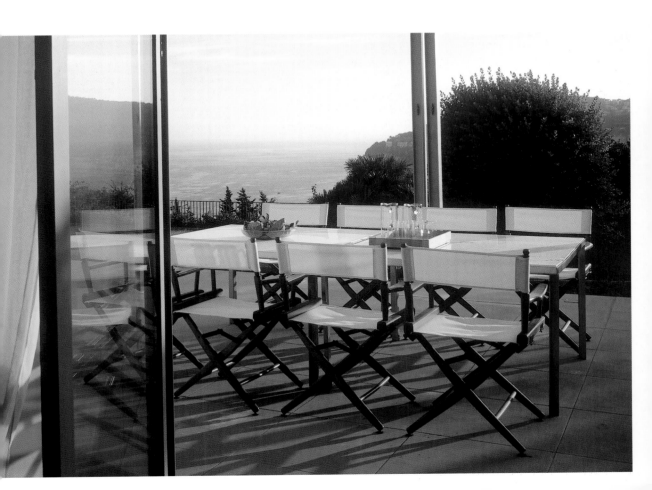

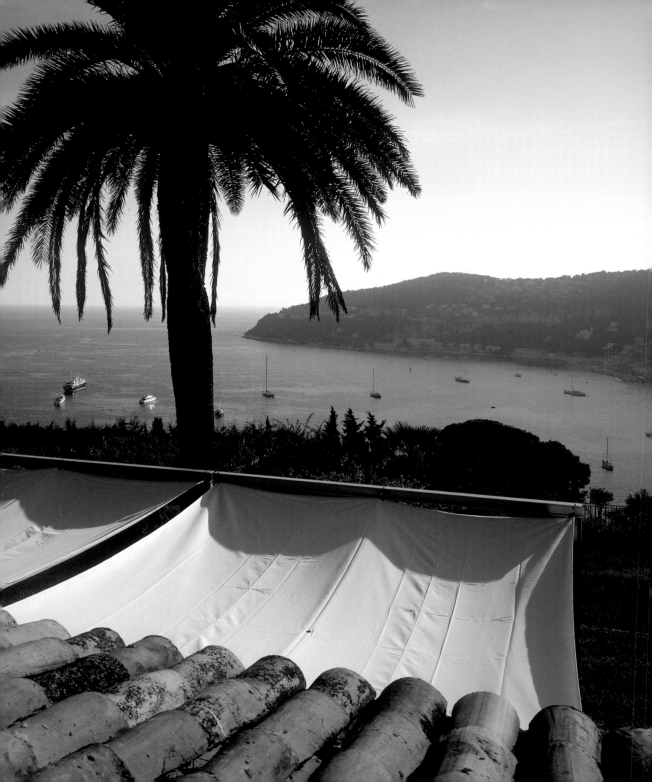

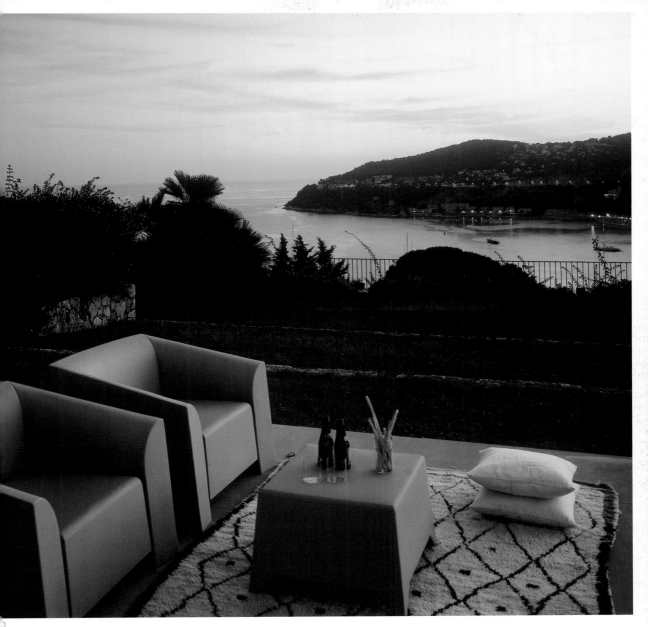

e terrace stretches out towards the garden and, as the day goes by and the light changes, it becomes a space for magical evenings.

 terrasse se prolonge vers le jardin. Elle se transforme au fil des heures et des fluctuations de la lumière du jour et devient un endroit aux couchers de soleil magiques.

e Terrasse verlängert sich zum Garten und verändert sich im Laufe des Tages so, wie sich auch das Licht verändert. Die Abenddämmerung wird hier zu einem agischen Augenblick.

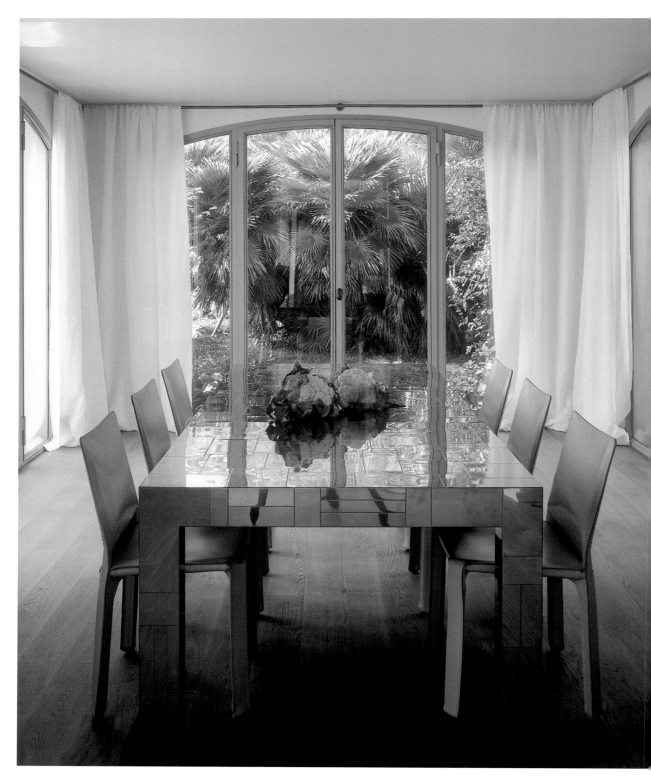

e eclectic decoration combines rustic textures like the parquet flooring with contemporary furnishings such as the mirrored table or the transparent, plastic panels.

 décoration éclectique affiche une alliance de textures rustiques, à l'instar du bois des revêtements aux finitions contemporaines, telle la table au miroir ou les panneaux de stique transparent.

i der eklektischen Dekoration wurden rustikale Texturen wie die Holzfußböden mit modernen Flächen wie dem verspiegelten Tisch und den Paneelen aus nsparentem Kunststoff kombiniert.

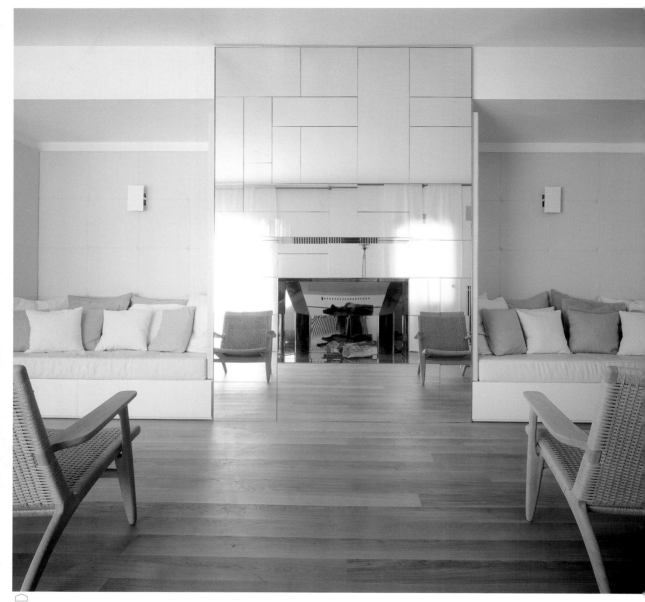

The impressive mirrored fireplace offers a daring contrast where the element, designed to house the fire, consists of cold, polished glass that reflects its light.

L'impressionnante cheminée au miroir offre un contraste audacieux où cet élément, destiné à abriter le feu, est constitué de verre froid et poli reflétant la lumière.

Der beeindruckende, verspiegelte Kamin sorgt für einen gewagten Kontrast zwischen heißem Fener und kaltem, poliertem Glas, welches das Licht reflektiert.

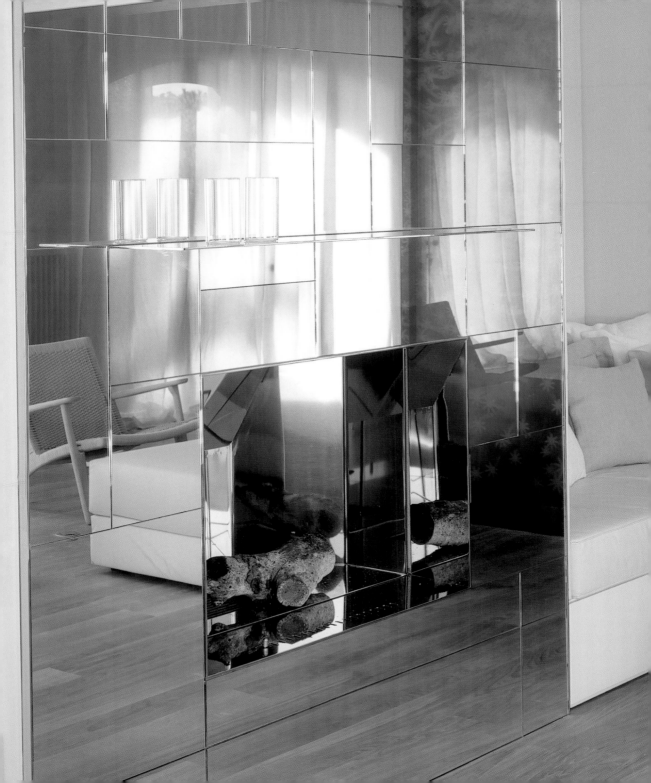

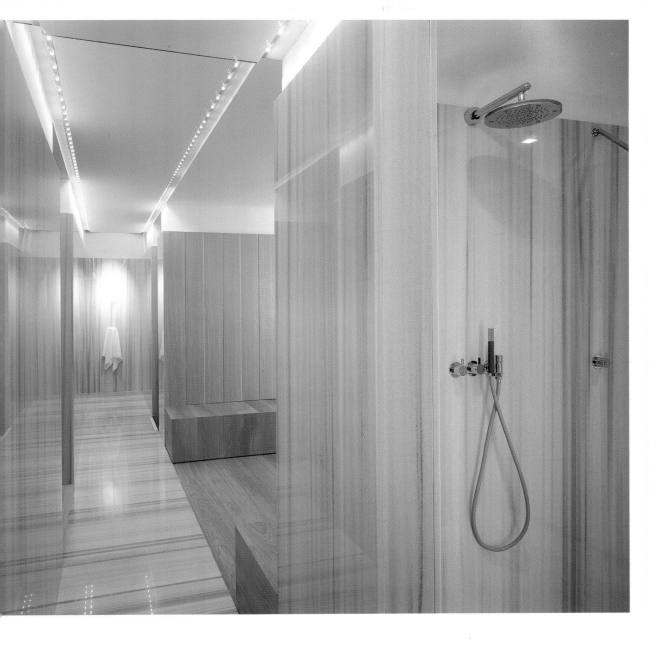

The large bathroom area is another example of stunning, innovative design, with the vertical-line pattern of the marble creating an optical effect of draped fabric.

La vaste salle de bains est aussi une pièce qui étonne par sa conception novatrice : le marbre des surfaces, aux lignes verticales, paraît être une matière textile.

Ein weiteres, überraschendes Element ist das innovative Konzept des großen Badezimmers mit seinen Marmorflächen und den vertikalen Linien, die optisch wie ein Textilmaterial wirken.

Manara loft
Loft Manara
Manara Loft

Raed Abillama Architects

The Beirut rooftop location and the panoramic view over the sea are characteristic features of this project. The walls of the main interior spaces (living and dining room) achieve perfect unity. It is made lighter by a long horizontal blade with a tapering cross section suspended on fixed glass panels. This cutting-edge system strengthens the long façade against strong sea wind in addition to housing the top rail of the sliding panels. The façade is composed of three large glass panels collapsible into one, extending the interior space both visually and physically to the outside. The exterior edge is equally made transparent with the use of a glass balustrade reinforced at the top edge with a continuous wide stainless steel handrail, in the spirit of the façade. This virtually edgeless relationship with the sea connects the interior with its surroundings.

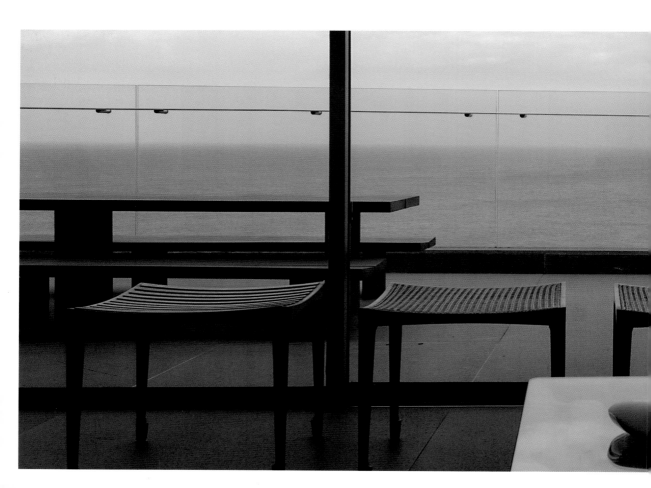

L'emplacement sur un toit de Beyrouth et les diverses vues panoramiques vers la mer définissent ce projet. La façade des principaux espaces intérieurs (salon et salle à manger) affiche une unité totale. Elle est allégée par une longue lame horizontale dotée d'une section transversale effilée suspendue sur des panneaux de verre fixes. Ce système tranchant protège la longue façade des bourrasques du vent de mer tout en abritant le rail supérieur des panneaux coulissants. La façade est formée de trois longs panneaux de verre escamotables en un seul, prolongeant ainsi l'espace intérieur de manière visuelle et physique vers l'extérieur. Le bord extérieur est également transparent grâce à une balustrade de verre renforcée sur la partie supérieure par une main courante continue en acier inoxydable, dans l'esprit de la façade. L'absence littérale de bords établit une relation continue entre la mer et l'intérieur qui est ainsi relié au paysage alentour.

Dieses Loft wird von der typischen, umgebenden Dachlandschaft Beiruts und der weiten Aussicht geprägt. Die Fassade der wichtigsten Wohnbereiche (Wohn- und Speisezimmer) wurde vereinheitlicht. Sie wirkt durch eine lange, waagerechte Schneide mit einem sich verjüngenden Querschnitt, die an Glasplatten hängt, leichter. Dieses innovative System verstärkt die Längsfassade und schützt sie vor dem starken Seewind. Außerdem dient es als Aufnahme einer Führungsschiene für Schiebeplatten. Die Fassade besteht aus drei großen Glasplatten, die zu einer zusammengeklappt werden können. So wird der Raum visuell und physisch nach außen vergrößert. Die Außenkante ist durch eine Glasbalustrade, die an der Oberkante mit einem durchgehenden Handlauf aus Edelstahl verstärkt ist, ebenfalls transparent. Dieses Element passt sich stilistisch perfekt an die Fassade an. Durch diese praktisch kantenlose Beziehung zum Meer werden die Innenräume mit der Umgebung verbunden.

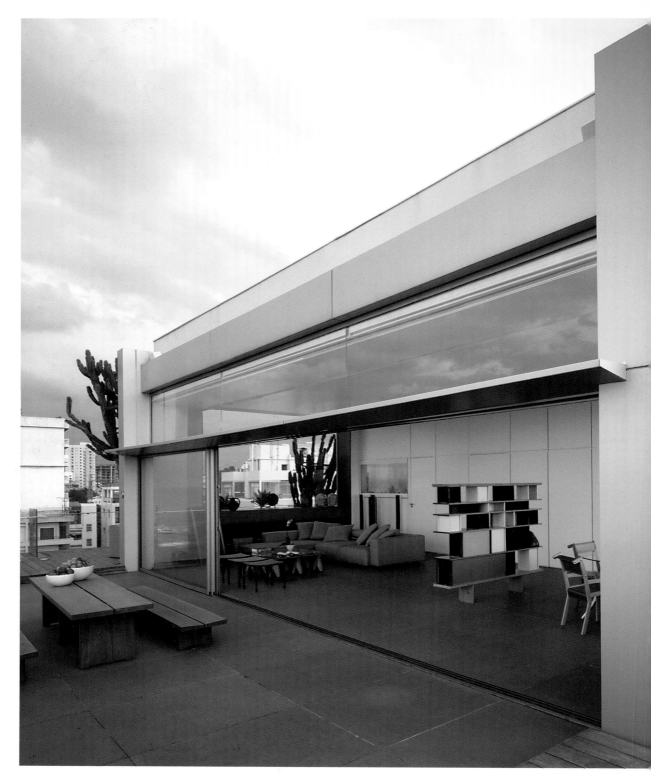

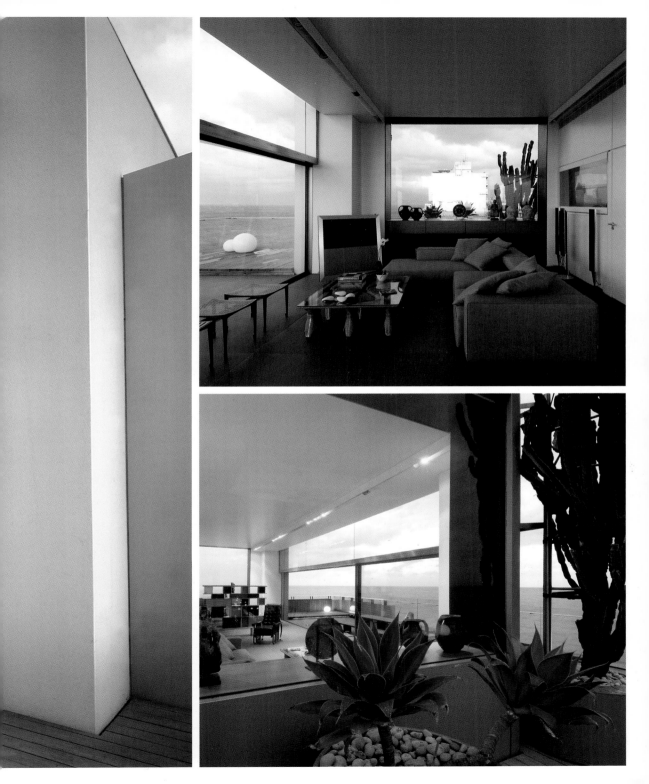

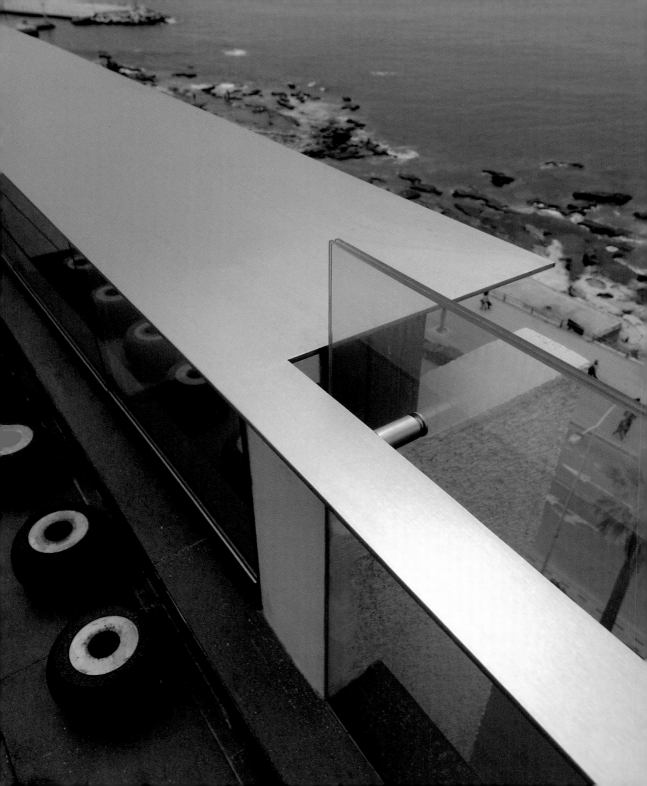

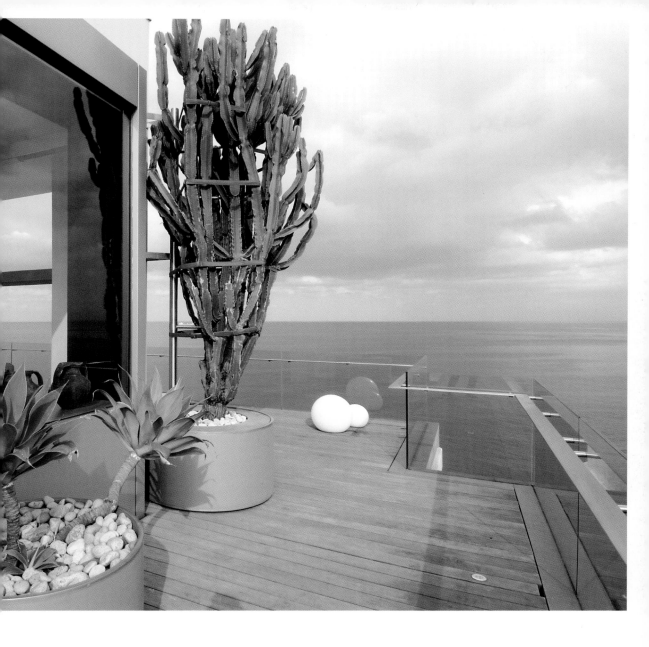

Glass has been used to cover most of the façade and for the balustrades, so that the house visually expands towards the sea line.

Le verre habille une grande partie de la façade et des balustrades, élargissant visuellement l'espace de l'habitation vers l'horizon marin.

Ein großer Teil der Fassade und der Balustraden ist mit Glas verkleidet, so dass der Raum visuell in Richtung des Meereshorizonts vergrößert wird.

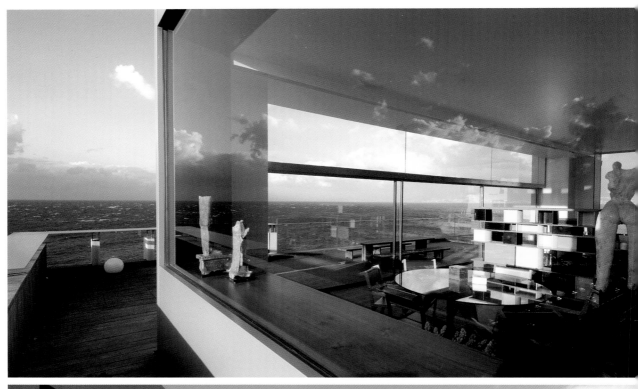
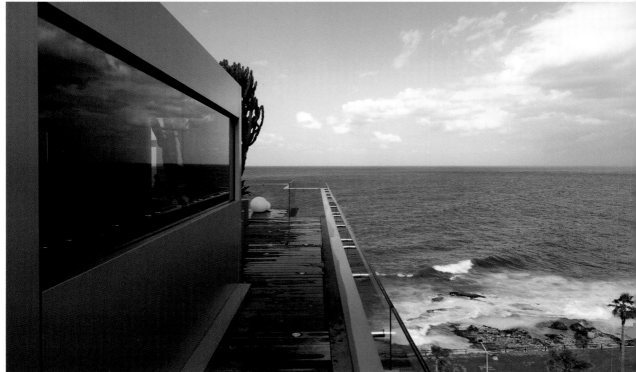

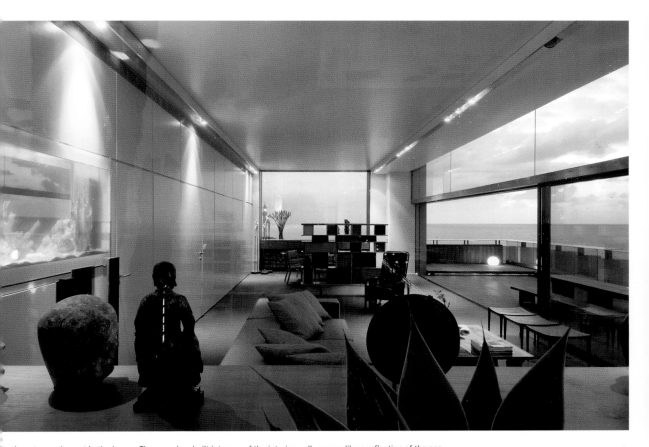

ter is a strong element in the house. The aquarium built into one of the interior walls seems like a reflection of the sea.

quasi omniprésence de l'eau caractérise cette habitation. L'aquarium encastré dans l'un des murs intérieurs semble être le reflet du paysage extérieur.

vorherrschendes Element der gesamten Gestaltung ist das Wasser. Ein Aquarium ist in eine der Wände eingelassen und scheint die äußere Landschaft zu reflektieren.

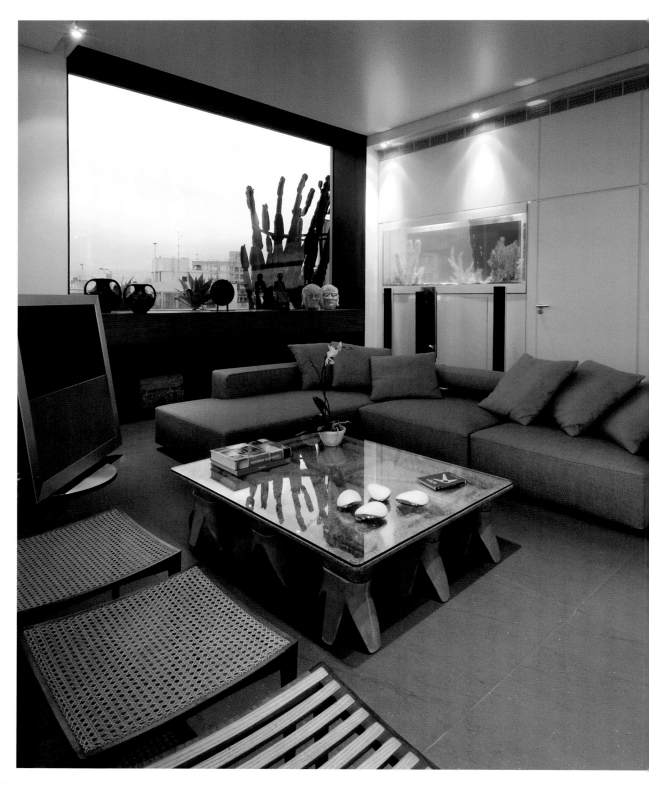

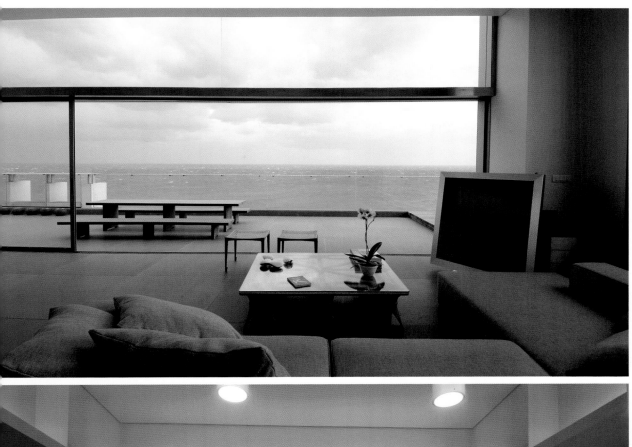

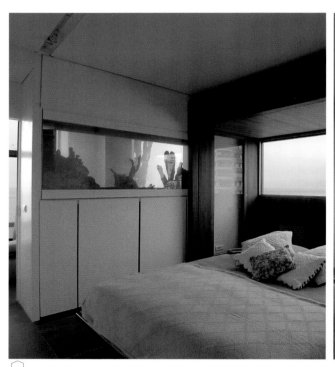
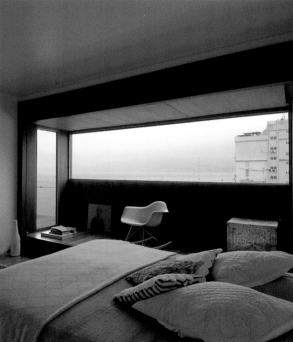

Strategically built-in storage spaces permit optimal use of space in different rooms.

L'installation d'espaces de rangement encastrés dans les murs des chambres à des points précis permet d'optimiser l'espace.

Um den Raum besser zu nutzen, wurde Stauraum strategisch in den Wänden der verschiedenen Räume geschaffen.

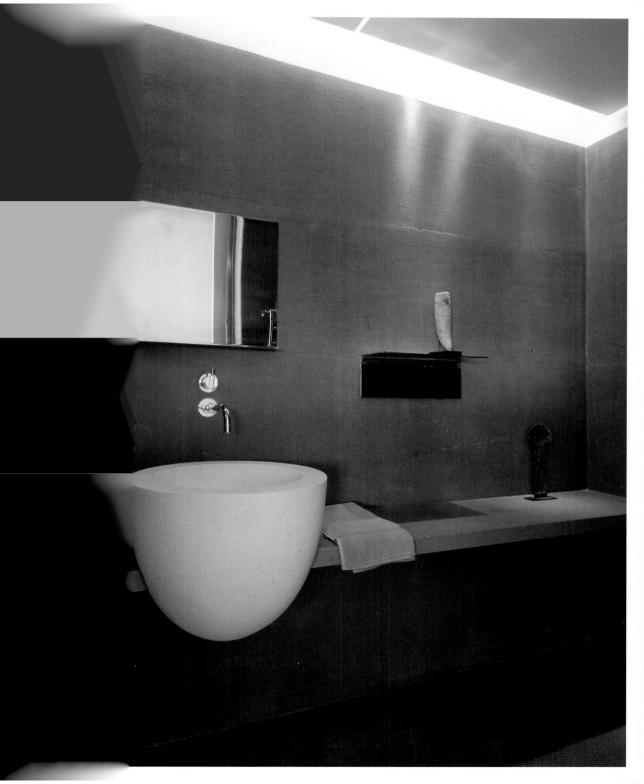

☐ Manca House
Maison Manca
Haus Manca

Marco Turchi

Falconara spa is located in the Italian region of Marche, six miles from Ancora, and extends along the coastline on the right-hand side of the mouth of the Esino, thus enjoying a two mile long beach. The house is tightly anchored on a sep slop and lurks between the sea and the hills. A typical 1970s building, the house has been completely renovated and adapts itself to the slope of the land. Floors set at different levels, both interior and exterior, generates a complex volume that maintains part of the structure of the previous building, adapting itself to the environmental context. Complexity and rigor surrender themselves to the views of the mountains and seas, which are immersed in the magnificent Mediterranean atmosphere.

La station balnéaire de Falconara est située dans la région italienne de la Marche, à 10 kilomètres d'Ancona. Elle s'étend le long du littoral, à droite de l'embouchure de l'Esino, bénéficiant ainsi d'une plage de 3 kilomètres de long. Cette habitation, bien ancrée sur une forte déclivité, se love au cœur de la petite ville qui s'étale entre mer et collines. La maison, une construction typique des années soixante-dix, entièrement rénovée, épouse la pente du terrain. Les étages répartis à différents niveaux, intérieurs ou extérieurs, génèrent un volume complexe qui conserve une partie de la construction antérieure, tout en s'adaptant au contexte environnemental. Complexité et rigueur s'offrent aux vues sur les montagnes et la mer, le tout baigné dans une merveilleuse atmosphère méditerranéenne.

In der italienischen Region Marken, zehn Kilometer von Ancona entfernt, befindet sich der Kurort Falconara. Er liegt an der Küste, rechts der Mündung des Flusses Esino, und hat einen drei Kilometer langen Strand. In dieser kleinen Stadt zwischen Meer und Hügeln steht dieses Wohnhaus an einem steilen Hang, an den es sich festklammert. Das Haus in der heutigen Form, das sich ausgezeichnet an die Geländeneigung anpasst, ist das Ergebnis einer radikalen Renovierung eines Gebäudes aus den Siebzigerjahren. Verschiedene äußere und innere Ebenen schaffen einen komplexen Körper, der zu einem Teil noch aus der vorherigen Struktur besteht, und passen das Gebäude an die Umgebung an. Die komplexe und strenge Struktur wird durch den Blick auf die Berge und das Meer besänftigt, und es herrscht eine bezaubernde, mediterrane Atmosphäre.

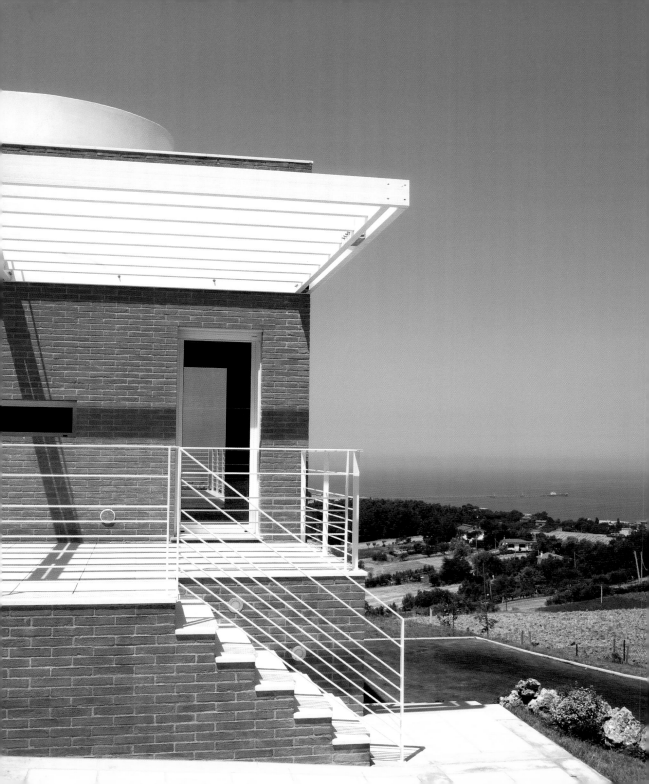

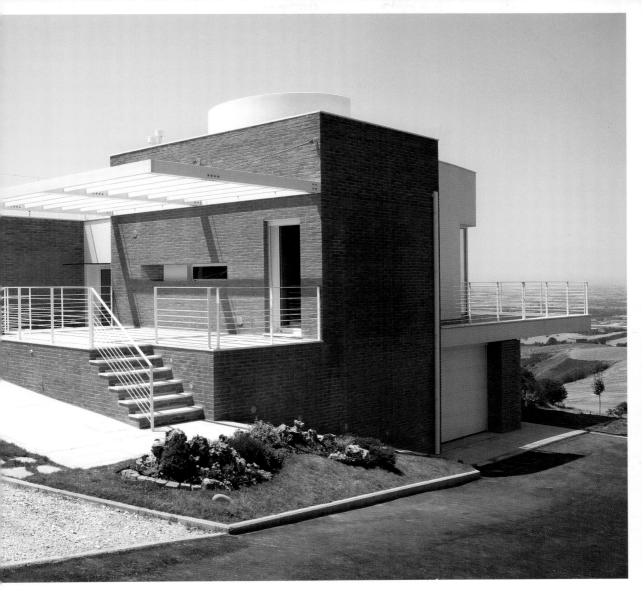

s house, standing on top of a hill by the Adriatic Sea, has been designed to take full advantage of its privileged location and built following the natural inclination of the land.

projet de cette maison, située au sommet d'une colline à côté de la mer adriatique, vise à optimiser la situation privilégiée. La construction épouse la pente naturelle terrain.

der Planung dieses Hauses auf einem Hügel an der Adria wollte man vor allem den bemerkenswert schönen Standort betonen. Das Haus passt sich deshalb an die ürliche Neigung des Geländes an.

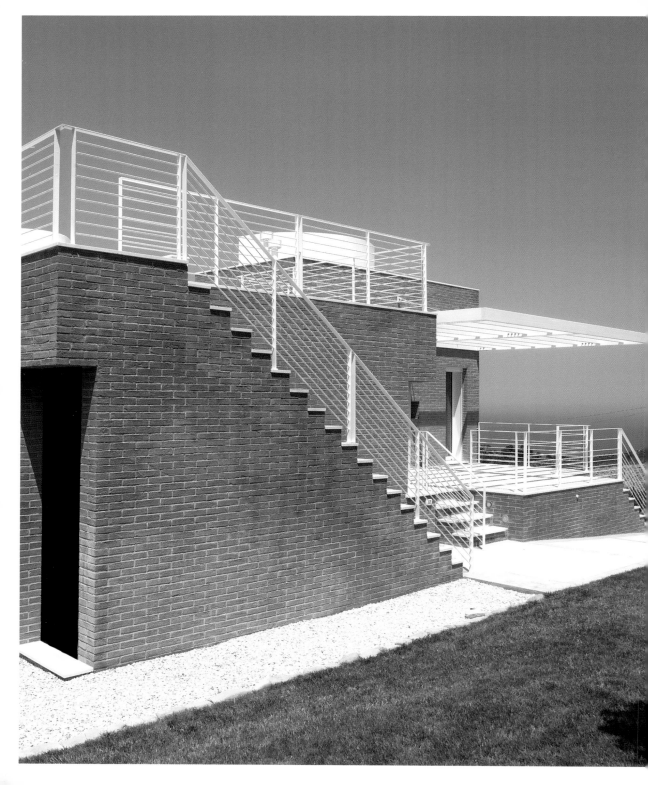

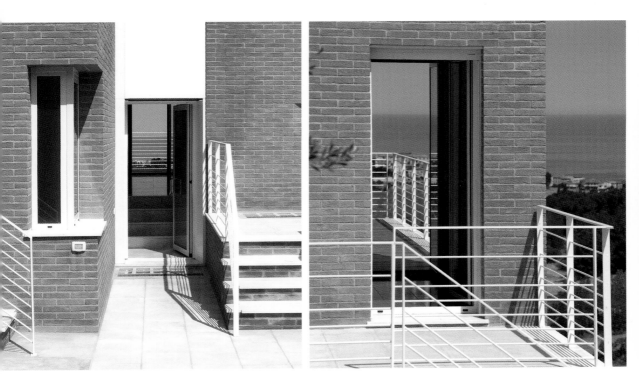

doors and windows have been strategically placed so that the magnificent view over the sea can also be enjoyed from the back of the house.
plantation des ouvertures suit une stratégie précise, permettant depuis la façade arrière orientée vers l'intérieur, de jouir des splendides vues sur la mer.
Fenster und Türen sind strategisch so angeordnet, dass man vom hinteren Bereich aus einen wundervollen Blick auf das Meer hat.

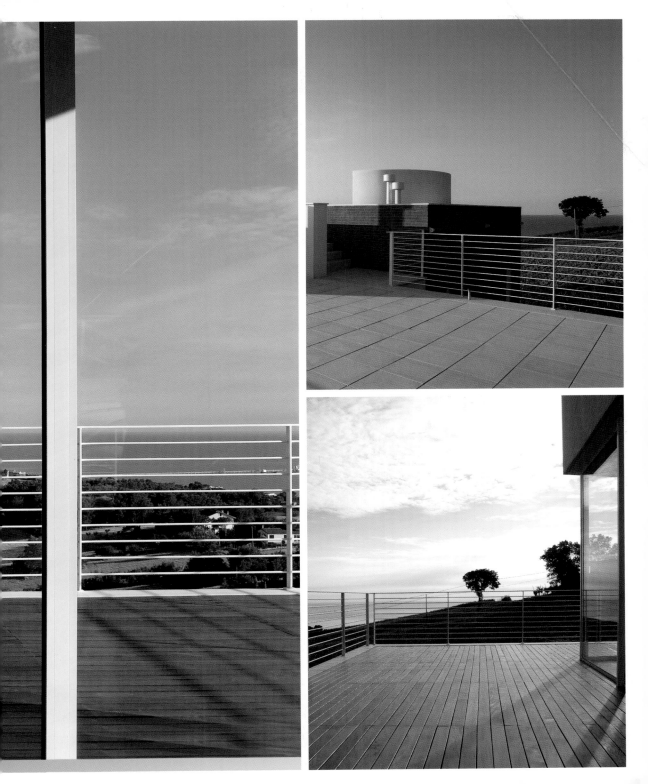

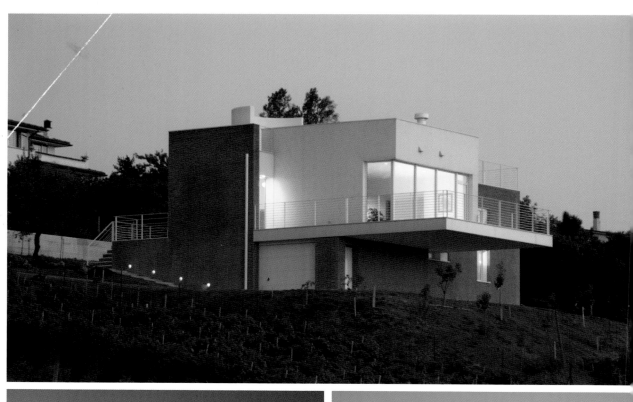
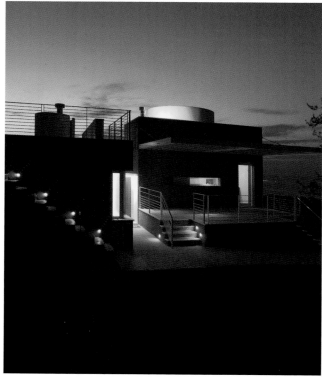

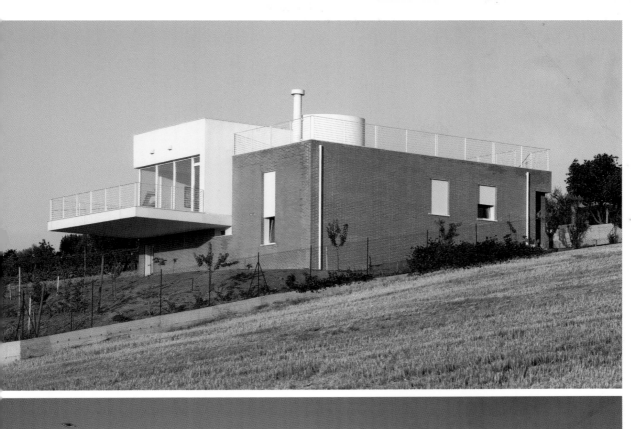
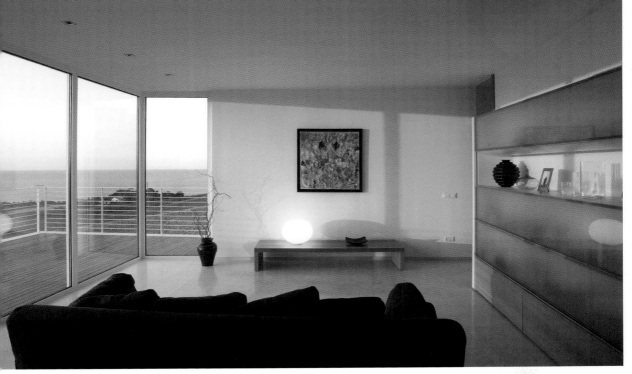

Lores House
Maison Lores
Haus Lores

Joan Jesús Puig de Ayguavives,
Claudia Rueda Velázquez

The pleasant coffee color of the wenge wood used in this house also appears in the design of the floor, creating an elegant and comfortable Mediterranean atmosphere enhanced by the different shades of brown of the chairs, dining-room table, headboard, and the rugs. The beige and white marble covering of the walls completes the harmony. The dining and living rooms on the ground floor are connected, but can be separated if necessary. Both look out onto the heated swimming-pool in the garden and onto a shaded terrace. Marble and wood have also been used for this area, surrounded by the olive, carob and palm trees typical of the region. The more private rooms are located on the upper floors, with sliding doors that offer flexibility and a sense of space emphasized by the light beige and brown tones.

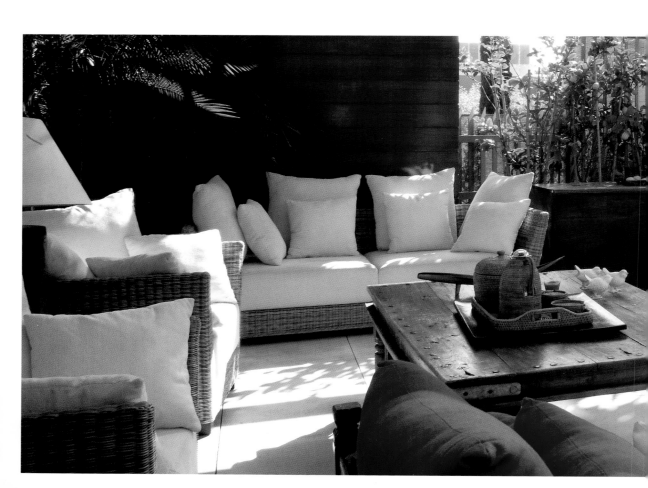

Les tons café du bois de wengué dotent cette habitation d'une couleur agréable qui se reflète également dans le design du sol pour créer un environnement méditerranéen, élégant et pratique. Cette mise en scène de couleurs est exaltée par les différentes teintes de marron du mobilier : sièges, table de la salle à manger, tapis et tête de lit. Les habillages des surfaces murales, déclinant marbre blanc, beige et gypse, s'harmonisent à merveille avec l'ensemble. La salle à manger et le salon se trouvent au rez-de-chaussée. Ces deux pièces n'en font qu'une, mais elles sont séparables, si nécessaire. Elles ont vue sur la piscine climatisée du jardin et sur la terrasse couverte. Cette zone de vie, également conçue en marbre blanc et bois, est entourée d'oliviers, caroubiers et palmiers, arbres typiques de la région. Les espaces plus privés sont situés aux étages. Les portes coulissantes créent un design modulable, plus spacieux, accentué par les teintes de beige clair et de marron.

Das angenehme Kaffeebraun des Wengeholzes, das in diesem Haus verwendet wurde, findet man auch an den Fußböden. So entstand eine elegante und komfortable, mediterrane Atmosphäre, die noch von den verschiedenen Brauntönen einiger Möbelstücke, der Stühle, des Esstisches, der Teppiche und des Kopfteils des Bettes unterstrichen wird. Die Wände, die mit weißem und beigem Marmor und Gips verkleidet sind, passen ausgezeichnet zu diesen Farben. Das Speise- und das Wohnzimmer liegen im Erdgeschoss. Beide Räume sind miteinander verbunden, können aber, falls notwendig, voneinander abgetrennt werden. Von beiden Räumen aus schaut man auf den geheizten Swimmingpool im Garten und die überdachte Terrasse. In diesem Bereich, der von Oliven- und Johannisbrotbäumen und typischen Palmen der Region umgeben ist, herrschen ebenfalls weißer Marmor und Holz vor. Die privateren Räume befinden sich in den oberen Etagen. Durch Schiebetüren werden die Räume flexibler und größer; diese Weite wird noch durch helle Beige- und Brauntöne unterstrichen.

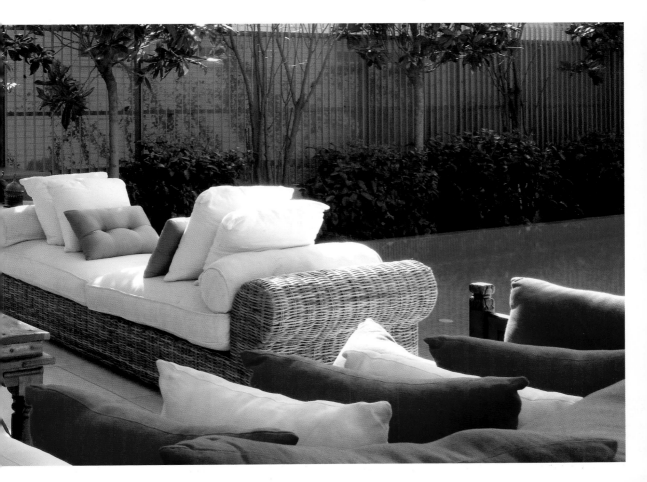

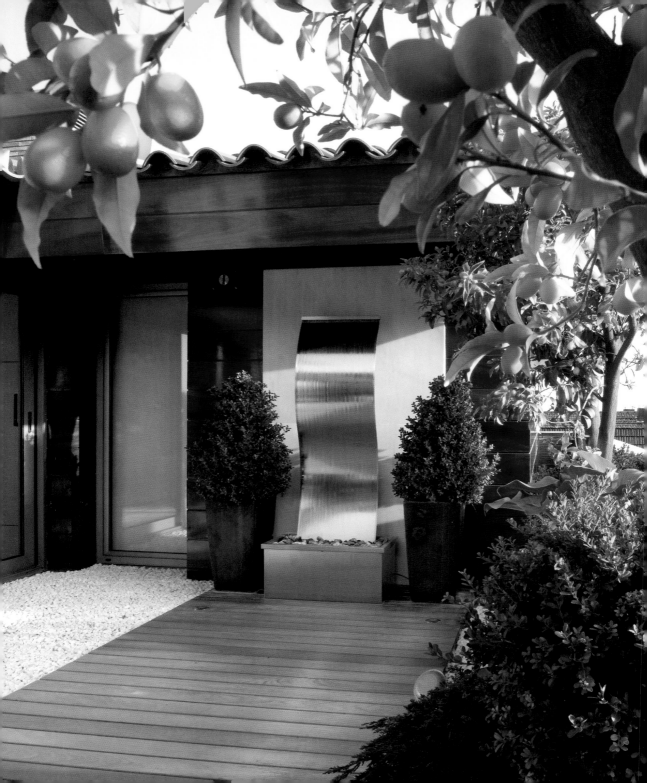

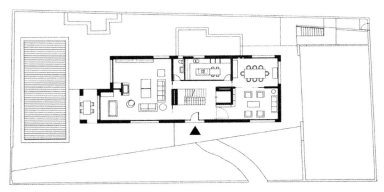

Ground floor Rez-de-chaussée Erdgeschoss

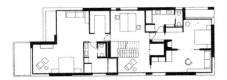

First floor Premier étage Erstes Obergeschoss

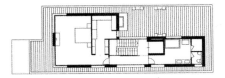

Second floor Deuxième étage Zweites Obergeschoss

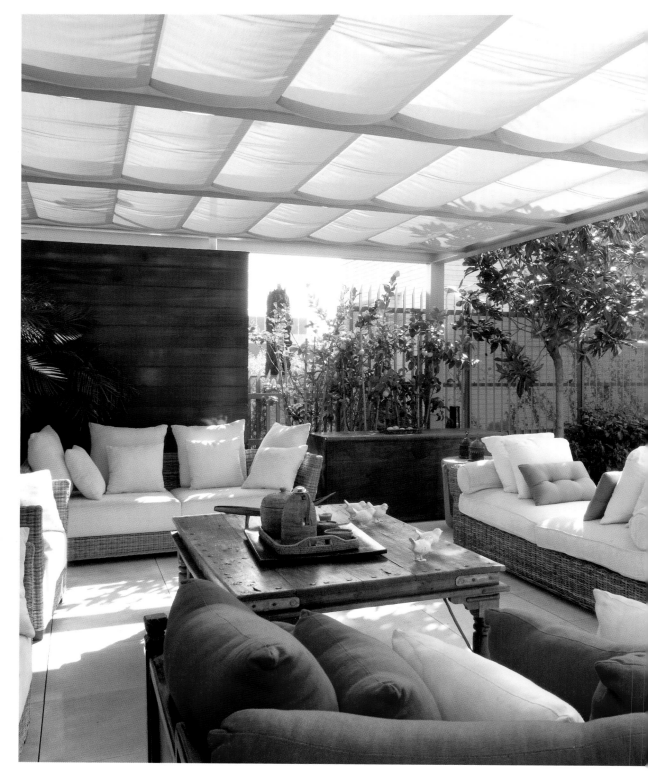

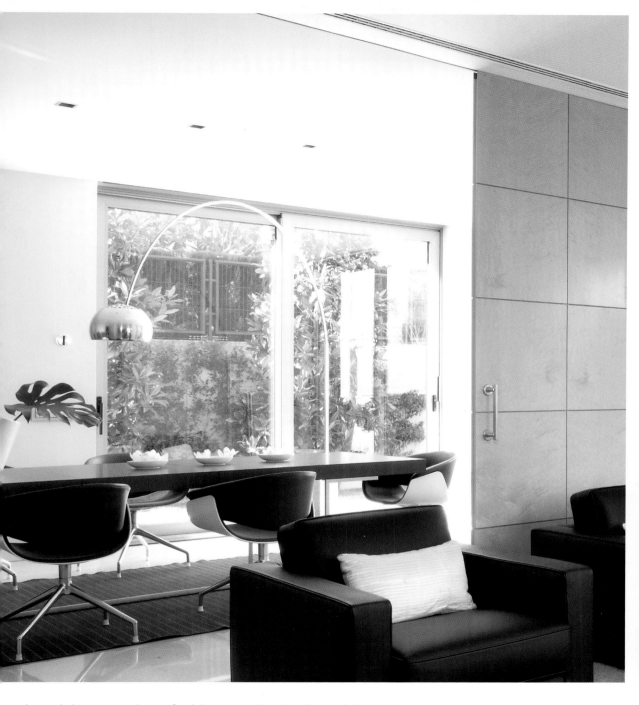

e awning over the large terrace on the upper floor helps create a cooler and relaxing space in the summer.

l'étage supérieur, l'ample terrasse, protégée en été par une toile, se métamorphose en un espace de fraîcheur et de repos.

e obere Ebene der großen Terrasse kann mit einer Markise überdacht werden, so dass hier im Sommer ein kühler Raum zum Ausruhen entsteht.

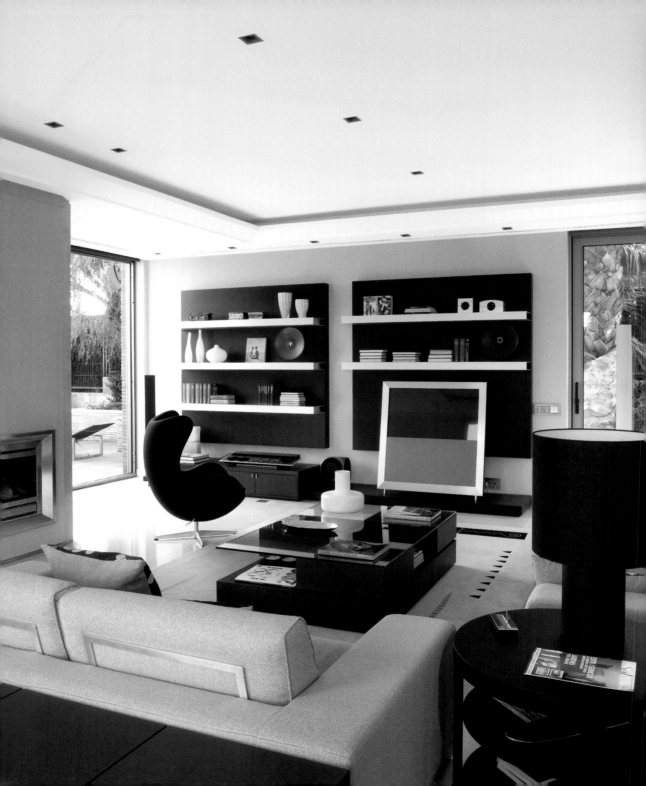

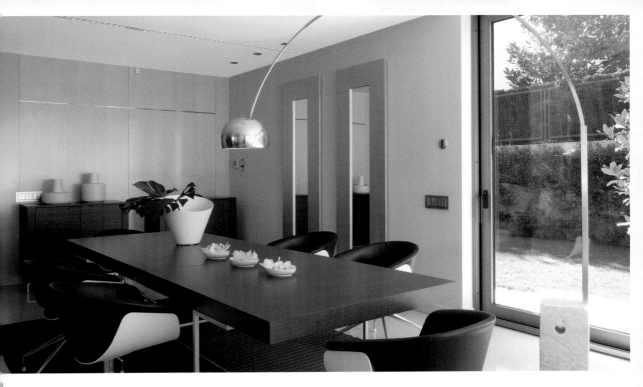

e dining room area has been arranged so that diners can enjoy the light and the views of the garden.

ce à la disposition de la salle à manger, les habitants profitent de la lumière et des vues sur le jardin.

Esszimmerbereich ist so angeordnet, dass man beim Essen das Licht und den Blick auf den Garten genießen kann.

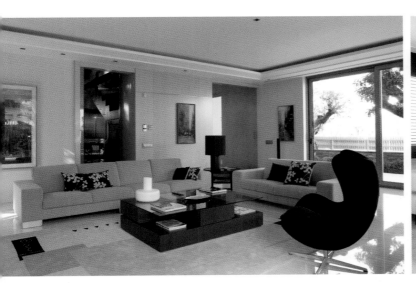

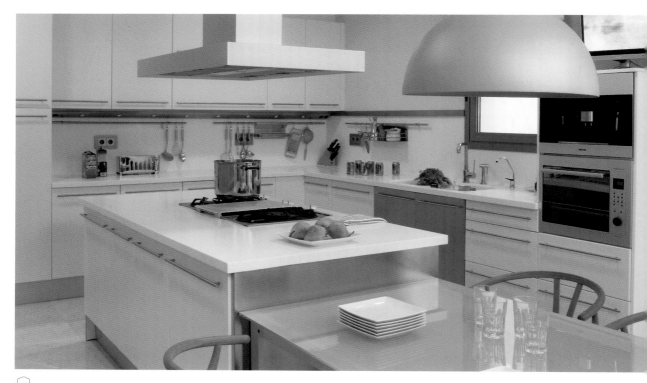

In the kitchen, spacious and very functional, a central island houses the stovetop and a small space for breakfast and informal meals.

Dans la cuisine, spacieuse et très fonctionnelle, un îlot central accueille l'espace de cuisson ainsi qu'un petit coin sympathique pour prendre les petits déjeuners et les repas en toute simplicité.

In der weiträumigen und sehr funktionellen Küche befindet sich eine Kücheninsel mit dem Herd und einem kleinen Bereich zum Frühstücken und für Zwischenmahlzeiten.

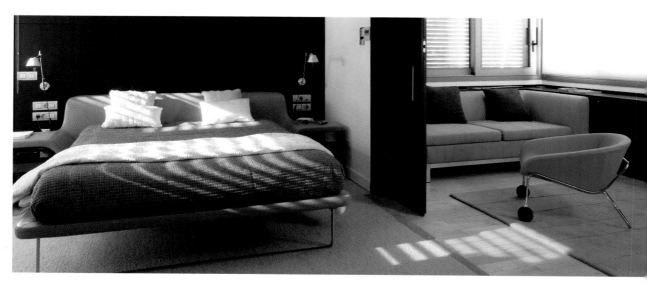

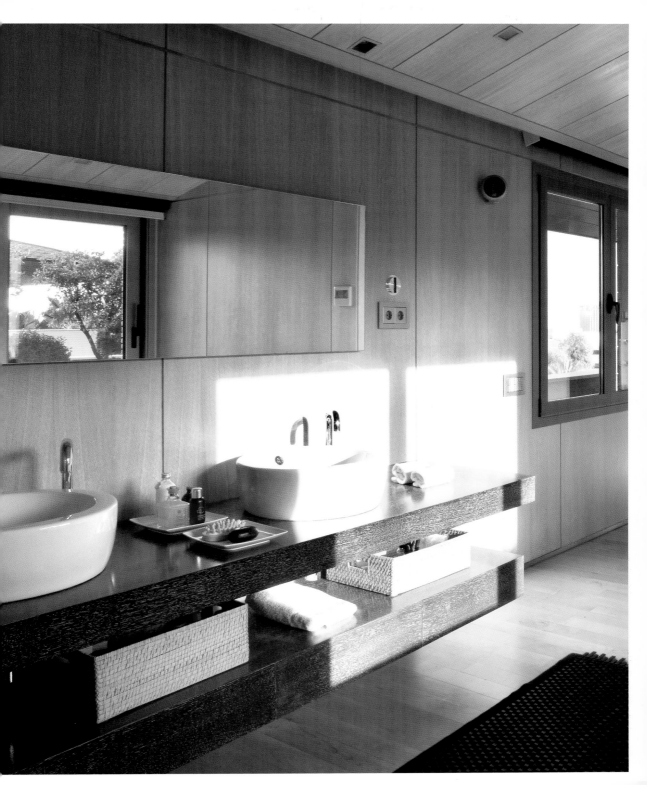

☐ Espacio Habitat

De la Mora Hernández, Sánchez Tappan / SOFAR

The renovation and interior design of a 860-sq-ft flat in a protected historical building dating from 1736 in Barcelona's Gothic Quarter reinforces the feeling of spatial continuity between the exterior and interior by extending the 172-sq-ft terrace from the back to the front of the apartment with a strip of Cumaru wood running alongside it and providing it with a humid area. The architects have succeeded in blending the old and the new by displaying the restored materials with careful lighting and introducing basic materials such as concrete, iron and glass. The stainless steel kitchen enhances the distribution while forming a discreet part of it. The former distribution has been redefined into an open space that includes two bedrooms and two fully equipped bathrooms and can be used both as a short-term living area as well as a habitable business showroom.

La rénovation de cet appartement de 80 m², situé dans le quartier Gothique de Barcelone, au sein d'un édifice de 1736 classé bâtiment historique, offre un design qui accentue la continuité spatiale entre l'extérieur et l'intérieur, en prolongeant les 16 m² de la terrasse arrière vers la façade principale, par une frange en bois de Cumaru pour extérieur, créant une zone humide le long de l'appartement. Les architectes ont réussi à marier l'ancien et le nouveau, en faisant ressortir la texture des matériaux anciens restaurés, grâce à un éclairage parfaitement étudié et à l'introduction de matériaux de base comme le verre, le béton et le fer. La cuisine aux finitions en acier inoxydable s'inscrit discrètement dans l'espace tout en accentuant la distribution. L'ancienne distribution a laissé place à un espace ouvert, doté de deux chambres à coucher et deux salles de bains complètes, octroyant à l'ensemble la flexibilité nécessaire pour remplir la double fonction d'habitation temporaire et d'espace d'exposition habitable de l'entreprise.

Die Renovierung und Innengestaltung einer 80 m² großen Wohnung in einem Gebäude des gotischen Viertels von Barcelona aus dem Jahr 1736 unterstreicht die räumliche Kontinuität, bei der innen und außen ineinander übergehen. Die 16 m² große, hintere Terrasse wird durch einen Streifen aus Cumaru-Holz bis zur Hauptfassade verlängert. So entsteht ein Feuchtbereich entlang der gesamten Wohnung. Durch den Eingriff der Architekten wurde ein Gleichgewicht zwischen Neu und Alt geschaffen. Die Texturen der alten, restaurierten Materialien wurden mit einer sorgfältig durchdachten Beleuchtung unterstrichen, und es wurden weitere Materialien wie Glas, Beton und Eisen eingeführt. Die Küche aus Edelstahl unterstreicht die Kontinuität des Raumes und die Stahlflächen scheinen mit dem Raum zu verschwimmen. Es entstand ein offener Raum mit zwei Schlafzimmern und zwei komplett ausgestatteten Bädern, der flexibel genug ist, um zeitweilig als Wohnung und zeitweilig als bewohnbarer Showroom der Firma zu dienen.

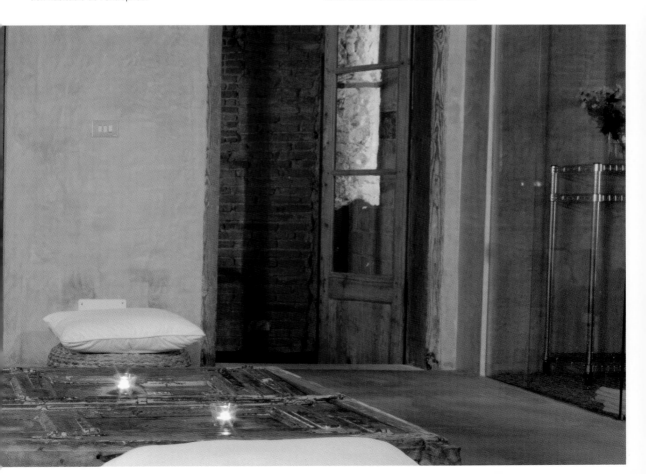

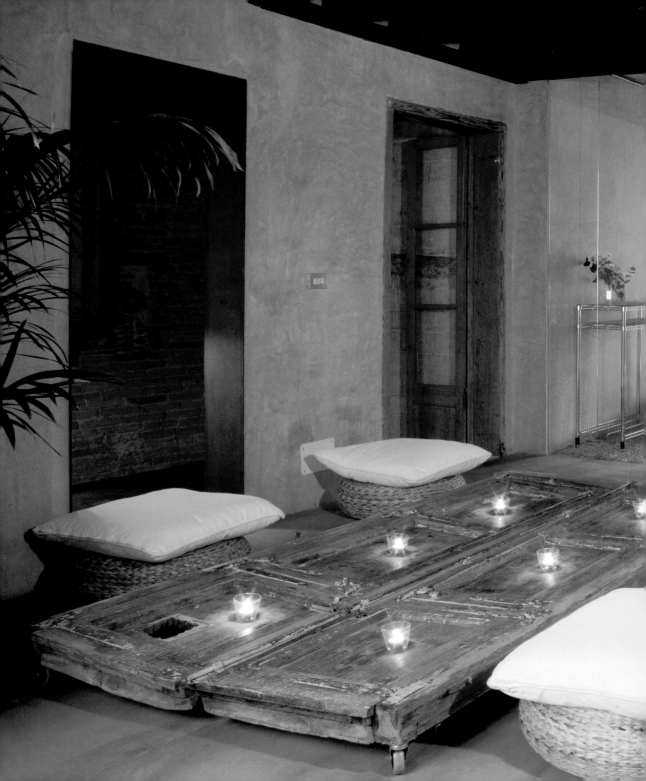

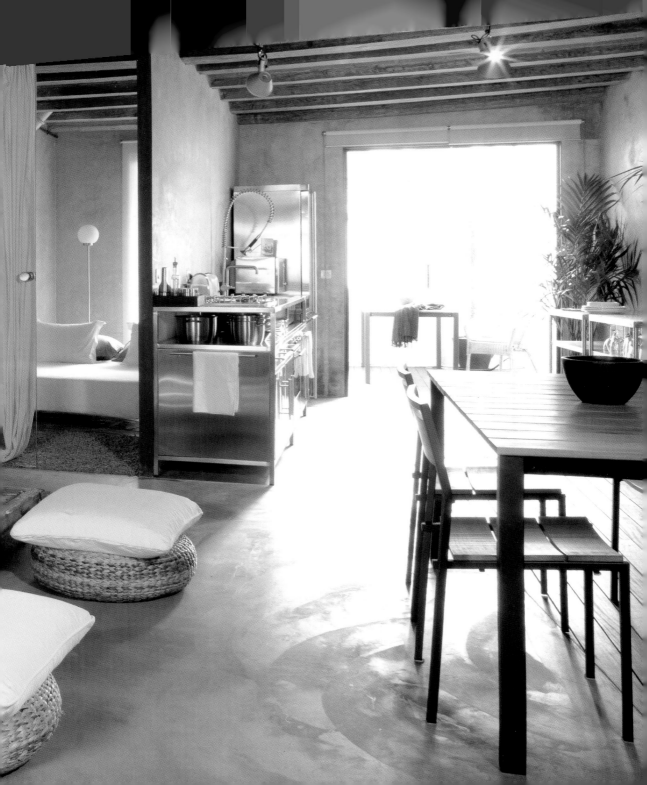

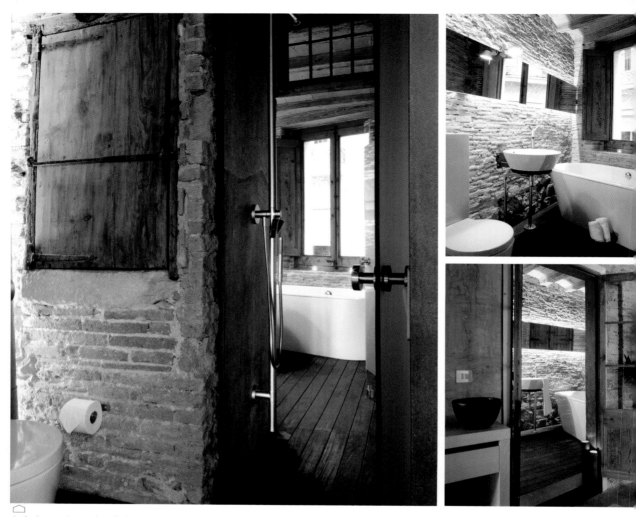

In the house, the new installations are in harmony with the existing textures and materials, such as the old walls or beams and the restored wooden windows.

Dans la maison, les installations nouvelles cohabitent harmonieusement avec les textures et les matériaux existants, à l'instar des vieux murs ou des poutres et fenêtres restaurées en bois.

In diesem Haus werden neue Installationen harmonisch mit bereits vorhandenen Texturen und Materialien wie den alten Wänden, den Balken und den Fenstern aus restauriertem Holz kombiniert.

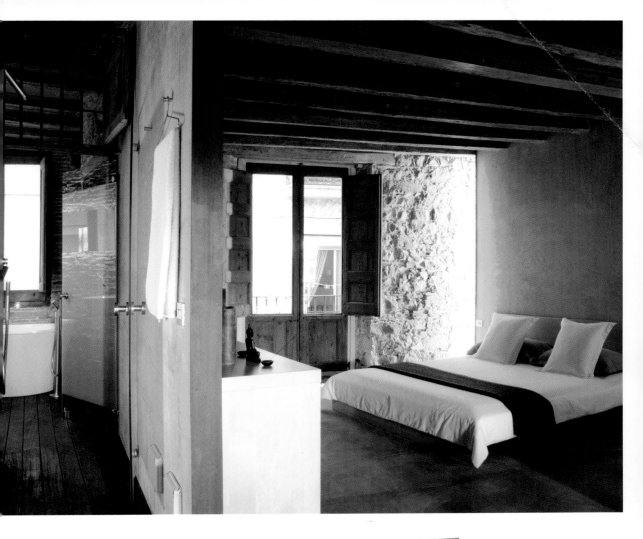

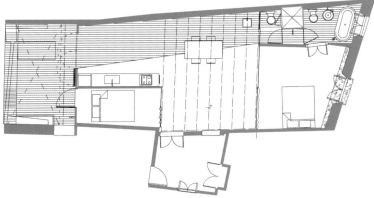

Plan Plan Grundriss

☐ **Villa F**

Nabil Gholam

The site lies on a magnificent pine-covered hilltop, 3,940 ft above sea level on Mount Lebanon, commanding extraordinary views in all directions and enjoying the excellent Mediterranean climate all year round. The sharp slope presented many challenges, such as the construction of a sweeping arched retainer wall to hold back the hill, allowing a series of orthogonal local sandstone walls to spring out from the land. Horizontal plans of cross-cut travertine slabs, cool reflecting ponds and cantilevered canopies intersect the walls in harmony with the slope, forming the living spaces of the house. Careful orientation and sun-shading, crawling greenery, hanging gardens on the fifth façade and obsessive attention to proportion help the house integrate perfectly into the hill and respect the environment. A rational layering of horizontal joints overlap the rough-stone construction of the main sandstone walls, making horizontal incisions into the landscape.

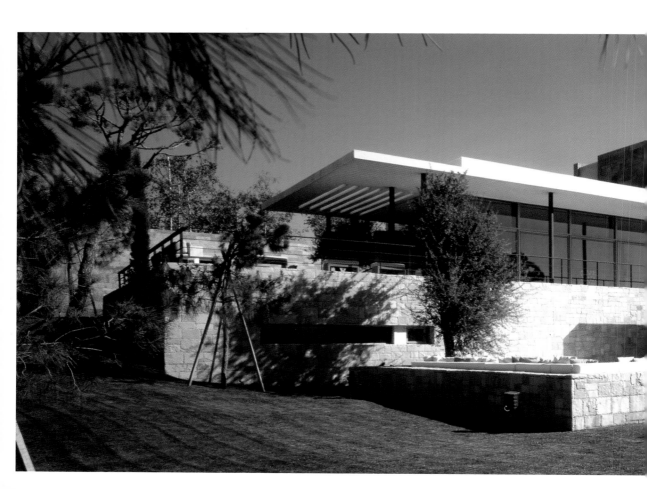

Le site repose sur une magnifique colline recouverte de pins, à 1.200 m au-dessus du niveau de la mer, sur le Mont Liban, jouissant de vues panoramiques extraordinaires et de la douceur du climat méditerranéen tout au long de l'année. La forte pente du terrain présente de nombreux défis, telle la construction d'un immense mur de soutien cintré qui retient la colline, permettant à une série de murs orthogonaux en pierre calcaire locale de jaillir du terrain. Un plan horizontal formé de dalles transversales en travertin, de petits plans d'eau rafraîchissants et d'auvents saillants, entrecroise les murs en dialogue avec la pente, créant ainsi les espaces de vie de la maison. Une orientation bien étudiée et une protection solaire, les jardins de toit de la cinquième façade, une végétation rampante et un sens des proportions poussé à l'extrême, permettent l'intégration parfaite de la maison à la colline et le respect de l'environnement. Une disposition rationnelle en couche, de joints horizontaux, chevauche la construction en pierre brute des principaux murs en calcaire, créant ainsi des incisions dans le paysage.

Das Grundstück liegt auf einem prächtigen, von Pinien bedeckten Hügel 1.200 m über dem Meeresspiegel auf dem Berg Libanon mit einem wundervollen Blick in alle Richtungen und ist das ganze Jahr über dem milden Mittelmeerklima ausgesetzt. Die starke Geländeneigung war eine Herausforderung an die Architekten, die zunächst eine gebogene Stützmauer zum Hügel hin schufen. Dem Grundstück entspringen eine Reihe von rechtwinkligen Sandsteinmauern. Waagerechte Ebenen aus quer verlaufenden Travertinplatten, kühle Teiche mit spiegelnden Wasserflächen und freistehende Vordächer durchbrechen die Mauern, schaffen eine Verbindung zu dem Abhang und zusätzlichen Raum für die Bewohner. Durch eine durchdachte Ausrichtung der an die Fassade angebauten, bepflanzten Sonnendächer und eine sorgfältige Planung der Proportionen fügt sich das Haus in den Hügel ein und respektiert die umgebende Natur. Die Schichtung waagerechter Verbindungen überdeckt die Quadersteine der Hauptwände und sorgt für Einschnitte in der Landschaft.

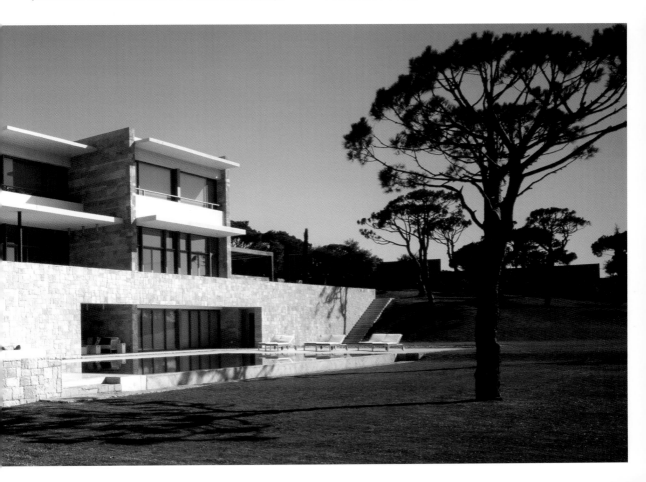

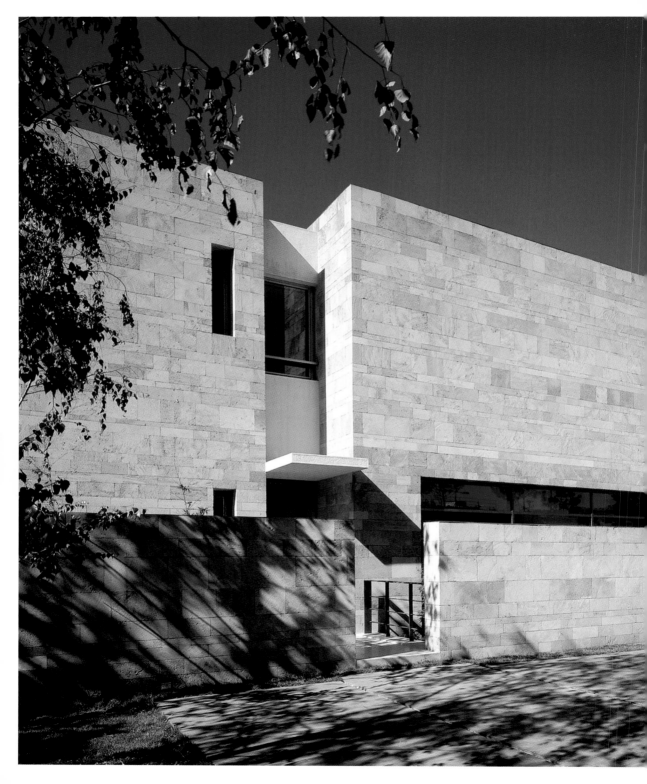

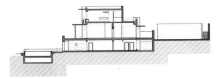

Cross section Section transversale Querschnitt

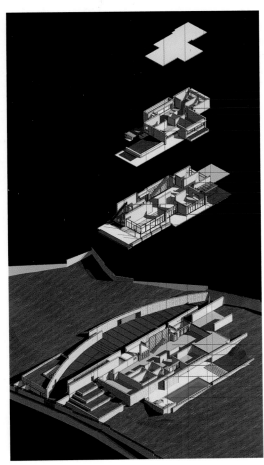

Exploded view Vue éclatée Einzelteildarstellung

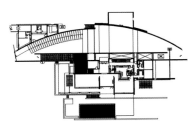

Ground floor Rez-de-chaussée Erdgeschoss

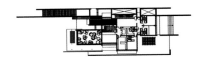

First floor Premier étage Erstes Obergeschoss

Despite its considerable size, the house blends into the surroundings thanks to the materials chosen and to the natural inclination of the land.

En dépit de ses dimensions considérables, la maison s'intègre au paysage par le biais d'une sélection de matériaux et aussi en tirant partie de la déclivité naturelle du terrain.

Trotz seiner Größe integriert sich das Haus aufgrund der gewählten Materialien und der Tatsache, dass es sich an die natürliche Neigung des Geländes anschmiegt, gut in die Landschaft.

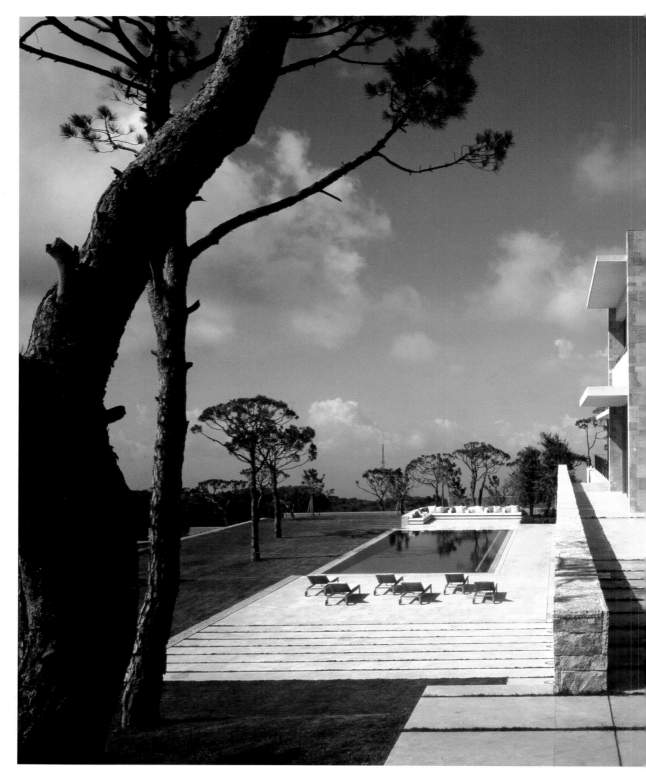

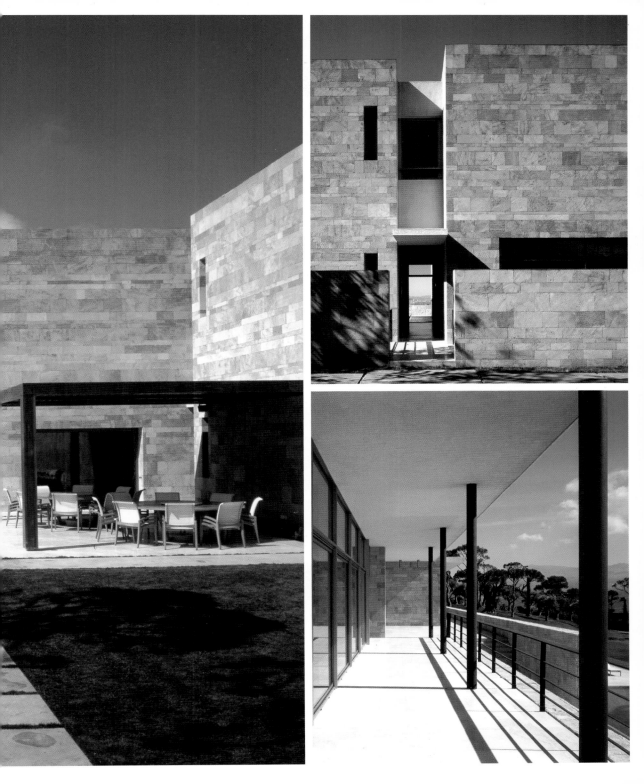

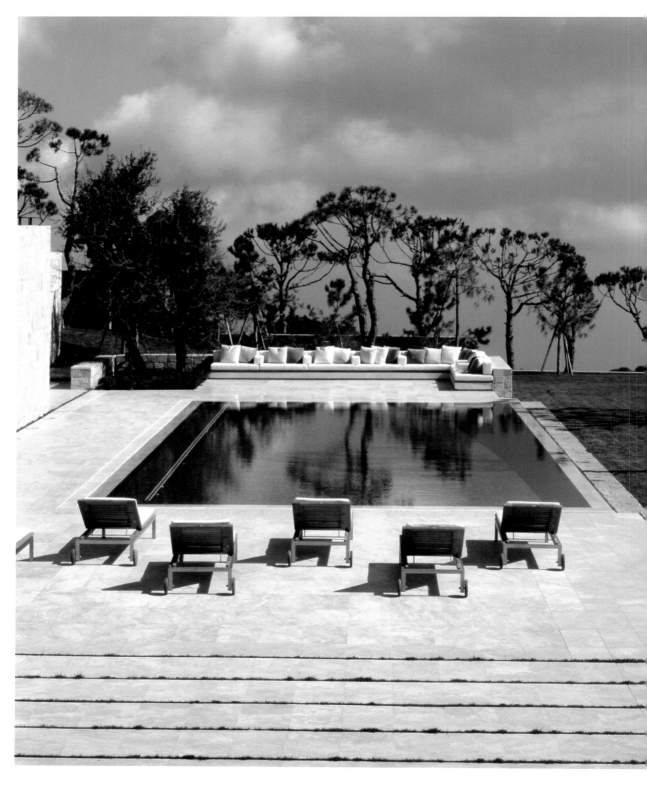

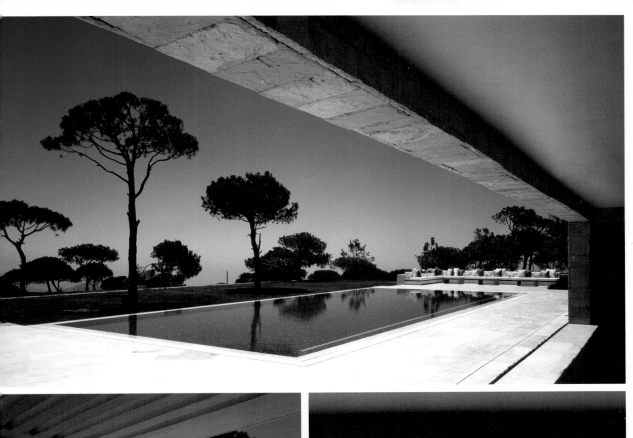
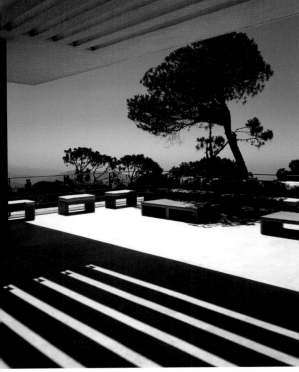
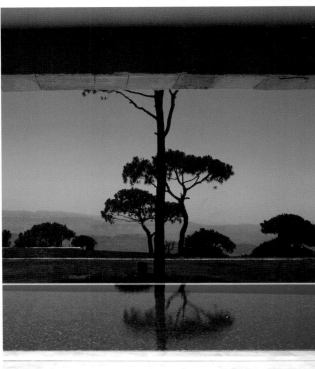

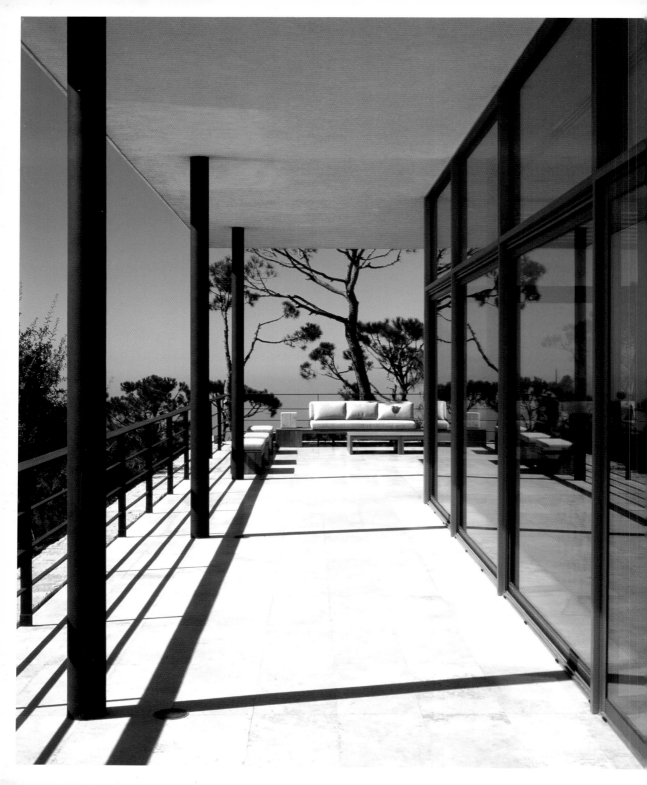

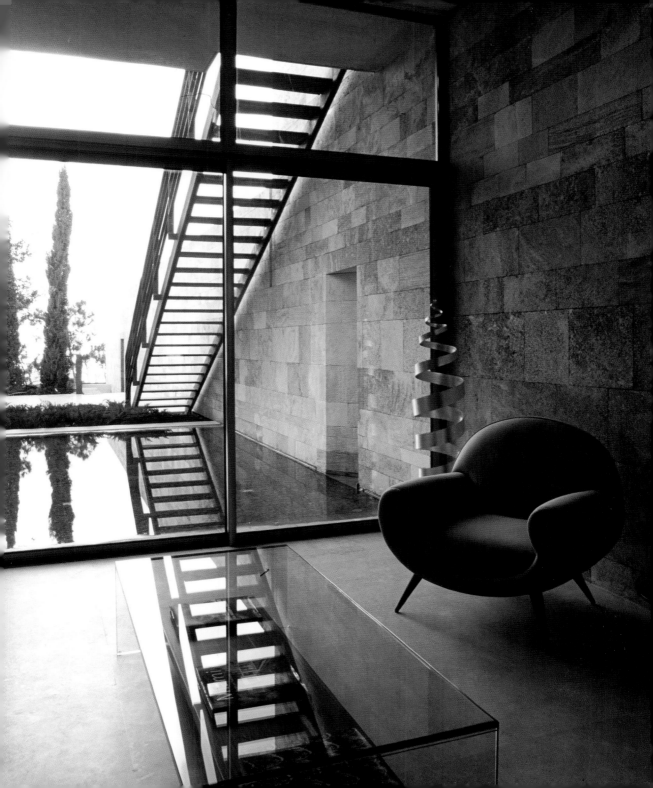

☐ Villa in Positano
Villa à Positano
Villa in Positano

Lazzarini Pickering Architetti

The renovation of this Italian residence, formerly part of a monastery, aimed at creating a contemporary space within a historical context. The interpretation of the traditional architecture has given birth to a majestic interior, reinforced by the great height of the living-room ceiling and the original 18th- and 19th-century tiles, which can also be found in the main bedroom. The outdoor swimming-pool is reminiscent of Arabic design, and the discreet terrace has, despite its apparent simplicity, great charm and refinement thanks to its breathtaking view over the sea and the elegance of its lines. The subtlety of the forms standing out in the natural surroundings is what makes this place particularly attractive.

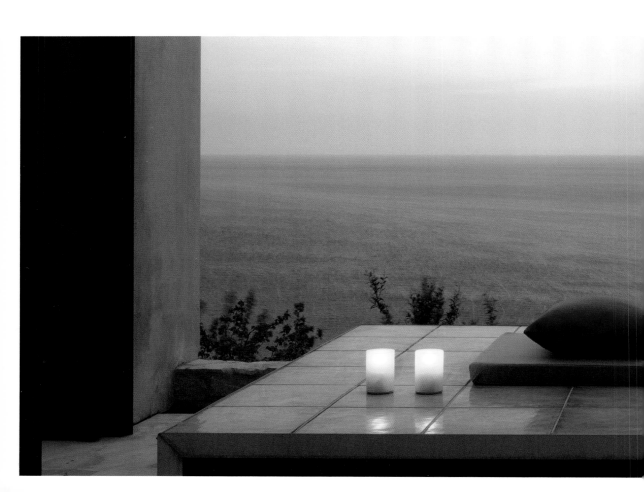

La restauration de cette résidence italienne, faisant partie autrefois d'un monastère, vise à créer un espace contemporain au cœur d'un contexte historique. L'interprétation de l'architecture traditionnelle affiche un intérieur majestueux qui met en scène la grande hauteur de plafond du salon et la céramique originale des XVIIIe et XIXe siècles. Ce type de céramique orne également la chambre à coucher des maîtres. A l'extérieur, on trouve une petite piscine aux réminiscences arabes et une terrasse subtile avec des vues imprenables sur la mer. La terrasse est un espace qui affiche une simplicité de conception apparente, mais les vues sur la mer et l'élégance de ses lignes lui confèrent charme et raffinement. C'est un lieu où tout l'attrait est dans la subtilité des formes qui sublime l'environnement naturel.

Die Restaurierung dieser italienischen Villa, die zu einem Kloster gehörte, wurde durchgeführt, um eine moderne Wohnumgebung in einem historischen Kontext zu schaffen. Durch diese Interpretation der traditionellen Architektur entstanden majestätische Räume, die sich durch hohe Decken und die Orginalkeramik aus dem 18. und 19. Jh. auszeichnen. Im Hauptschlafzimmer ist diese Art von Keramik ebenfalls zu finden. Draußen gibt es einen kleinen Swimmingpool im arabischen Stil und eine elegante Terrasse mit einem überwältigenden Blick auf das Meer. Die Terrasse ist schlicht gestaltet, aber der wundervolle Seeblick und die eleganten Linien machen sie sehr edel und anmutig. Die Schönheit dieses Ortes beruht auf den subtilen Formen, die die Schönheit der umgebenden Natur unterstreichen.

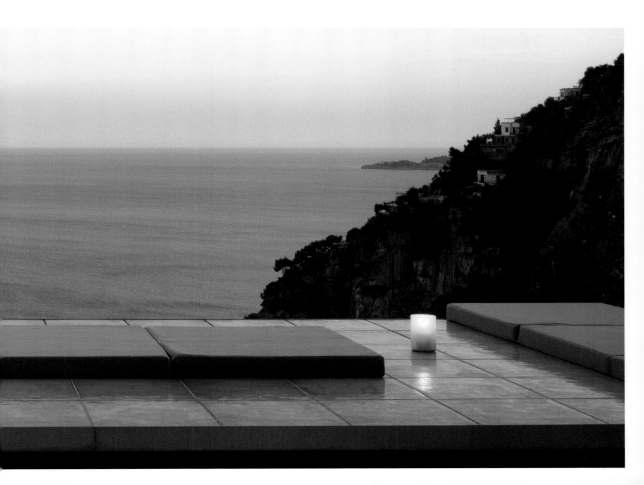

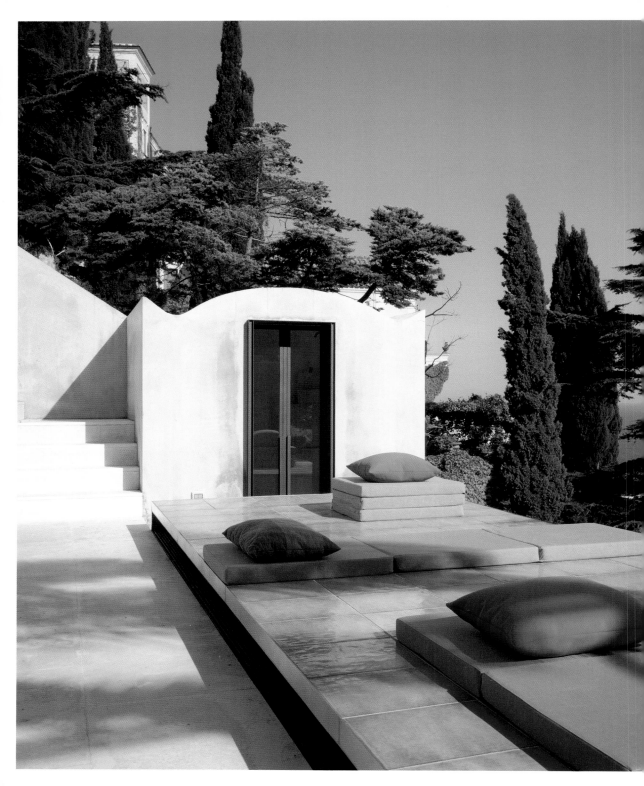

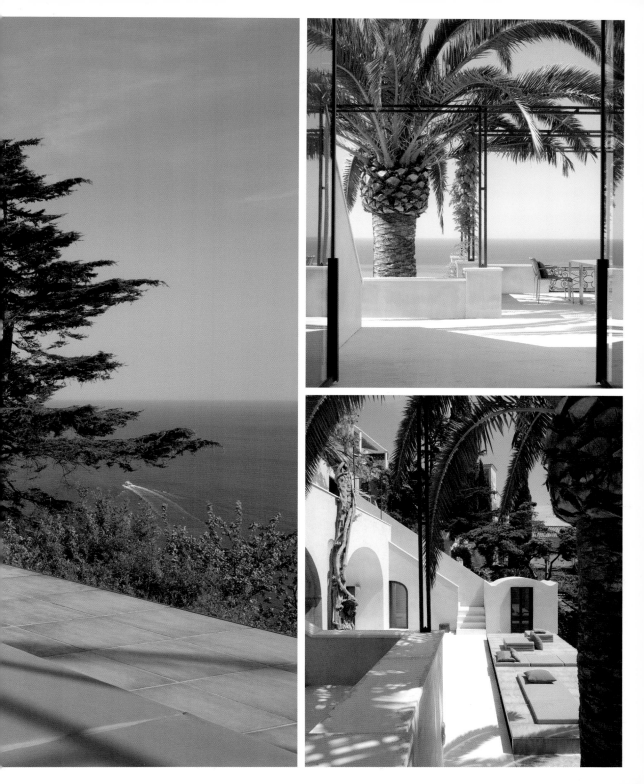

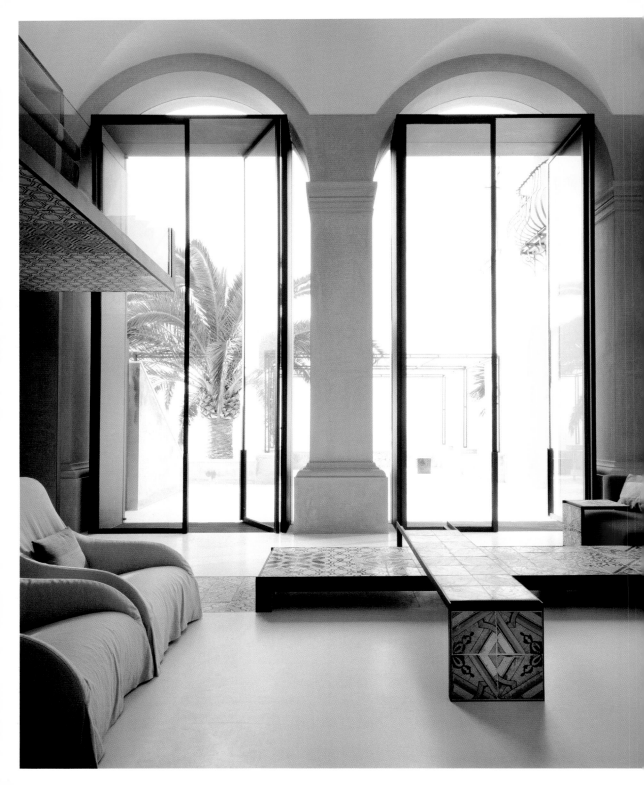

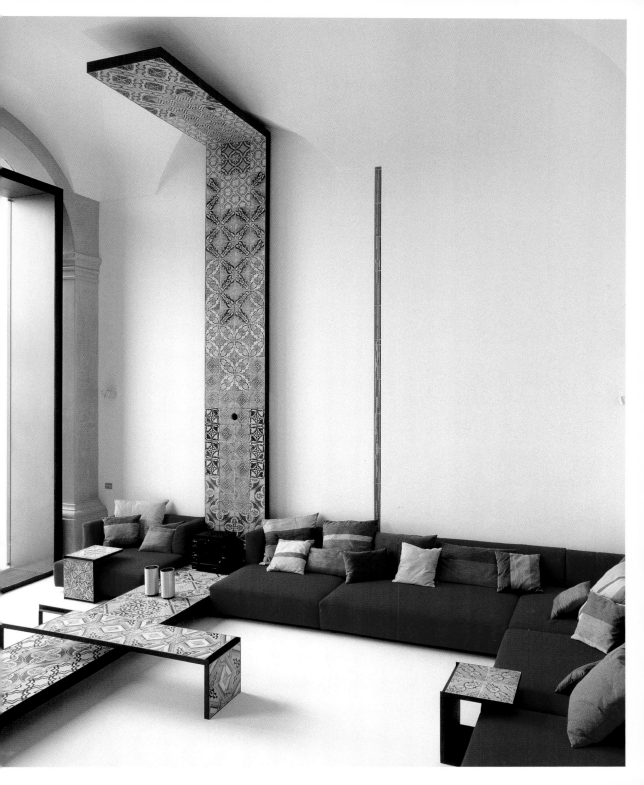

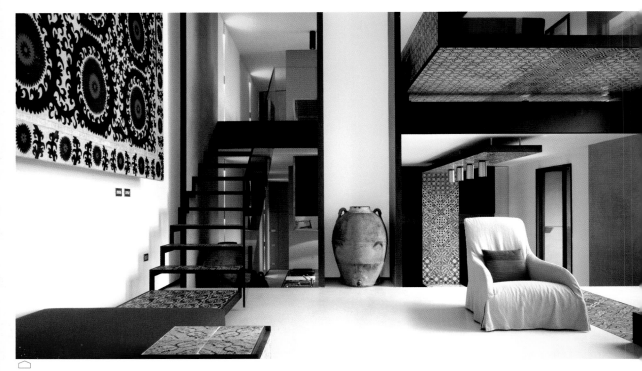

A daring combination of volumes and materials, enhanced by the white background of the surfaces and punctuated with careful lighting, make the interiors quite remarka

Les intérieurs sont marqués par le mélange audacieux des volumes et des matériaux, réalisés sur les fonds blancs des surfaces et ponctués d'un éclairage minutieusem étudié.

Die Dekoration zeichnet sich durch die gewagte Kombination von Formen und Materialien aus, die durch den weißen Hintergrund, den die Flächen bilden, und eine gut durchdachte Beleuchtung noch hervorgehoben werden.

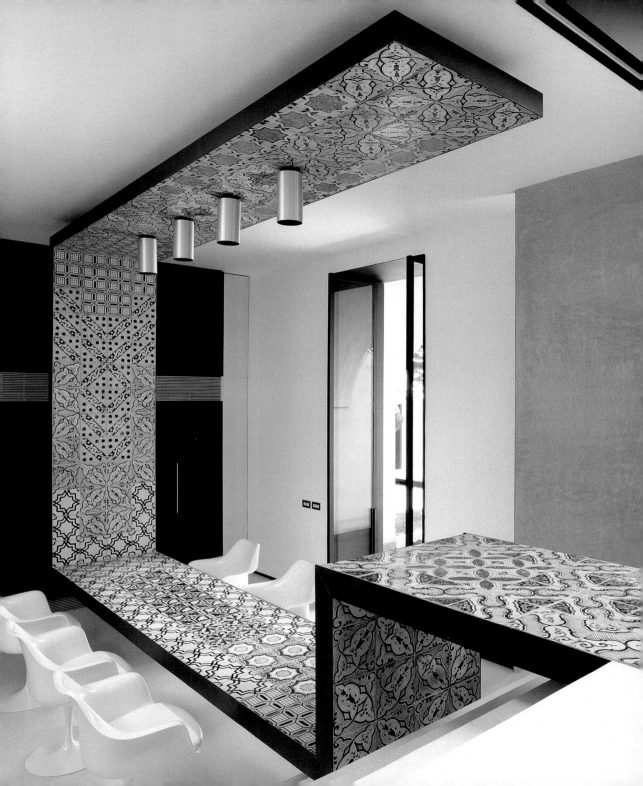

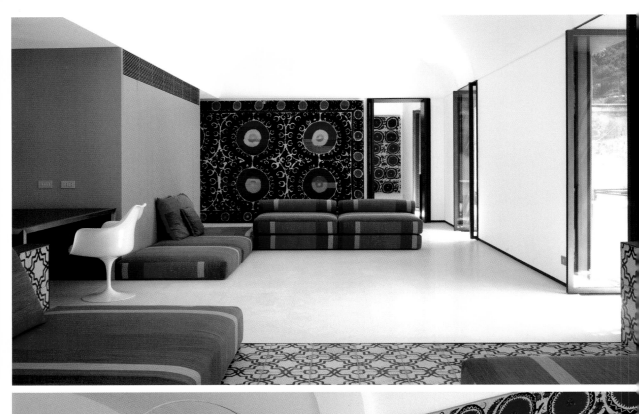
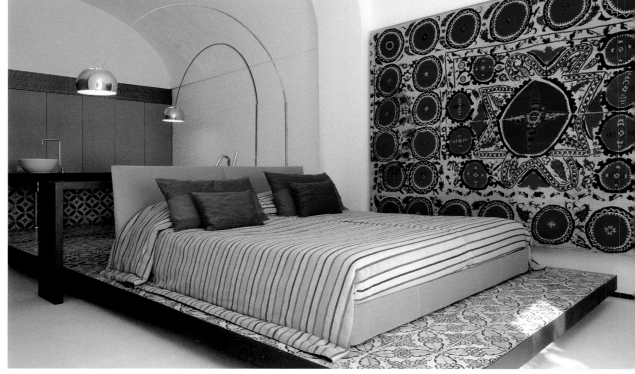

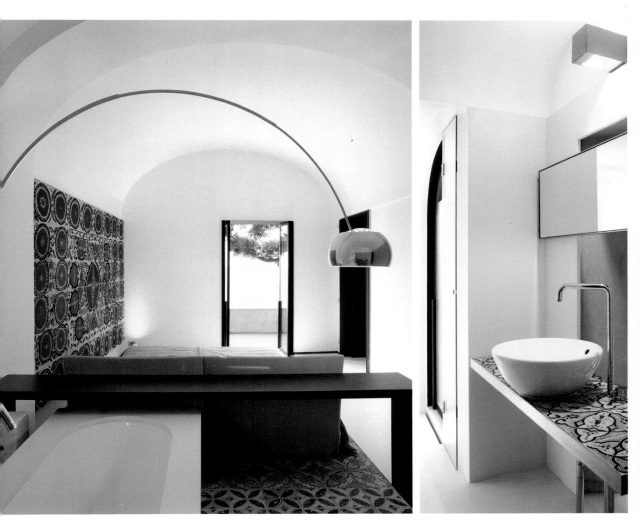

bedroom is separated from the bathroom by a simple wooden table. In both spaces, the textures and geometrical patterns of the textile pieces and the tiles form a ...erful combination.

...chambre à coucher est séparée de la salle de bains par un simple plan en bois. Dans les deux espaces, les textures et géométries produites par les tissus et la ...amique affichent un joyeux mélange.

...s Schlafzimmer ist vom Bad durch eine einfache Holztafel getrennt. In beiden Räumen vermischen sich die Texturen und Geometrien der Textilien und Keramik fröhlich ...einander.

☐ Small Refuge in Mallorca
Petit refuge à Mallorca
Kleines Refugium auf Mallorca

Toni Muntaner

This small house is the property of an art and antique dealer. Close to the city of Palma, this idyllic place has been converted into a refuge where one can switch off from the stress of every-day life. The house is simple and decorated with great delicacy and a Mediterranean touch. Inside, a multitude of oriental objects, such as oil lamps, rugs and bedspreads help create a relaxed and colorful atmosphere. The bedroom area, together with the small cove of crystal-clear water, is another of the privileged nooks of this residence, a true hiding place and oasis of peace. The terrace, with spectacular views over the Mediterranean, is one of the most luxurious places in the house where stunning sunsets and fantastic outdoor dinners can be enjoyed. A wrought-iron and mosaic table and some wicker chairs are the only pieces of furniture and a simple canvas awning protects the area from the sun.

Cette petite maison est la propriété d'un marchant d'art et d'antiquités. Proche de la ville de Palma, ce lieu idyllique est un véritable refuge pour se déconnecter et oublier le stress de la vie quotidienne. C'est une petite habitation simple qui se démarque par une décoration subtile aux allures méditerranéennes. A l'intérieur, une multitude d'objets orientaux, à l'instar de lampes à huile, tapis et couvre-lits, contribuent à créer une ambiance décontractée, haute en couleurs. La zone de repos, adjacente à la petite calanque aux eaux transparentes, est un des coins privilégiés de cette propriété, véritable refuge et havre de paix. La terrasse, forte de ses vues spectaculaires sur la Méditerranée, est un des lieux les plus luxueux de l'habitation. On peut y savourer de merveilleux crépuscules et de délicieux dîners en plein air. Les seuls meubles, qui en ponctuent le décor, sont une table de fer forgé et mosaïque et des fauteuils en osier. Un simple velum en toile qui la protège du soleil parachève l'ensemble.

Dieses kleine Haus ist Eigentum eines Kunst- und Antiquitätenhändlers. Der idyllische Ort in der Nähe der Stadt Palma dient seinen Bewohnern als Zuflucht, um sich vom Stress der täglichen Arbeit zu erholen. Das schlichte Haus ist mit viel Geschmack im mediterranen Stil dekoriert. Im Inneren befinden sich zahlreiche orientalische Objekte wie Öllampen, Teppiche und Bettüberwürfe, die eine entspannte und bunte Wohnumgebung schaffen. Der Ruhebereich an der kleinen Bucht mit kristallklarem Wasser ist einer der schönsten Winkel dieses Hauses; ein Versteck und ein Ort der Ruhe. Einer der luxuriösesten Räume des Hauses ist die Terrasse mit dem überwältigenden Blick auf das Mittelmeer. Hier genießen die Bewohner wundervolle Sonnenuntergänge und bezaubernde Abendessen im Freien. Die einzigen Möbel auf dieser Terrasse sind ein schmiedeeiserner Tisch mit Mosaiken und ein paar Korbstühle. Eine einfache Leinenmarkise, die vor der Sonne schützt, vervollständigt das Bild.

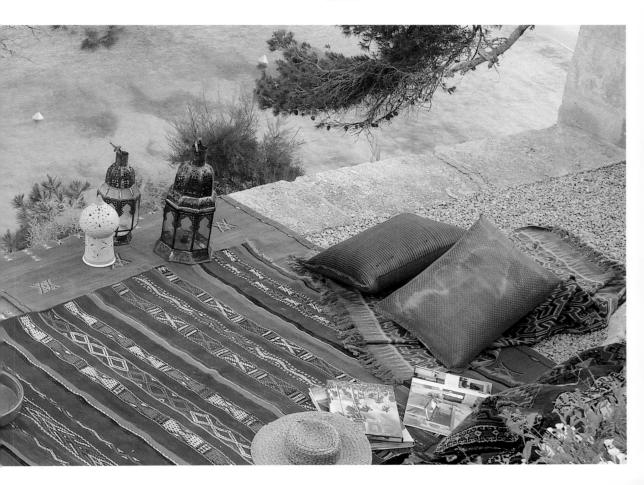

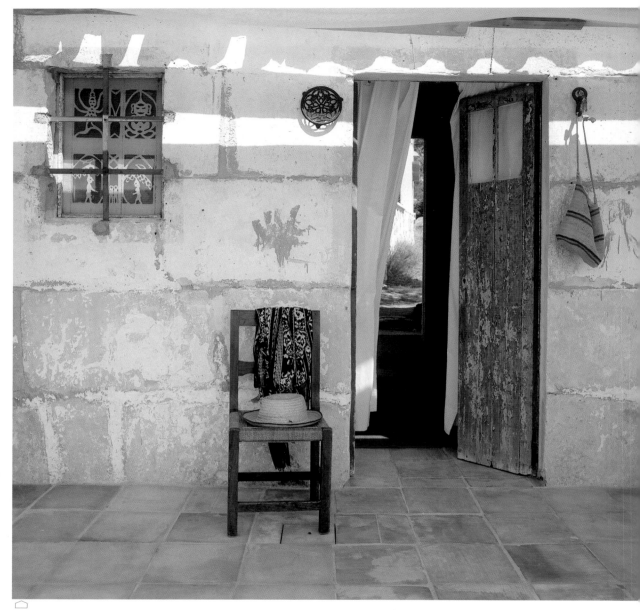

Great care has been taken to conserve the original woodwork and other elements during the renovation of this house in order to convey beauty and the peaceful passing of time.

La restauration de la maison dont les menuiseries ont conservé leur aspect original, a suivi une ligne totalement conservatrice et l'ensemble parvient ainsi à transmettre la beauté et le calme du temps qui passe.

Bei der Renovierung dieses Hauses, bei der man die Fenster- und Türrahmen im Originalzustand erhielt, war man sehr vorsichtig, so dass das Ergebnis die Schönheit und den ruhigen Lauf der Zeit zu zeigen scheint.

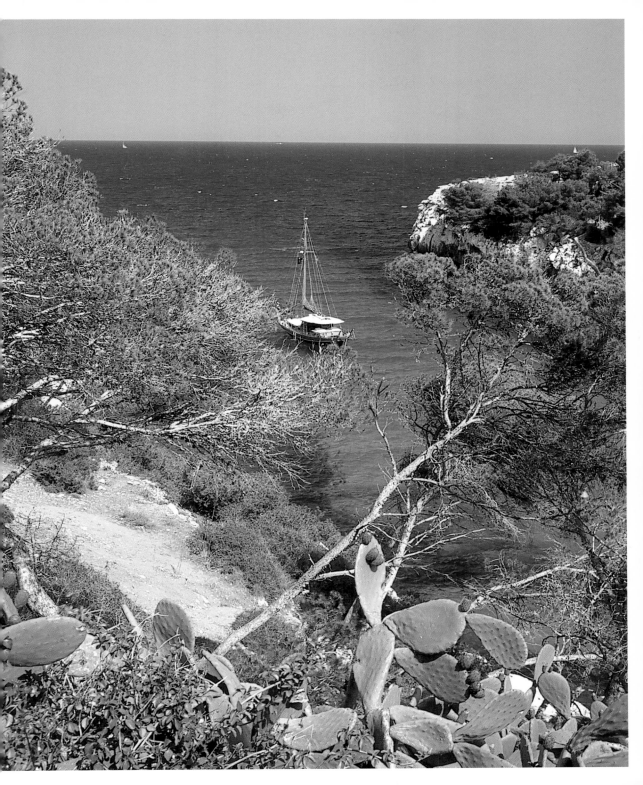

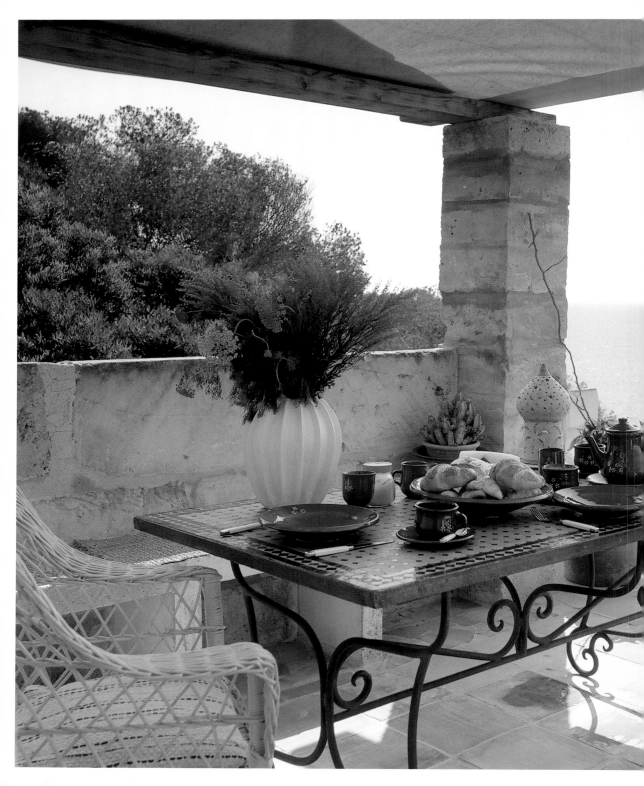

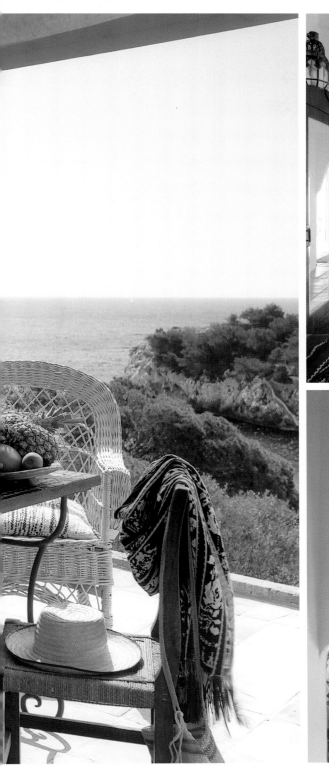

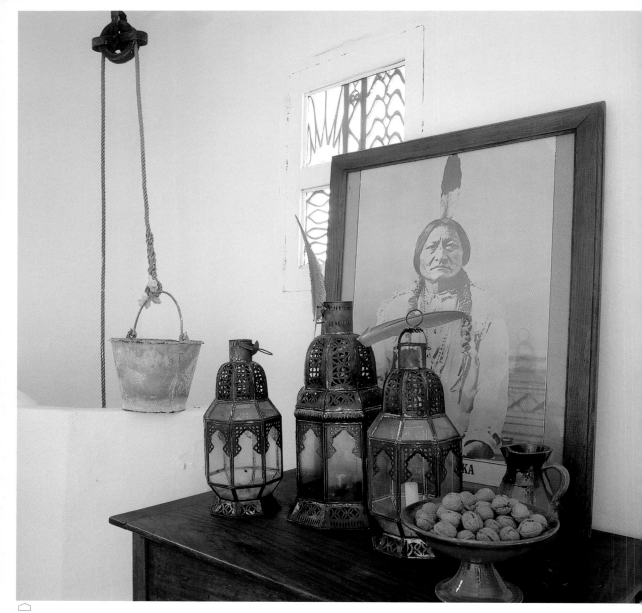

Inside this art dealer's residence, a timeless atmosphere has been recreated thanks to the structure of the house and the objects selected for its decoration.

A l'intérieur de la maison, résidence d'un marchand d'art, une atmosphère intemporelle a pu être recréée grâce à la structure de la construction et aux objets sélectionnés pour la décoration intérieure.

Im Inneren des Hauses, das einem Kunsthändler gehört, schuf man jedoch durch die Struktur und die sorgfältig gewählten Dekorationselemente eine zeitlose Atmosphä

House on Tinos Island
Maison sur l'île de Tinos
Haus auf der Insel Tinos

Due to its extraordinary location on a hillside above the harbour, this house suffered in turn neglect and a great number of alterations carried out by the numerous occupants who followed each in the course of 700 years. With the passing of time, it has become the most spectacular villa on the island. Today, old structural elements, such as ancestral walls and tiles, co-exist happily with state-of-the-art equipment and technology. The kitchen is a particularly good example of this combination. The roof has been rebuilt in the region's traditional Mediterranean style using its most typical material: slate. Slate has been employed both in the construction and the decoration of the house, while wooden beams and impressive whitewashed blocks of stone support the whole structure. Open indoor patios with large bay windows and numerable nooks and crannies are perfect for admiring the surrounding landscape.

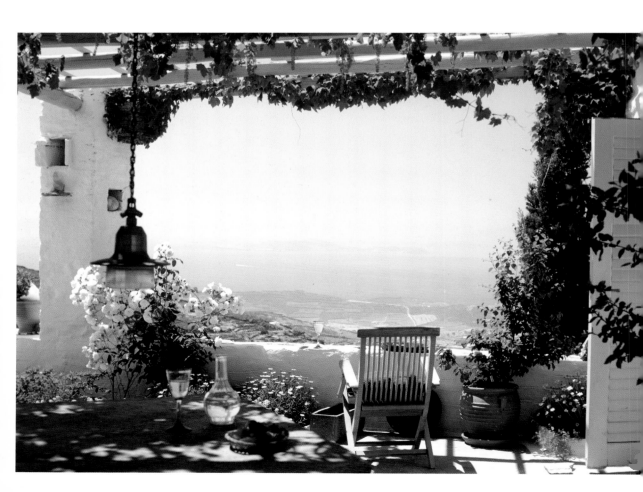

Implantée sur un site extraordinaire, accrochée à flanc de colline et surplombant le port, cette résidence, occupée et abandonnée tour à tour sept siècles durant, a été, sur le plan structurel, maintes fois modifiée et remodelée. Au fil du temps, cette villa est devenue la plus spectaculaire de l'île. A l'intérieur, d'anciens éléments structuraux côtoient des équipements de technologie de pointe, à l'instar de la cuisine qui allie céramiques et murs ancestraux à un électroménager de dernier cri. La toiture est façonnée selon un design qui s'inscrit dans la tradition des constructions méditerranéennes typiques de cette zone où l'ardoise est la protagoniste. Ce matériau est employé à la fois dans la construction et la décoration. Les poutres de bois et les grands blocs de pierre blanchis à la chaux, matériaux de soutènement de la maison, permettent de créer des patios intérieurs ouverts, de grandes baies vitrées et des petits recoins privilégiés pour savourer les vues inégalables sur le paysage méditerranéen.

Aufgrund des außergewöhnlichen Standortes an einem Hang über dem Hafen blickt dieses Haus auf eine 700 Jahre lange, wechselhafte Geschichte zurück. In all diesen Jahren wurde es bewohnt und wieder verlassen, es wurde umgebaut und Teile der Originalstruktur abgerissen. Im Laufe der Zeit ist diese Villa zu dem auffälligsten und prunkvollsten Gebäude auf der Insel geworden. Im Inneren kombinierte man die alten Strukturelemente mit technologischen Neuheiten, wie zum Beispiel in der Küche, in der die modernen Küchengeräte einen Kontrast zu den alten Wänden und Fliesen bilden. Auch beim Entwurf des Daches ließen sich die Planer von der typischen mediterranen Bauweise aus Schiefer inspirieren. Dieses Material wird in dieser Region sowohl für die Gebäudestruktur als auch für die Dekoration benutzt. Die Holzbalken und großen, gebrochen weißen Steinblöcke sind die Strukturmaterialien des Hauses. Im Inneren wurden offene Höfe, große Fenster und gemütliche Winkel angelegt, so dass man einen wundervollen Blick auf die schöne, mediterrane Landschaft genießen kann.

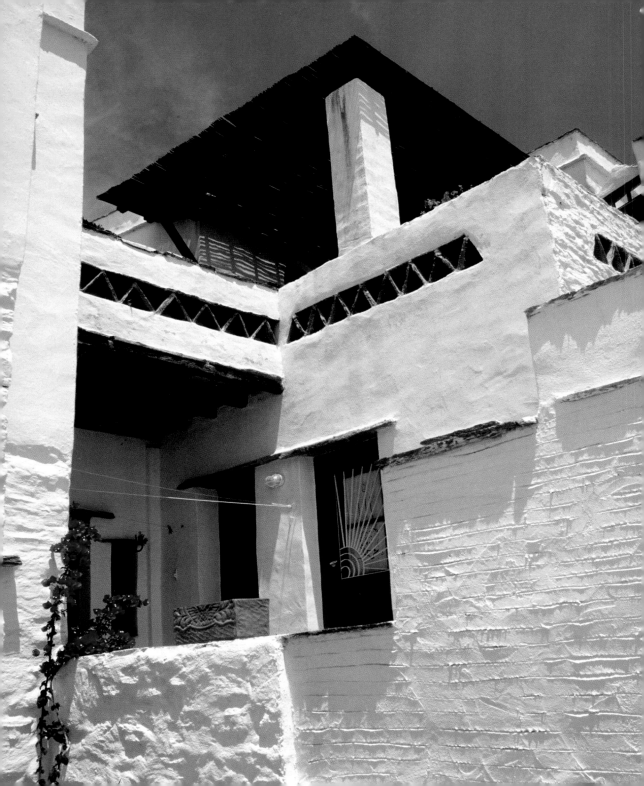

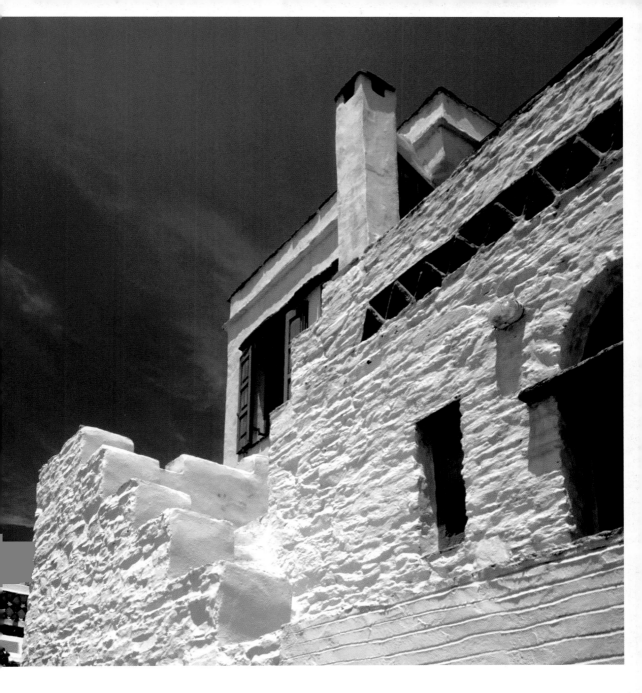

The house is a beautiful example of vernacular architecture renovation, carried out with with the utmost respect for the original lines while adapting them to modern requirements.

La maison est un bel exemple de restauration d'architecture vernaculaire réalisée dans le plus grand respect des lignes originales tout en les adaptant aux nécessités actuelles.

Dieses Haus ist ein wunderschönes Beispiel für die Renovierung eines jahrhundertealten Gebäudes. Die ursprünglichen Linien wurden soweit weit wie möglich respektiert und an die Anforderungen der modernen Zeit angepasst.

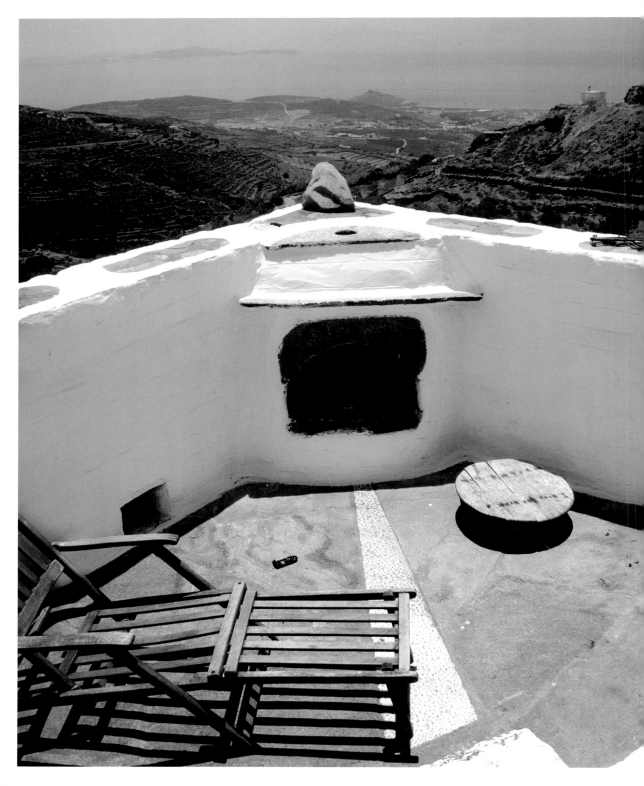

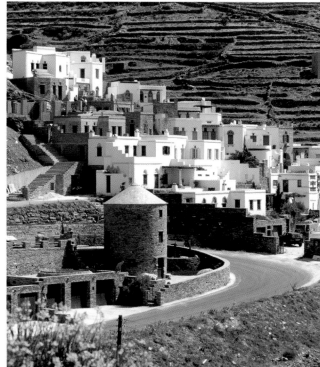
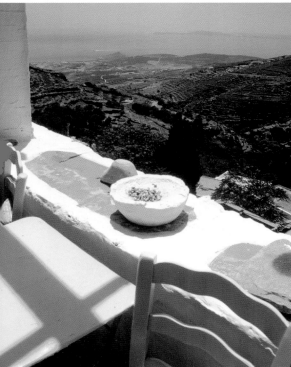

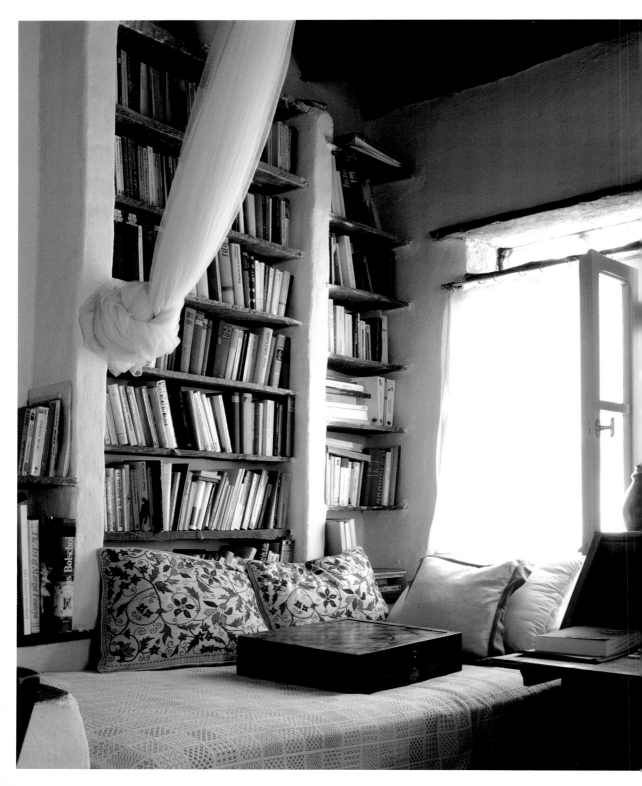

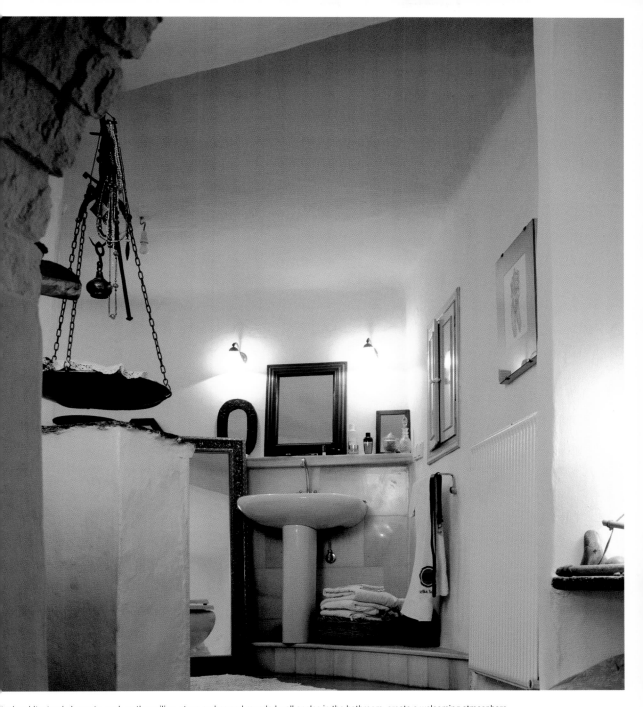

nal architectural elements, such as the ceiling, stone arches and rounded wall angles in the bathroom, create a welcoming atmosphere.

alle de bains affiche des éléments architecturaux originaux, comme les arcs en pierre ou les angles arrondis entre les murs et le plafond, créant ainsi une atmosphère
eillante.

ad sieht man noch die originalen architektonischen Elemente wie die Steinbögen und die abgerundeten Ecken zwischen den Wänden und der Decke. Diese Details
ffen eine sehr einladende Atmosphäre.

☐ Villa in Capri
Villa à Capri
Villa auf Capri

Interior design: Vicky de Dalmases de Romano

The island of Capri has been one of the most famous tourist destinations in the Mediterranean for over a century. The residences built here reflect the luxury and exclusiveness still enjoyed by the island today. The villa described here exudes opulence and elegance. The magnificent view over the sea from the protected terrace and the interiors reminiscent of bygone days create an evocative and delicate ensemble. Here past and present meet, forming a fascinating picture in which the antique mural paintings and the romantic gardens are the main protagonists. Part of the terrace has been covered to provide shade and the decoration gives the entire place an atmosphere of Arabic tents and magical summer nights.

Depuis plus d'un siècle, l'île de Capri est une des destinations touristiques les plus connues de la Méditerranée. Les résidences qui y sont construites reflètent l'ambiance de luxe et d'exclusivité qui règne dans l'île jusqu'à aujourd'hui. L'objet présenté ici est une ancienne villa où opulence et élégance sont de mises. Depuis le porche, les magnifiques vues sur la mer mêlées à des intérieurs qui reflètent des époques révolues, chargées d'histoire, forgent un ensemble évocateur et subtil. Passé et présent fusionnent pour offrir une vision fascinante où peintres anciens, fresques murales et jardins romantiques sont les protagonistes. La terrasse en partie couverte procure une zone d'ombre. La mise en scène décorative de l'espace lui confère des allures de tente arabe, le transformant en un refuge exceptionnel où savourer la douceur des nuits d'été.

Die Insel Capri ist schon seit über einem Jahrhundert eines der berühmtesten Urlaubsziele im Mittelmeer. Die Villen, die man hier errichtete, zeigen diesen luxuriösen und exklusiven Lebensstil, den man auch heute noch auf der Insel findet. Bei diesem Objekt handelt es sich um eine alte, sehr prachtvolle und elegante Villa. Von der Veranda aus genießt man einen überwältigenden Blick auf das Meer, und die Räume scheinen von der Pracht und Großartigkeit ihrer Vergangenheit durchflutet zu sein. Die Vergangenheit und die Gegenwart verschmelzen und lassen eine faszinierende Vision entstehen, in der die alten Wandmalereien und die romantischen Gärten zu den wichtigsten Elementen gehören. Ein Bereich der Terrasse wurde überdacht, um einen schattigen Raum zu schaffen. Die Dekoration lässt diesen Raum wie eine arabische Haima wirken; ein ganz besonderer Ort, um die warmen Sommernächte zu genießen.

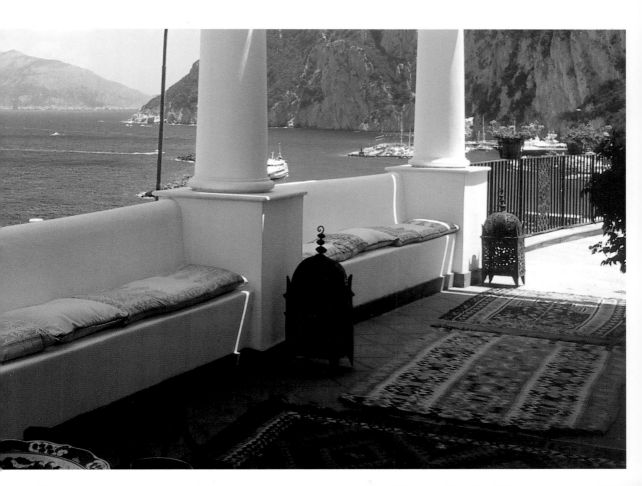

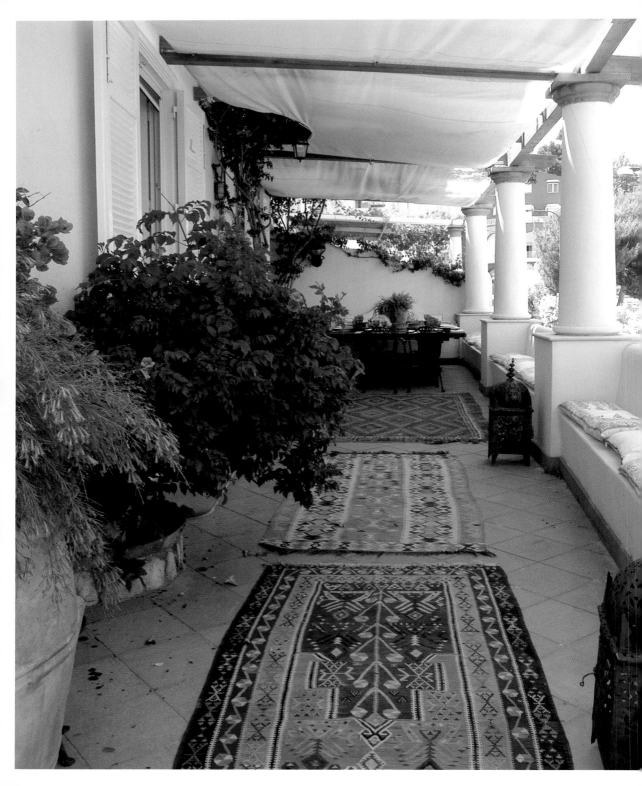

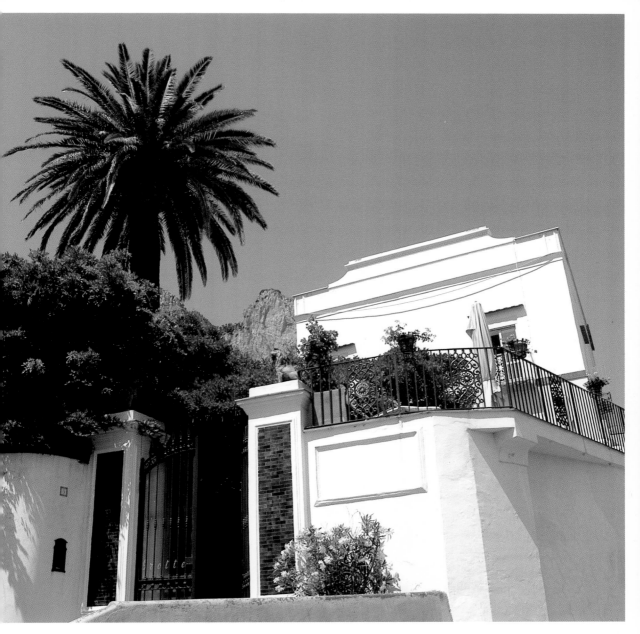

...rtain air of gentle decadence is the perfect counterpoint to an unsurpassable location.

...etit air décadent de cette habitation s'affiche en parfait contrepoint à son emplacement imparable.

...ewisses, dekadentes Flair bildet in diesem Haus den perfekten Gegensatz zu dem unübertrefflichen Standort.

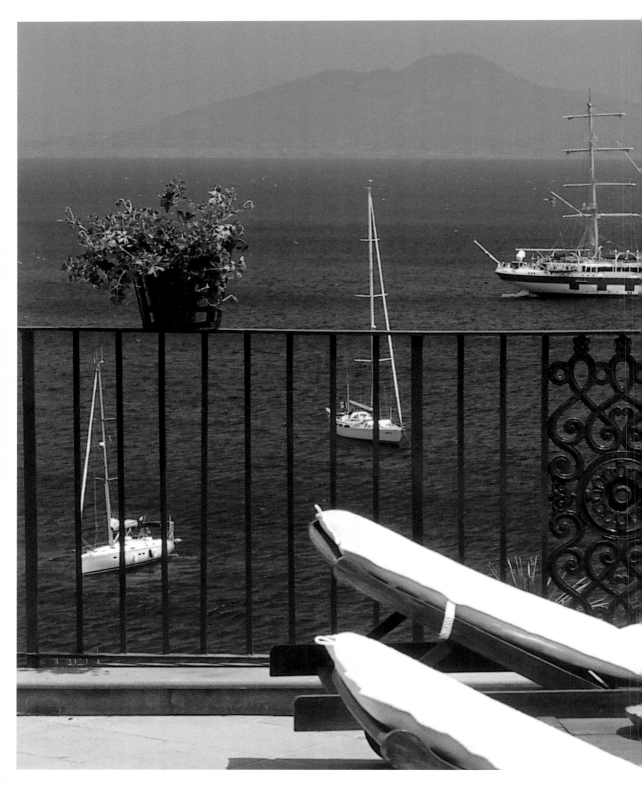

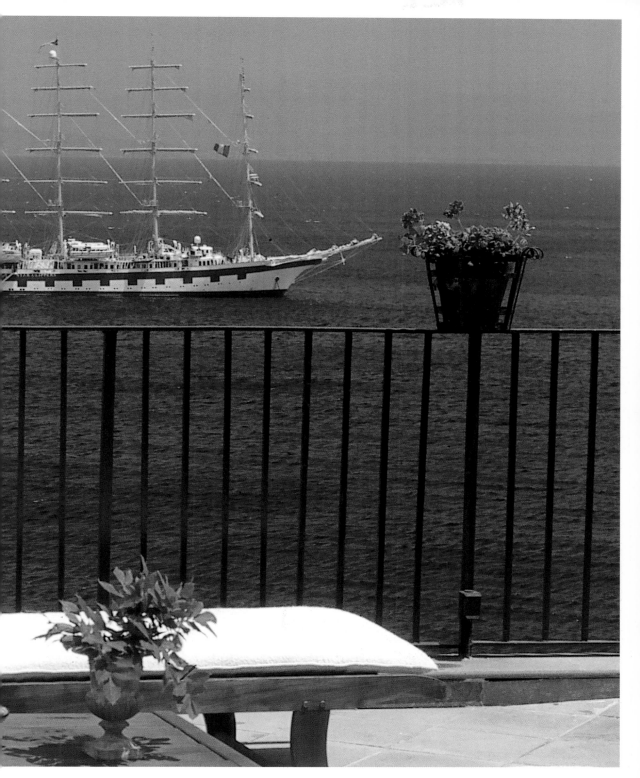

Photo credits Crédits photographiques Fotonachweis

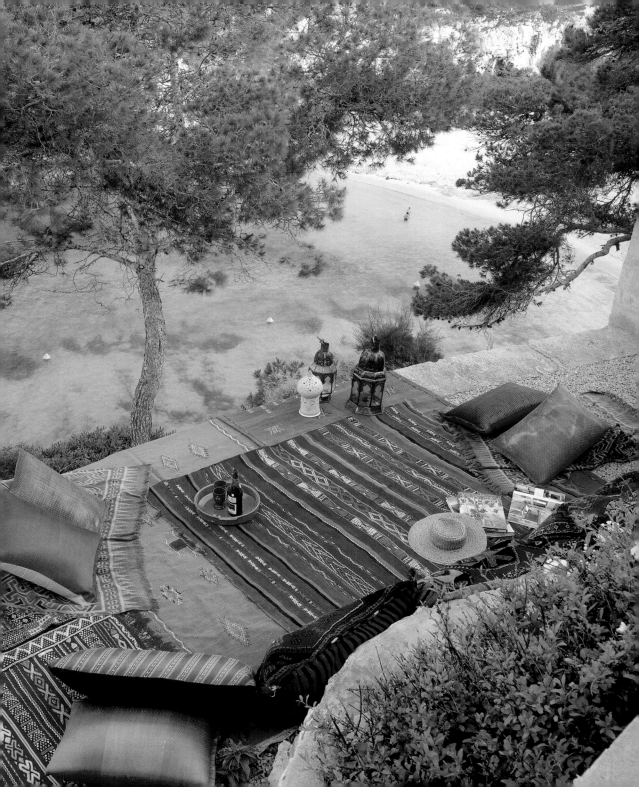